Working Space

The Charles Eliot Norton Lectures
1983–84

WORKING SPACE

FRANK STELLA

HARVARD UNIVERSITY PRESS CAMBRIDGE, MASSACHUSETTS AND LONDON, ENGLAND

46247

Publication of this book has been supported through the generous provisions
of the Maurice and Lula Bradley Smith Memorial Fund

This book is printed on acid-free paper, and its binding materials have been
chosen for strength and durability.

Library of Congress cataloging information is on the last page of the book.

For my family, past, present, and future

Acknowledgments

I would like to thank Anita Domizio for her cheerful assistance in contending with the endless details of lecturing, and Paula Pelosi for her inspired help in managing two careers at once. I would also like to thank Mary Ellen Geer for her patient and tactful editing of the manuscript.

Finally, I would like to thank my wife, Harriet, for unselfishly disrupting her life in order to help me, and I hope all of us, learn more about painting.

Contents

Caravaggio 1

The Madonna of the Rosary 23

Annibale Carracci 47

Picasso 71

A Common Complaint 99

The Dutch Savannah 127

Illustration Credits 171

Index 173

Working Space

Caravaggio

Painting today stands in an awkward position in relation to its own past. Many defenders of contemporary art look backward for sanctions of value and quality. Some suggest the recent past for support, enlisting Pollock and Kandinsky (fig. 1), for example, while others look to the more distant past, citing Titian (fig. 2) or Velásquez. But no one has seriously suggested looking back beyond the Renaissance for anything more than vague affinities. Perhaps this is because we assume that the justification for any new and worthwhile development in painting must be founded in greatness, and although we deeply appreciate art before the Renaissance, it remains qualified in our eyes. Its schematicism, however brilliant, is read as undeveloped illusionism. We believe that great painting—painting that is illustratively full, substantial, and real—was born with the Renaissance and grew with its flowering.

But even if we could establish links of value and quality with some of the great art of the past, it is still not certain that abstraction's line of succession is guaranteed. After Mondrian abstraction stands at peril. It needs to create for itself a new kind of pictoriality, one that is just as potent as the pictoriality that began to develop in Italy during the sixteenth century. The problem is not the overwhelming ambitiousness of the undertaking, but rather the difficulty that abstraction has today in relating to the past—for example, in extending its roots beyond Cubism. In the sixteenth century Renaissance artists appeared to profit directly both from their recent and their distant past. Donatello and Phidias were available to Michelangelo in a way that Seurat was, but that Giotto and Celtic manuscript illumination were not, to Mondrian. At least, this is the way it appears if we want to speak with any certainty about sources rather than similarities.

The reality of abstraction's constricted sources reminds us that picture making is a recent development in Western art and that twentieth-century abstraction is limited by the inexperience encoded in its development. Yet we would like to survey abstraction today and find to our surprise that abstract painting has grown, that it has developed a special sense of pictoriality similar to that which took hold during the sixteenth century—the sense that painting, albeit in the service of belief, can rise above the self-concerns that determine its ends. But we hesitate even to look for an approximation of this result. Something about the essential difference between the imagery and intentions of abstract painting and those of representational painting makes it very hard for us to relate abstraction to the past. This same difference makes it hard for us to look to the future. We seem to be enmeshed in a difficult present.

Nonetheless, if we confine our concern with abstraction's future to its own immediate history in the twentieth century, we can find a parallel with a similar crisis in painting at the end of the sixteenth century, the eventual resolution of which might give us some hope. Broadly speaking, the present crisis can be defined by two major disappointments that twentieth-century abstraction has experienced. One of them is the feeling that Mondrian's example and accomplishment have gone almost for naught. The other is that by 1970, it appeared that the most promising branch of postwar American painting—the successors of Barnett Newman, the color-field abstractionists—had turned to ashes. This predicament was not unlike the situation facing painting in Italy

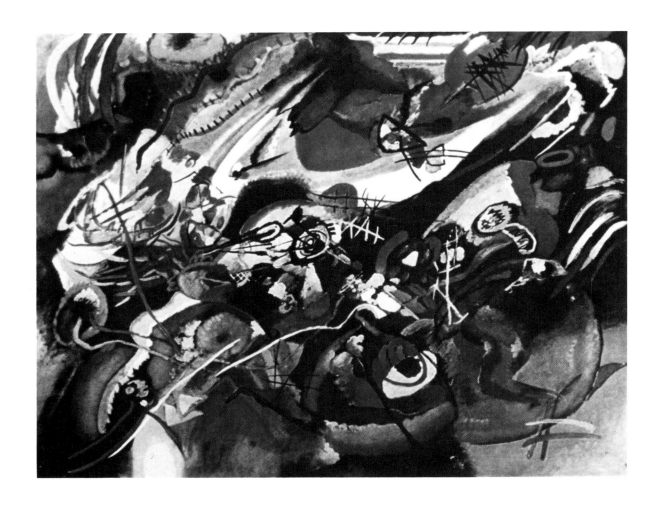

Figure 1 WASSILY KANDINSKY
Sketch 1 for Composition VII (1913)
Oil on canvas, 30¹¹⁄₁₆ × 39⅜ in.
Private collection

Figure 2 TITIAN
Presentation of the Virgin (1534–38)
Oil on canvas, 131⅞ × 305⅛ in.
Gallerie dell'Accademia, Venice

after the death of Titian. Where were the heirs of Roman classicism and Venetian color going to come from? What painting was going to stand up to Leonardo, Michelangelo, and Raphael? What painting was going to glow as brightly as Giorgione's and Titian's? The answer, of course, was Caravaggio's painting. But few painters in the early part of the seventeenth century would have believed this except Rubens and possibly Velásquez; and today, even though many would concede Caravaggio's importance, few would call him the successor of Michelangelo and a rival of Titian. But that is exactly what he became, and in doing so he created the kind of pictoriality we take for granted when we call a painting great, a kind of pictoriality that had not existed before.

The question we must ask ourselves is: Can we find a mode of pictorial expression that will do for abstraction now what Caravaggio's pictorial genius did for sixteenth-century naturalism and its magnificent successors? The expectation is that the answer is yes, but first we have to try to understand what Caravaggio actually did in order to see if his accomplishment can help us.

In the process of turning to the past I should clarify my declaration of Caravaggio's importance, since by praising Caravaggio I am surely vulnerable to charges of following current art-historical fashion. Fears of modishness notwithstanding, by naming Caravaggio as the successor of Michelangelo I mean just that: a convincing successor to the best of sixteenth-century painting, including especially Raphael. Similarly, I emphasize Caravaggio's enlargement of Renaissance painting, his purposeful addition of immediacy and strength to the character of its pictorial space.

If we assess Caravaggio's importance by posing him as a rival of Titian, however, the story is a little different. Quality cannot be the sole issue, for if Caravaggio had to compete with Titian on Titian's own terms, matching his inspired painterliness, the former would certainly not fare well. A broader, perhaps more salient question asks what contributions each made to the future direction of painting. This concern signals a more even contest, one between Caravaggio's confrontational, projective illusionism and Titian's impressionistic vitality. With the future in mind, Caravaggio questions the viability of Venetian painterliness, challenging its superficiality (that is, its emphasis on surface) and its materiality (that is, its emphasis on pigment). This confrontation with Titian stands for something more than an encounter of conflicting styles. Caravaggio does not try to present an alternative to Titian by simply looking back to an idealized antique past in the way that, say, Poussin's tepid classicism does, but rather he tries to create a pictorial reality that subsumes stylistic differences. He tries to create a pictorial container for both Venetian painterliness and the monumental figuration of Rome without giving in to either of their inherent liabilities. In the case of Venice, the fault lay in a tendency toward awkwardness, with uncontrolled lateral spreading and flattened surfaces. In Rome, a vacuous symmetry often characterized High Renaissance art, where even spectacular perspective invention and acrobatic foreshortening failed to fill the void.

Caravaggio does present some successful alternatives: for example, the *Beheading of Saint John the Baptist* in Malta offers a kind of cinemascopic depth and an ovoid delimitation of space that enables painting to enhance the theatrical flatness of Venetian muralism, while in another vein his Vatican *Deposition* shows clearly how to activate a classicist void without falling into Mannerist excesses. In these two paintings Caravaggio signals the advent of modern pictorial space, exhibiting a power whose versatility and vitality may free us from the perpetual tyranny of the soft and the hard, the ragged struggle of the successors of Rubens versus those of Poussin. It may be that the sense of balance and proportion that seems so right in Velásquez and Manet comes from a mixing of their gifted painterly bias with this lesson learned from Caravaggio, the lesson that explains the efficacy and utility of expansive, close-up pictorial presence. Unfortunately, the example of Velásquez and Manet does not seem

to have taken hold; as a result, we may have to seek out Caravaggio's way directly to help combat the recent enervation of painterliness. Our contemporary painterliness cannot seem to produce anything like the fullness of Delacroix, Turner, or Monet; it is as though pigment, light, and surface have disappeared into Mondrian's black grid. We are left to worry about pictorial space almost by default.

But, after all, the aim of art is to create space—space that is not compromised by decoration or illustration, space in which the subjects of painting can live. This is what painting has always been about. Sadly, however, the current prospects for abstraction seem terribly narrowed; its sense of space appears shallow and constricted. This seems ironic when we remember that painting had to work so hard to create its own space, or perhaps more accurately, had to work so hard to free itself from architecture. This latter effort is, in effect, the drama that began to play itself out in the sixteenth century; it began with Leonardo's *Mona Lisa* and ended with Caravaggio's *Calling of Saint Matthew.* By becoming more of an artist than a craftsman, more of an individual professional—what we now call self-employed—the Renaissance artist began to direct himself away from decoration and illustration, away from altarpieces and fresco cycles, toward his newfound responsibility: the creation of his own space. This is the task to which Caravaggio addressed himself with amazing success.

The idea of Caravaggio creating his own space in his painting may not seem very novel, but we should be aware that he was creating a space with a special, self-contained character. Out of habit, we take modern painting to begin with Jan Van Eyck. The increased use of oil paint on the portable wooden panel is seen as emphasizing a significant break with painting's medieval predecessors. At the same time, we see the beginnings of a growing mastery of representational skills as leading inevitably to the individualized idealism of the High Renaissance. But both of these notions may be a bit misleading because oil paints, wooden panels, and an expanding repertoire of representational techniques do not seem to be enough to make painting an enterprise that is spatially independent and self-contained. The narrowness and artificiality of, say, the space Crivelli created make it clear that the space in painting before Leonardo is not the space of painting as we know it now. It is not the problem of perspective, either linear or atmospheric; nor is it the problem of flatness that makes this space so different, although this often seems the best way to describe it. Rather, it appears to be something in the intention, in the acceptance of commissioned configurations, in the attitude toward covering a given surface that held painting back, that actually kept it from creating a surface that was capable of making figuration look real and free.

One could say that artists before Leonardo accepted the given surface and made the best of it. Most of the time the best artists could squeeze out enough working space to make great art, but we do not see and feel their pictorial space in the same way that we see and feel the pictorial space in great art since the example of Rubens, Velásquez, and Rembrandt. By adding elasticity and flexibility to the promise of High Renaissance space, Caravaggio gave his successors the pictorial roundness and completeness that we call great and that we instinctively use as a standard to judge painting today, whether we realize it or not. It is through the eyes of seventeenth-century painting that we have come to see great art, both before and after the seventeenth century. It may seem odd, but Rubens, Velásquez, and Rembrandt dominate our view of both Raphael and Picasso.

In order to feel the impact of seventeenth-century painting, we have to recognize the limits of fifteenth-century pictorial space and understand its consequent growth in the sixteenth century. Before 1500 the artist had to battle hard surfaces—unyielding panels and walls—trying to create space on surfaces that would have been content to stay flat. After 1500 the artist became critical of his relationship to the surfaces of

architecture and sought to modify it, either by separation, making more use of individual portable panels and canvases, or by accommodation, creating a painted space that interacted in some meaningful, though often competitive, way with the structure.

Leonardo signals the beginning of painting's attempt to free itself from architecture. His *Mona Lisa* (fig. 3) tells us about landscape space, about modeling the human figure, about atmospheric perspective and *sfumato*—all the things that begin to separate sixteenth-century painting from the painting that went before it. But the best news is that the *Mona Lisa* comes in a tidy package, a marvelous, manageable rectangle. How wonderful it would be to see it in the Uffizi, in Florence, where it really belongs, rather than in Paris in the Louvre. In the Uffizi it would be a new dawn, a glass house rising above the jagged Levittown of gold altar pieces. In the Uffizi's opening rooms (fig. 4) its simple rectilinearity would rest our eyes after their arduous tour around the crazy edges of early Italian painting. But wonderful as this experience might be, we have to be careful not to miss something obvious about this half-length figure in a landscape. What surrounds the figure might be hard to see right away: it is the shape of the space that Leonardo has created for the *Mona Lisa*. The configuration of Leonardo's space suggests two beautiful, slightly bulging soap bubbles bound together. Their films join at the painting's main spatial divider, at the columns enframing the landscape and the figure of the Mona Lisa. One bubble projects itself out toward us, engaging the balustrade, while the other curves away from us to catch the horizon line.

The image of soap film is meant to suggest a transparent membrane capable of enveloping and encircling space in order to give us a better sense of the idea of shaping pictorial space. By shaping its own space, painting makes itself incompatible with architecture, competing directly with it for control of the available space. In the *Mona Lisa* the enframing columns and the balustrade are anomalies; they get in the way of the space Leonardo wants to create. But they are not able to dull Leonardo's success with *sfumato*, the smoky chiaroscuro that produced such a profound encapsulation of landscape and the human figure.

What Leonardo does, as no one else could do, is to spin off the shadows of modeling, creating a sense of atmospheric softness that gives way in turn to a kind of magical sculptural impressionism. The result is a pictorial "rounding" of space that paves the way for Caravaggio and becomes, at the same time, part of our basic spatial vocabulary for judging great painting. The delicate inventiveness of Leonardo's space was applauded, but his successors met with a much different reception. The evolution of Leonardo's pictorial space into the manic gargantuanism of Michelangelo was received with skepticism, while the angular, projective assaults of Caravaggio, which ensured Leonardo's perpetual availability to the future of painting, were passionately denounced.

If the idea of an artist shaping space and actually being able to share the vision of that space with the viewer seems farfetched, we should remember that art offers little in the way of verifiable experience. We try to see as best we can, hoping that our intuitions and insights provide illumination. It is very true that it is hard to see space, especially in paintings, but we are moved by the resonance of color in Titian's Venetian atmosphere and by the presence of light in Velásquez's interiors, things which are equally hard to see.

This ephemeral quality of painting reminds us that what is not there, what we cannot quite find, is what great paintings always promise. It does not surprise us, then, that at every moment when an artist has his eyes open, he worries that there is something present that he cannot quite see, some-

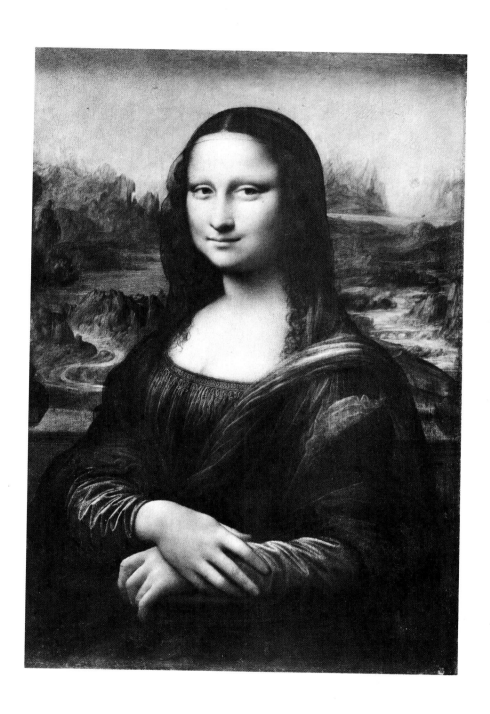

Figure 3 LEONARDO DA VINCI
Mona Lisa (c. 1503–05)
Oil on panel, 30¼ × 21 in.
Musée du Louvre, Paris

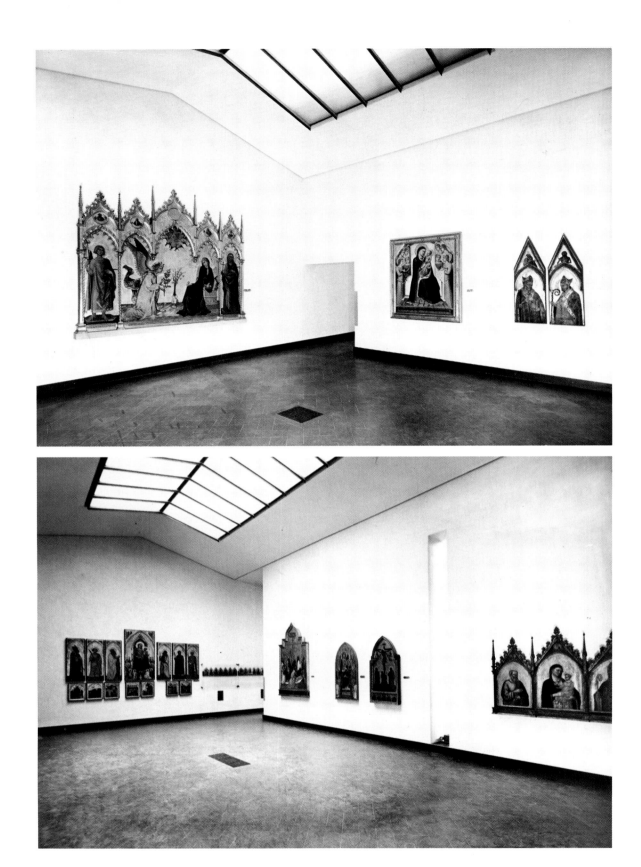

Figure 4 Opening rooms
Galleria degli Uffizi, Florence

thing that is eluding him, something within his always limited field of vision, something in the dark spot that makes up his view of the back of his head. He keeps looking for this elusive something, out of habit as much as out of frustration. He searches even though he is quite certain that what he is looking for shadows him every moment he looks around. He hopes it is what he cannot know, what he will never see, but the conviction remains that the shadow that follows but cannot be seen is simply the dull presence of his own mortality, the impending erasure of memory. Painters instinctively look to the mirror for reassurance, hoping to shake death, hoping to avoid the stare of persistent time, but the results are always disappointing. Still they keep checking. We can see Caravaggio looking at himself from *The Martyrdom of Saint Matthew*, Velásquez surveying his surroundings in *Las Meninas*, and Manet testing the girl at the bar to see if there is anything different about those who have to work rather than see for a living.

It may be that in the *Allegory of Painting* (the artist in his studio; plate I) Vermeer was the only one really to come to grips with the worrisome blank spots in the artist's vision. Possibly he was the only one to realize that painting has to account for what it cannot see even though it fears this confrontation, and certainly he was the only one to recognize that this accountability implies a line of continuity that is in the end painting's salvation, a line of continuity that can be seen as a connection to the past and an engagement of the present, ensuring its future. By observing the observer observing, by putting a model in artist's clothing, by making the recorder of the pictured event an anonymous mannequin, and by revealing the mannequin's blank, unseeing, unprotected, unaware side, Vermeer created a weightless presence (the artist himself) to complement the ethereal, feminine personification of art.

Our first reaction after pulling back the curtain at the edge of the painting is one of delight. It is as though we have stumbled on the ultimate refinement of art; everything in front of us is suddenly true and clear. Unfortunately this vision is unstable, at times threatening to disappear. Yet we feel that the miraculously lit, encapsulated pictorial space

will endure, that it will drift along with us, accompanying our collective spectating consciousness until we cease to exist, after which we expect that it will quietly latch onto the consciousness of our successors, whoever they may be. Anticipating such an endless journey, Vermeer seems to have deliberately dried the life out of his models, leaving two shells full of chalky, incandescent presence to trace the continuity of art through the ever-present. We have the feeling of invading a private moment as we enter Vermeer's painting, but soon the sense of penetrating detail, the sense of a tapestry unraveling in our hands, suggests that this private moment is merely everyone's accommodation to passing time, and that in the end we are not the observers but simply victims whom Vermeer has trapped. He is, after all, standing behind us, watching us watch art.

Seeing for the purposes of making art is basically a circular experience. Perhaps this experience is not as sophisticated as our perceptual capacities suggest it could be, but its goal—that of making art—is a difficult one. Art must be a communicable whole, and perception tends to be fragmented and self-serving. In the most obvious and fundamental way the artist wants to see what is going on around himself. His paintings, almost by definition, should have a spherical sense of spatial containment and engagement—a spatial sense, obviously, at odds with the boxlike mechanics most commonly and effectively used for the representation of space. An effective painting should present its space in such a way as to include both viewer and maker each with his own space intact. It is not that this experience should be literal; it is simply that the sense of space projected by the painting should seem expansive: expansive enough to include the viewing and the creation of that space. The artist should strive to encourage a response to the totality of pictorial space—the space within and outside of the depicted action of the painting, the space within and outside of the imagined action of making the painting. The act of looking at a painting should automatically expand the sense of that painting's

space, both literally and imaginatively. In other words, the spatial experience of a painting should not seem to end at the framing edges or be boxed in by the picture plane. The necessity of creating pictorial space that is capable of dissolving its own perimeter and surface plane is the burden that modern painting was born with. No one helped lighten this burden more than Caravaggio.

Now many would find this view of pictorial space unnecessarily complex and confusing. The basic spatial problem of painting has been described simply as one of having to represent three dimensions on a two-dimensional surface. There is obvious truth to this view, but the history of painting from 1500 to 1600 suggests that the artist's concern for how he, first, and then the viewer in turn, should experience art and the space it invoked was more complicated than merely representing three dimensions successfully on flat surfaces. It is safe to say that as the ability for rendering convincing three-dimensionality grew, the idea of what this space should be and should do for painting grew. Unfortunately it began to grow in different directions at the same time, creating a sense of conflict. One direction pointed to a painting with one stationary viewer; the other favored architectural decoration with multiple viewers and multiple points of view. Not surprisingly, the first of these conventions dominates today, while the other has virtually disappeared.

Two great "failures" signal the break between painting and architecture—Leonardo's *Last Supper* and Michelangelo's *Last Judgment*. That both works are about "last" events suggests that in the minds of their creators there might have been some other last thoughts. Wall decoration obviously was not the kind of ambitious goal Leonardo had in mind for painting—witness his inability to make emulsified paint stick on walls. If Leonardo expressed ambivalence about decoration, Michelangelo went even further, unleashing pure anger and frustration. There is no doubt about Michelangelo's intentions in the *Last Judgment:* he totally destroyed the visual coherence of the Sistine Chapel by blasting out the end wall. It is very hard to know what this mural means

to say about painting. Michelangelo's florid aggressiveness seems to attack everything that has gone before, including his own work on the ceiling immediately above. The *Last Judgment* is illusionism run rampant. There is no compositional restraint, no pictorial enframement, no sense of physical weight; the figures float high and wide. Pictorial cohesion, architectonic space, sculptural gravity—all these aspects of Michelangelo's genius become just so many pieces of driftwood. Painting before the *Last Judgment* was painting one could look at, or at least into; after the *Last Judgment* painting became something one could walk through. Michelangelo dissolves the end wall of the Sistine Chapel so that we can exit the church through heaven and hell, moving out of the Renaissance toward Caravaggio's world, a world of sensuality and spatial incongruity beyond even Michelangelo's imagination.

In the Borghese Gallery there is a Bronzino, *Saint John the Baptist* (plate 2), oil on wood panel, from about the middle of the sixteenth century. It is not a very startling painting, probably because it is a little worn and in need of cleaning, but it is nonetheless worthy of our attention. A catalogue entry notes that "the position of the young man is built up out of a bold use of foreshortening and a bending of limbs which alone constitute the architecture of the work." Nothing could provide a better summary of the tormented relationship of painting and architecture at the beginning of the sixteenth century, and, perhaps, nothing could provide a better introduction to the genius of Caravaggio than the image of "bending limbs which alone constitute the architecture of the work." Of course architecture means structure in this description; but the point is well made, however inadvertently, that the Mannerist figure has built its own space for painting at the expense of architecture as well as conventional pictorial structure.

Bronzino's *Saint John* gives us a good preview of how Caravaggio came to see painting's own self-contained space, what we have come to understand today as strictly pictorial space. Perhaps the twisting of limbs into architecture can be understood better the other way around, so that with a little syntactic license we get the twisting of architecture into the limbs of painting. Hence we see how Michelangelo's chiaroscuro and foreshortening climb over each other in a Mannerist frenzy to push on with what Leonardo had started—the search for an independent pictorial space for painting. Taking a hint from Bronzino, Caravaggio ended the hunt. He took the space that Bronzino had elegantly described, the space from Saint John's left toe to his left thumb, and made it almost inexplicably larger and grander. Toward this end he used light and dark more coherently than it had ever been used before, and foreshortening more cleverly. But more important, where Leonardo had triumphed before him—modeling the human figure, giving life to contour—Caravaggio rose to even greater heights by modeling the whole painting, giving life to pictorial space, creating the roundness and fullness of figure and atmosphere that so impress us in the great painting of the seventeenth century, particularly in the work of Rubens and Rembrandt. It seems clear that Caravaggio's compelling realism extends to the space around his figures as well as to the figures themselves. In fact, in painting after painting we are forced to notice Caravaggio's real genius—a projective displacement of space secured by brilliant right-angled foreshortening. This manipulation of pictorial space gives his painting the familiar close-up realism we prize so often in motion pictures.

To be able to carry in our minds the space of Caravaggio's large commanding works, such as the Vatican *Deposition* and the *Seven Acts of Mercy* from Naples, we need some kind of image to help form an idea about the design and purpose of Caravaggio's pictorial space. The image that comes to mind is that of the gyroscope—a spinning sphere, capable of accommodating movement and tilt. We have to imagine ourselves caught up within this sphere, experiencing the moment and motion of painting's action. Fanciful as this space may be, it has the cast of reality; we have to take it seriously. Caravaggio's space differs from that of Raphael and Titian before him and from that of Rubens and Poussin after him. The sense of projective roundness, of poised sphericality, is important because it offered painting an opportunity that was not there before, and that was, amazingly enough, diluted soon afterward. The space that Caravaggio created is something that twentieth-century painting could use: an alternative both to the space of conventional realism and to the space of what has come to be conventional painterliness.

The sense of a shaped spatial presence enveloping the action of the painting and the location of the creator and spectator is a by-product of the success of Caravaggio's realistic illusionism. The sensation of real presence and real action successfully expands the sensation of pictorial space. This is the first miracle of Caravaggio, a miracle that with stunning economy both anticipates and deflates subsequent Baroque illusionism.

The second miracle of Caravaggio is the miracle of surface. Skin, flesh, and pigment blend into reality. Painting is acknowledged as an act and as a physical fact, but immediately afterward, almost simultaneously, the presence of the human figure is felt as real, touchably there. Caravaggio is simply a totally successful illusionist. His figures overcome the mechanics of representation; they are neither representations of models trying to appear convincing, nor representations of types trying to appear unique and present.

Caravaggio's advantage comes from his ability to create the sensation of real space within and outside of the action of the painting, powerfully reinforcing his masterful illusionism. Painters before him were encumbered either by the boxiness of measured settings or the ungainly spread of painterliness—not necessarily bad effects in themselves, just patently less real, obviously less focused, and, unfortunately, definitively less whole. Painters after Caravaggio fared no

better; they had to struggle with antique revivals and a naturalism compromised by illustration. Although these handicaps were surmountable, they endured quite stubbornly until the beginning of the nineteenth century, when genius once again overtook painting.

Probably the easiest way to get a sense of the effectiveness and excitement of Caravaggio's realism is to compare his Capitoline *Saint John* (plate 3) with Bronzino's *Saint John the Baptist* in the Borghese Gallery. Caravaggio's boy is caressable, kissable. Bronzino's young man merely offers his toe, while the rest of his features recede into a quasi-antique/Renaissance amalgam. Caravaggio's boy has an aura that cannot be missed—this is the face that launched great painting. Beneath this self-satisfied, cheeky smile lies aggressive ambition, a feeling that this youthful success can rival Titian's glory. The figure in Caravaggio's painting has a glow that makes pigmented flesh one with color and light. At the same time, the alignment of light and dark with figure and ground illuminates the Baptist's naked body. The definition of the figure is both hard and soft, linear and painterly, combining the prejudices of both Rome and Venice.

Furthermore, the colored light of the Capitoline *Saint John* yields a fluorescent afterimage, as if we had squeezed our eyes shut and successfully brought a once dead, but still ferociously desired, image back to life. This gift of Caravaggio's has a lot to say to emotion and psychology, but it also has a lot to say to painting today, especially to painterly abstraction. Caravaggio declares that pictorial drama is everything in art, and that this drama must be played out with convincing illusionism. It is the lack of a convincing projective illusionism, the lack of a self-contained space, lost in a misguided search for color (once called the primacy of color) that makes most close-valued, shallow-surfaced paintings of the past fifteen years so excruciatingly dull and unpromising. This is to say that today painterly abstraction has no real pictorial space—space, for example, like that of Caravaggio, Manet, Mondrian, Pollock, and, surprisingly, Morris Louis.

In order to be able to do what he did, Caravaggio had to change the way things were done in painting in the late sixteenth century. The biggest change was made by giving painting its own space. He freed painting from architecture and decoration, and pointed out what painting's proper relationship to patronage, both clerical and private, should be. But most important, he changed the way artists would have to think about themselves and their work; he made the studio into a place of magic and mystery, a cathedral of the self.

In the studio Caravaggio created his own space. There he embodied it in paintings that were later brought out into public view, installed in churches and private galleries, and abruptly abandoned to critical scrutiny. That they have survived so well is amazing. If one thinks of what painting had been before Caravaggio—Jan Van Eyck, Rogier van der Weyden, Botticelli, Piero della Francesca, Raphael, Michelangelo, Titian—it seems miraculous that a pictorial space was created that was not beholden to either the architecture of church and state or the architecture of nature, excepting, of course, the human figure. This is Caravaggio's final miracle.

After absorbing the work in the Contarelli Chapel, Caravaggio's famous St. Matthew cycle in the Church of San Luigi dei Francesi in Rome, we begin to see painting as belonging to the class of individual pictures, and as having almost by definition a sense of self-contained wholeness. In this regard the conglomeration of decorative and illustrative fragments that went into the creation of sixteenth-century Italian illusionism (seen at its best in the Sistine and Farnese ceilings) will seem especially disjointed. The result is that a sense of spectacular coherence and calm permeates our first impression of the Caravaggio paintings of St. Matthew as we unconsciously recall all of the great art trapped above us in Rome.

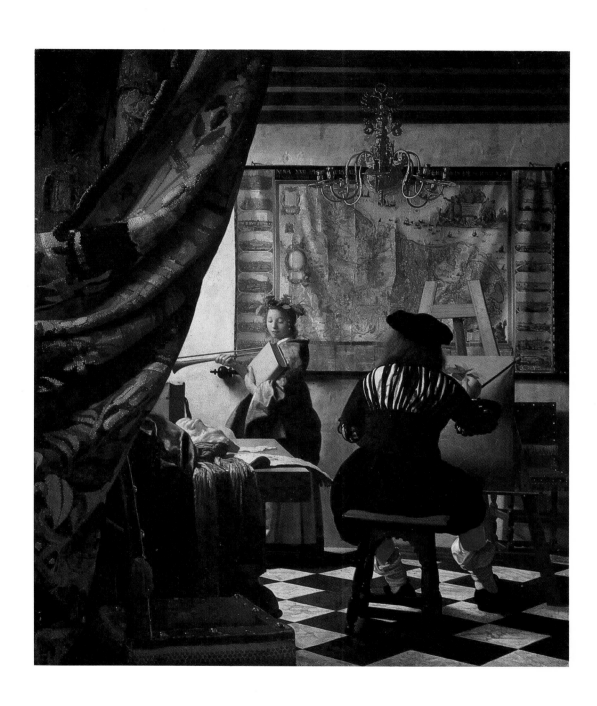

Plate 1 VERMEER
The Allegory of Painting (c. 1666–67)
Oil on canvas, 47¼ × 39⅜ in.
Kunsthistorisches Museum, Vienna

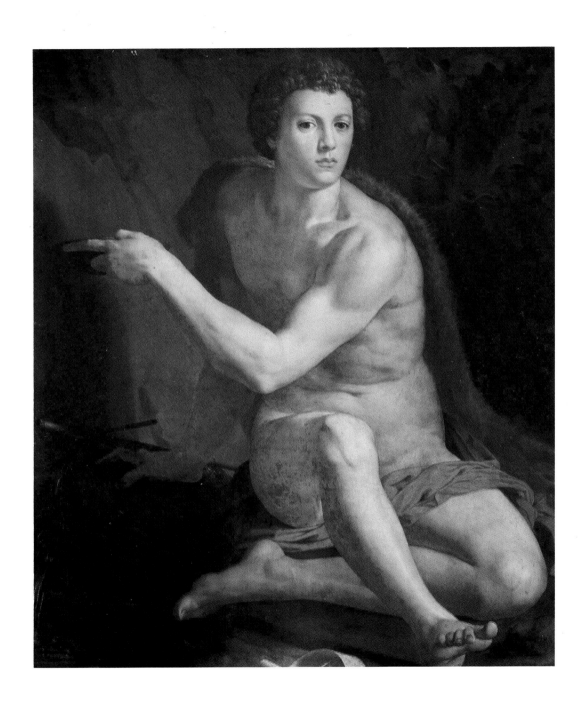

Plate 2 BRONZINO
Saint John the Baptist (c. 1550–55)
Oil on panel, 47¼ × 36¼ in.
Galleria Borghese, Rome

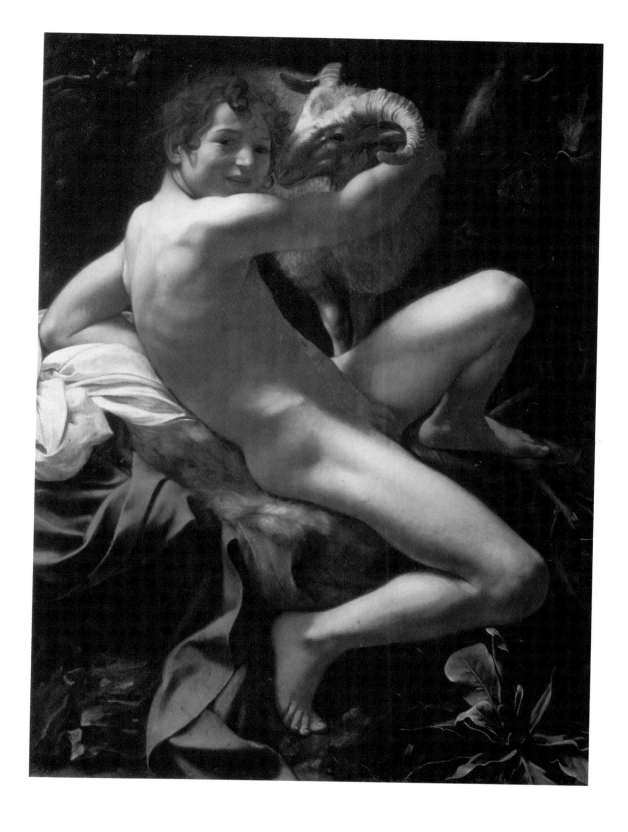

Plate 3 CARAVAGGIO
Saint John the Baptist (c. 1602–03)
Oil on canvas, 52 × 38¼ in.
Capitoline Museum, Rome

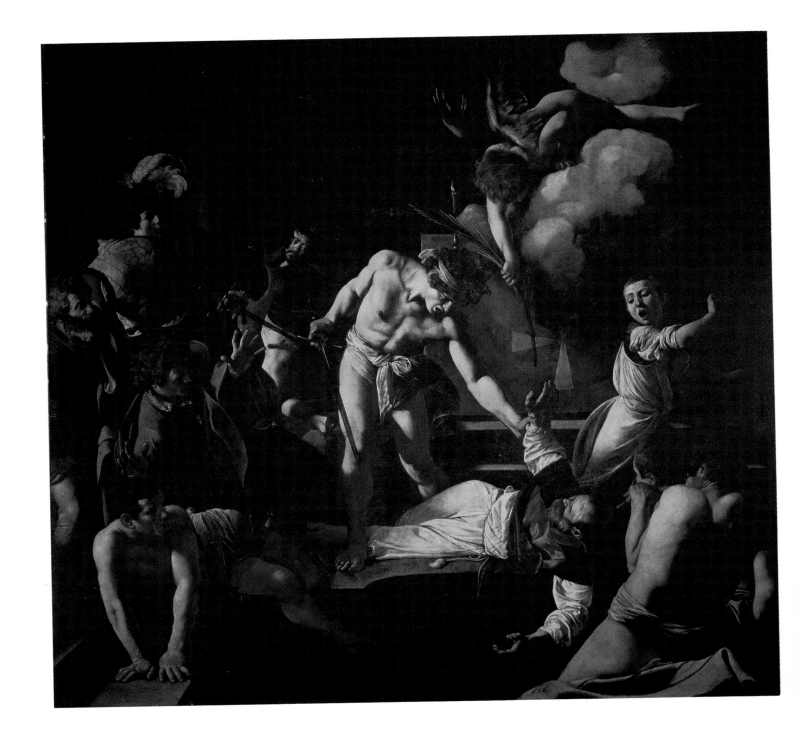

Plate 4 CARAVAGGIO
The Martyrdom of Saint Matthew (1599–1600)
Oil on canvas, 10 ft. 7½ in. × 11 ft. 3 in.
Church of San Luigi dei Francesi, Rome

Although Caravaggio's paintings are obviously at home in this chapel, they do not appear to need the church. This awareness triggers the uncomfortable realization that the paintings do not depend much on spectators either for their meaning or effect. The reason for this strong feeling of pictorial self-sufficiency and self-containment seems fairly clear: the paintings in front of us in the Contarelli Chapel were alive before they were put into the church. Even though we know it is not possible, we sense that we are close to the moment when these paintings were made. We feel that we want to leave the church immediately; we would like to locate the place and fix the moment where and when these paintings were made.

It seems perfectly natural to begin to look for Caravaggio's studio; the feeling from the paintings makes us sure that it is in the neighborhood. We almost expect to recognize some of the models hanging around and to catch Caravaggio at work. We especially want to see the models in the same room with the painting in progress because we want to see them be real in two places at once, in place in the painting and posing in front of it. We remember that Caravaggio has made us see his models as real, an experience altogether different from other painting where we have seen merely a picture of rendered models. We recognize suddenly that this sense of convincing reality within a declared pictorial setting is made absolute by Caravaggio's ability to get the action to us while we are actually looking at the picture. Perhaps this is the sense of immediacy which is often claimed to characterize great art. We want to run to Caravaggio's studio and see how it happens.

If we are to believe Bellori's seventeenth-century criticism, we would have a hard time making out what is going on. Bellori tells us that Caravaggio "went so far in [his] manner of working that he never brought his figures out into the daylight, but placed them in the dark brown atmosphere of a closed room, using a high light that descended vertically over the principal parts of the bodies" (quoted in Walter Friedlaender, *Caravaggio Studies,* New York, Schocken Books, 1969, p. 247). If we take Bellori's description of the dark brown atmosphere of a closed room and combine it with the settings of the *Calling of Saint Matthew* and the *Beheading of Saint John* in Malta, we can fashion a pretty good composite of Caravaggio's working space.

What went on here in this cellar that Caravaggio "did not know how to come out of" is probably what we would most like to know about early seventeenth-century painting. It was here, according to Bellori, that Caravaggio's critical competitors complained with unknowing insight that Caravaggio "painted all his figures in one light and on one plane without any gradations" (p. 248). In this cellar, in this presumably theatrical studio, Caravaggio won a sustaining freedom for painting; one light, one plane makes a nice complement to the idea of one man, one painting, realizing the inevitable individualistic thrust of Renaissance culture. For Caravaggio's detractors the one light was simply too dim: they could not read the depth of his one important plane; they could not comprehend its inclusiveness; and finally, they could not acknowledge the pictorial significance of the planar change that turned the middle ground into the whole ground and stretched the middle distance into a total distance. This kind of contained elasticity was beyond the limits of their imagination.

But even though we believe that the results emanating from this dark cellar were wholesome, we have a hard time believing that what went on there was anything other than fare suitable for mature audiences. There is no doubt that much of the success of Caravaggio's paintings comes from the ability of his model/actors to go both ways—to be total and complete participants, to be both performers and spectators. We know that they are capable of stepping out over the picture frame to join us in the audience. What we suspect from our first impression in the Contarelli Chapel is that their preference is to step out with Caravaggio and become the critical audience. These paintings are self-contained in more ways than meet the eye.

To have been in the studio when the models were setting up for *The Martyrdom of Saint Matthew* (plate 4) must have been an unusual experience. Even Caravaggio seems to be looking out at the action in amazement. It is very hard to imagine how the ensemble modeling was arranged. The x-rays give us some idea of the changes of composition and poses, but no idea of what idea informed the dynamics of the organization of the ensemble and their actions. We cannot help thinking of Velásquez looking out from behind his canvas in *Las Meninas,* but the tranquillity of his scene is overwhelmingly tame when compared to the agitation we imagine in Caravaggio's studio. Still, the question we really want to ask is where Caravaggio is when he paints. Does he stand behind his canvas like Velásquez and look out at his models? It is hard to imagine him dodging about, looking around a huge canvas at this panorama of the martyrdom; and it is very hard to imagine him placing the canvas at an oblique angle to the action, since he is such a decisively frontal painter. What seems most likely is that we would see the canvas against one of the walls with Caravaggio in front of it, directing his models who would be standing behind him. This might not be the easiest way to imagine an artist working, but it would be in character. Caravaggio would be in the center of his universe, orchestrating the twin realities of pictoriality—subject and object—while his model/actors reveled in the immortalization of their own performance, watching themselves in Caravaggio's canvas mirror.

Yet the organization of the studio is not enough; we want to see more, to move closer. We want to measure the extravagant gestures, test the clever scaffolding, and inspect the tantalizing props. We have to measure, test, and scrutinize because we are driven by a compelling uncertainty: we suspect that the effects we recognize in Caravaggio's paintings—the subjects, objects, and settings that we think we have seen before in Italian painting of the fifteenth and sixteenth centuries—are not what they seem. Our sense of familiarity is confounded: do we witness references or reality? We are convinced that the only way to know what we see in Caravaggio's painting is to lay our hands on whatever we see. Here sight is reduced to enticement. This might be Caravaggio's only real perversion.

After we have handled the physical objects we remember the subjects, the figures in the paintings. We wonder if the models run through the martyrdom scene freezing at the moment Caravaggio shouts. Does he correct the individual poses as he remembers Raphael, as he remembers Titian and Tintoretto? How long are the exaggerated gestures held intact? What role does Caravaggio himself play—will we find him like Mel Brooks or Ingmar Bergman, like Fassbinder or Fellini? The literature is not likely to yield an account of the studio at the Eight Corners in Rome; as a result, we are thrown back on the paintings themselves.

If there is one thing that can be said with certainty about Caravaggio, it is that he was better at creating internal space, space among the figures constituting the action and subject of his pictures, than anyone who came either before or after him. When he combined this gift with his ability to project a sense of palpable, moving space external to or extending from the action of his paintings, he earned himself a place in Bernard Berenson's "Palace of Art." He was probably the best "space-composer" (to use Berenson's own term) we will ever see. However, Caravaggio's apparently destructive manner of realizing his gift for spatial composition, the confounding of light and the virtual elimination of landscape and architecture, turned Berenson against him. Berenson constantly complained that there was no space in Caravaggio's paintings, that it was impossible for the spectator to orient himself to really know where he was. Caravaggio's negative emanations, his reductivist bent, blinded Berenson to what now seems obvious—that no one realized Berenson's feeling about space and religiosity better than Caravaggio.

Here Berenson is writing about Perugino and Raphael, but we have a hard time keeping Caravaggio from our thoughts: "Art comes into existence only when we get a sense of space not as a void, as something merely negative, such as we customarily have, but on the contrary, as something very positive and definite able to confirm our consciousness of being, to heighten our feeling of vitality" (*Italian Painters of the Renaissance,* vol. 2, *Florentine and Central Italian Schools,* London, Phaidon, 1968, p. 88). After setting the scene for the importance of the positive effects of space on art and experience, Berenson notes that "space-composition is the art which humanizes the void, making of it an enclosed Eden, a domed mansion wherein our higher selves at last find an abode." He continues: "Space-composition . . . woos us away from our tight, painfully limited selves, dissolves us into the space presented, until at last we seem to become its permeating, indwelling spirit . . . And now behold whither we have come. The religious emotion . . . is produced by a feeling of identification with the universe; this feeling, in its turn, can be created by space-composition; it follows then that this art can directly communicate religious emotion . . . And indeed I scarcely see by what other means the religious emotion can be directly communicated by painting—mark you, I do not say represented" (pp. 88–89, 90–91).

Berenson's description of the space that is possible in painting, coupled with his description of what space-composition can do, aptly and somewhat ironically reinforces my descriptions of Caravaggio's efforts, the efforts that manifest his spatial gifts: the ability to dissolve us into the space presented, the ability to make a domed mansion of the void, and the ability to establish a positive and definite sense of space. These words of Berenson's marvelously illustrate the ways in which Caravaggio manipulated space, the ways in which he created a poised and projective shaping of space whose clear purpose was to break the tyranny of the perimeter and support surfaces that had ruled the space available to painting before his time. Painting before Caravaggio could move backward, it could step sideways, it could climb walls, but it could not march forward; it could not create its own destiny. Without a deliberate sense of projective space, painting could not become real. The road to pictorial reality must pass through the dissolution of perimeter and surface. This is the road paved by Caravaggio to lead great art toward what we now call great painting. Caravaggio's story is the story of how individual pictures became the successful rivals of great altarpieces and great murals. The agony for us is that the road in this story may turn out to be a one-way street; we may not be able to recover some of the magic that belonged to those inhospitable pictorial surfaces, the altarpieces and murals of past great art.

Berenson was talking about religious emotion, but he could just as well have been talking about illusionism and its search for truth when he said that through the offices of space-composition religious emotion can be directly communicated rather than represented by painting. It is this direct communication, not the representation by painting of a convincing illusion and present sense of reality, that has made Caravaggio as famous as he is. There is an assumption that his realism is related to technique, that it can be learned and understood. But this assumption is itself an illusion. Botticelli, Raphael, Correggio, Titian and Tintoretto before Caravaggio; the Carracci, Rubens, Reni, Velásquez, Ribera, and Rembrandt with and after him—all were less convincingly real in their ability to present a pictorial space within which their subjects could perform. One way or another, they were all controlled by the surface they worked on. They were capable of magnificent alterations, but they could not explode the surface and still contain the action the way Caravaggio did. If we do not understand the success of Caravaggio's illusionism—that which strives to be real and painting at the same time, that which becomes a *pictorially* successful illusionism, one that gives sense to the assertion that painting can be "real" in a multiplicity of ways—it seems impossible that we will be able to understand the

Figure 5 PIET MONDRIAN
Composition in Yellow, Blue, and White, I (1937)
Oil on canvas, 22½ × 21¾ in.
Gift to The Museum of Modern Art, New York
The Sidney and Harriet Janis Collection

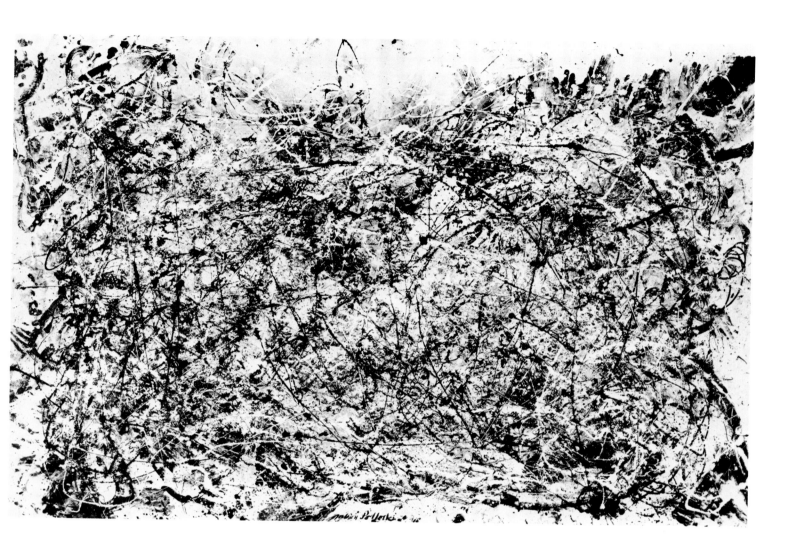

Figure 6 JACKSON POLLOCK
Number 1, 1948 (1948)
Oil on canvas, 5 ft. 8 in. × 8 ft. 8 in.
Collection: The Museum of Modern Art, New York
Purchase

genius of nineteenth-century art manifested in the work of Géricault and Manet, which in turn became the foundation for modern painting. The conviction that the successful depiction of pictorial space and subject, bound to each other as a self-contained whole, carries the necessary germ of painting as we understand it today was born with Caravaggio and nurtured by Manet. Now more than ever we stand sorely in need of both Caravaggio's invention and Manet's insightfulness.

We have to understand the success of Caravaggio's realism in order to recognize its great differences from the painting that surrounded it—that of Titian, Rubens, and Poussin. Of these three, Poussin seems the most distant and the least interesting. Classicism, with its parallel receding planes and its sharp-focused miniaturization, makes itself somehow beside the point. More serious issues are raised by Titian and Rubens: they advance notions of painterliness, impressionistic color, and continuous pictorial surface, three concerns about painting which more than any others have led inexorably toward twentieth-century abstraction. This is the way of Rembrandt, Delacroix, Turner, and Monet. This is also the way to Mondrian and Pollock; but we would do well to remember that if Mondrian and Pollock were heirs only of painterliness, broken color, and a preference for a smooth surface resulting in the conscious lateral extension of modern pictorial space, abstract art would be in deep trouble, and these painters themselves would be less commanding of our attention. What gives Mondrian (fig. 5) and Pollock (fig. 6) the power they have is the strong link through Manet to the genius of Caravaggio. Mondrian and Pollock have "real" pictoriality; they acknowledge the spatial fecundity and compelling image manipulation with which

Caravaggio began modern picture making. This acknowledgment gave to the painterliness, color, and surface manipulation that Mondrian and Pollock had inherited the added dimensions needed to make these effects useful to abstraction. It is the legacy of Caravaggio's space and Caravaggio's illusionism that tipped the scales decisively in favor of abstraction by the middle of the twentieth century.

The Madonna of the Rosary

In some respects Rubens and Caravaggio are unlikely bedfellows; nonetheless, their slight entanglement helped to create the heart of modern painting. It is safe to say that our sense of fullness and expansiveness which we believe to be the core of what painting is about comes from Rubens' realization of Caravaggio's promise. Caravaggio (fig. 7) fused the spatial and emotional diversity of Renaissance painting into a powerful and accessible source of pictorial energy, and Rubens (fig. 8) quickly took advantage of Caravaggio's effort. The result was painting whose sense of wholeness appeared to yield more than the sum of its parts.

In effect, Rubens actually did something about what everyone at the end of the sixteenth century was worrying about: he made something manageable and fruitful out of Roman and Venetian painting. It was not really a synthesis; it was more like an explosion of imaginatively perceived possibilities, pushing painting out in all directions. In the process of setting seventeenth-century art on course, Rubens kept Caravaggio's classicism intact; he made the inventive quirkiness of Mannerist space coherent; and he rescued Venetian materialism. This last effort was no mean feat. In fact, today many applaud Rubens' enrichment of our understanding of Titian as a significant accomplishment, confident that the best painting of the modern era can find sanctions in Venetian painterliness. Be that as it may, Rubens took Titian's late work into his own hands and calmly constrained the pulsating saturation of its vaunted brushstrokes. He put movement and physicality into the textured surface of Venetian atmosphere in a way that made the density of its glazed color accessible to the future.

However, it may turn out that what Rubens did for Tintoretto and Veronese was more important than what he did for Titian; that is, what Rubens did for the extension of Venetian pictorial space may turn out to be more important than what he did for Venetian color. Turner and Monet may owe more to Rubens' enlarged painterly space than to his rich painterly colorism.

Nor is it an accident that Rubens picked up on the bluntness and directness of Caravaggio's use of oil painting technique. More than anything Caravaggio wanted to free painting from the frescoed restraints of architecture. He wanted the canvas he worked on to define the limits of pictorial space; he wanted to create the illusion of real presence in his own "real space." Nowhere is this more apparent than in Caravaggio's painting of the young St. John in the Capitoline Museum. The compelling success of this painting touts flesh that is real and painting at the same time. Rubens could not have missed it. When de Kooning said "Flesh was the reason why oil painting was invented," he said it for the leap that Caravaggio and Rubens made as well as for the step that Raphael and Michelangelo could not quite take.

In the end, though, what unites Rubens and Caravaggio more than anything else seems to be the common inspiration both found in Raphael's work. If we add the *Transfiguration* now in the Vatican collection to the painted *stanze* already in the Vatican building, we see pictorial effort in Rome that is of such focused intensity and so fraught with painterly possibilities that it dominates most of the work that surrounded and succeeded it. Painters as wonderful as the mannerist Michelangelo, Rosso Fiorentino, Bronzino, Parmigianino, and the Carracci had a lot to say, but when compared with Raphael they somehow fail to speak to the heart of the

Figure 7 CARAVAGGIO
Supper at Emmaus (c. 1600–01)
Oil on canvas, 54¾ × 76¾ in.
Reproduced courtesy of the Trustees, The National Gallery, London

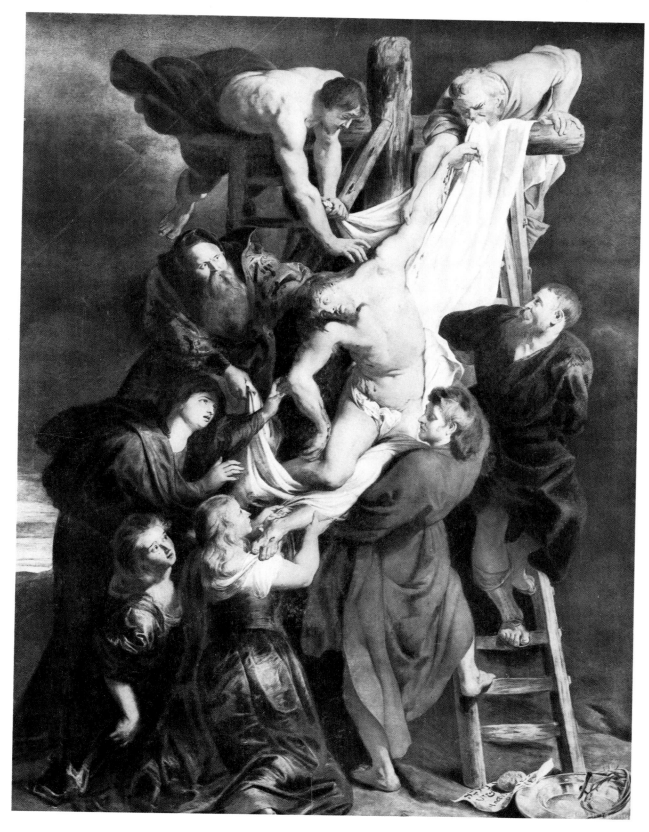

Figure 8 PETER PAUL RUBENS
Descent from the Cross (c. 1610)
Oil on panel, 13 ft. 9 in. × 10 ft. 2 in.
Koninkjijk Museum voor Schone Kunsten, Antwerp

matter. In many respects their efforts did not contribute as much to painting's subsequent growth as did the ideas that Caravaggio and Rubens grasped in Raphael.

In one sense Caravaggio and Rubens will always stand out: they were great builders on the past. Out of an instinctive sense of responsibility about the nature of art, they provided a firm pictorial base for their successors. Perhaps they knew that they would have to leave behind for their successors what Raphael had left for them. In this connection we have to assume Raphael's paramount importance as an influence on Caravaggio, in spite of some evidence to the contrary, especially if we are to account for the extent of Caravaggio's success and the direct communication of that success to Rubens. That is, we have to assume that both Rubens and Caravaggio got the message of Raphael's aggressive pictoriality, and that succeeding reforms and distractions in the development of sixteenth-century painting did not confuse them. Certainly the Caravaggio paintings of St. Matthew in the Contarelli Chapel have an inspired clarity that harks back to Raphael. A similar clarity in the early work of Rubens sings out with praise of Raphael.

Although Walter Friedlander soft-pedals Caravaggio's relationship to Raphael, merely noting in a discussion of the *Martyrdom of Saint Matthew* that it is "evident here that Caravaggio had made a careful study of Raphael's *stanze*," we should perhaps be more aggressive about Caravaggio's debt to Raphael. While there is no doubt that the sources of the *Martyrdom of Saint Matthew* are multiple, and in the opinion of many distinctly Venetian, still I think we can favor Roman over Venetian sources. Raphael's tapestry of the *Stoning of Saint Stephen*, for example, is probably a good source for some of the compositional outline of the *Martyrdom of Saint Matthew*. The two corner figures in the tapestry are much the same as the corner figures in the *Martyrdom of Saint Matthew*, and the sprawling angels occupy roughly

similar positions in each work. But more important, the persistent sense of déjà vu in the Saint Matthew paintings always brings us around to Raphael.

It is not surprising that Caravaggio should quote Raphael, but it would be interesting to know how and why he looked to Raphael so often. Part of the answer might lie in the notion of perfection. Caravaggio was exceptional as a painter in every way, and he must have known early on that it was in his hands to paint perfect pictures. As he became more conscious of his ability, he must have looked around Rome. Painting there toward the end of the sixteenth century was not very strong, and Raphael would have stood out. It is easy to imagine Caravaggio looking to Raphael's ideas for excitement and inspiration, while at the same time trying to improve on them. We get a strong sense of Caravaggio running his models through Raphael's paces. It is not difficult to imagine a living tableau created in Caravaggio's studio after a visit to the Vatican *stanze*, replaying his favorite painting of that day.

It may seem presumptuous to think of Caravaggio toying with Raphael rather than emulating him, but Caravaggio, after all, was a creator and not an imitator, and it is reasonable, given Caravaggio's gifts and temperament, to see him trying to pull Raphael together while attempting at the same time to fill him out. Raphael was a great, but busy, artist. There is a disjointedness and many-handedness in a lot of his work that Caravaggio was bound to react to. On the other hand, there is a spark to Raphael's space-creating gestures that Caravaggio would never forget.

Caravaggio's basic drive was to perfect Raphael, to give coherent expression to the pictorial ideas Raphael had splashed all over Rome. In this effort, he intended to fulfill the promise of Renaissance painting and to effect the rebuilding of sixteenth-century Italian painting that seemed so necessary to everyone after the death of the divine Michelangelo. Caravaggio instigated his redevelopment program in a startling and fastidious manner: he created a visual norm for the representation of figurative reality, followed, in turn,

by an enframing technique that allowed for the coherent containment of that reality. In this regard the obvious originality of the *Narcissus* in the Palazzo Corsini and the *Conversion of Saint Paul* in Santa Maria del Popolo present themselves as ready examples.

Until the invention of photography, Caravaggio's first norm reigned as the rule for figurative representation, while his supplemental norm reinforcing pictorial coherence still bounds our painterly definitions of wholeness. This accomplishment points out that Raphael and the greatness of Renaissance painting in general were flawed in two significant ways. First, Caravaggio makes us realize that Renaissance painting had a hard time putting figures together, grouping them in a convincing pictorial way. There was a tendency to make the figures appear real one at a time, to allow them to function individually, but no effort was made to make them "real" together. The sense of figurative grouping was basically stilted, even though individual figures might appear almost natural. Second, Caravaggio found Renaissance pictorial space surprisingly awkward. It really needed a better method of enclosure: a more coherent, more generous, and more flexible container. Caravaggio saw the pictorial space in Raphael's painting as disjointed, episodic, and dangerously thin. As a successor to Renaissance painting, Caravaggio knew he would have to provide spatial boundaries for painting that would be characterized by greater coherence and freedom. He expected this emphasis on spatial coherence to provide a more convincing, more naturalistic grouping of figures and figurative action, and he expected this emphasis on spatial freedom to provide a provocative, expandable sense of pictorial space—a space that would belong truly to painting alone, that would ensure the freedom of painting's singular development: a freedom from antique sculpture, from architecture, and from (in his eyes) the misguided Mannerist search for compositional exoticism.

Raphael's *Transfiguration* in the Vatican Pinacoteca (plate 5) is an astounding, brilliant painting. It has been scrupulously cleaned and now appears overilluminated by a rhapsodic, dawn-breaking blue that reveals a mélange of figures hysterically pointing to the accomplishment of painting disguised as the transfigured Christ. As the Vatican *Transfiguration* calls our attention both to the soul of Renaissance painting and to Raphael's accomplishment, its agitation brings to mind an apt opposite—Caravaggio's *Madonna of the Rosary* in Vienna (plate 6). Although the existence of pyramidal, carousel-like qualities in the two paintings implies connection and continuity, a terrible sense of completeness accompanies the calm of Caravaggio's painting, ensuring its separateness. The aura of finality suggests that Caravaggio is about to lower the curtain not only on his own painting, but also on the accomplishments and joys of all sixteenth-century painting.

There is a wistfulness in the *Madonna of the Rosary* that acknowledges the end of the line. Caravaggio knows how far he has taken Raphael and how far he has brought himself; the world of Renaissance painting and its antique baggage have been put to rest. After 1600 returns to the antique would risk revivalism and nostalgia. These deadly twins would haunt seventeenth-century painting, and the measure of great painting in that century always had to account for their presence. In this case less was truly more, Rembrandt being, in every sense, the best example.

The *Madonna of the Rosary* is basically a Janus-like, two-faced painting. In a figurative sense its front face looks out over its past, Renaissance painting of the sixteenth century, and its rear face looks toward its future, toward Baroque painting of the seventeenth century. The reason the Madonna is able to accomplish this miracle is that a mirrored version of her face masks the back of her head. When we look at this painting we feel that if we could walk into it and move around behind the figures posing there, we would find their mirror images facing us! But we can never get

behind them; the space that presents itself to us so invitingly suddenly resists penetration. Here the nature of painting spars with the nature of perception. Naturally we would prefer the situation to be more normal, less volatile. We want to move into the painting, to walk around the figures and see what we expect to see, the backs of the figures who were facing us and the faces of the figures who were turned away. But Caravaggio makes sure that this does not happen. Outwardly he is very generous; the space is inviting, almost real, yet Caravaggio's illusionism remains elusive. The harder we press to get our bearings, the more inconclusive our readings become. By insisting on its two-facedness, the *Madonna of the Rosary* remains a surface—an ambiguous one to be sure, but still a double-sided illusion whose thinness confounds. With a surface as slick as a transparent decal Caravaggio contradicts the authority of chiaroscuro, reminding us that no matter how successful it may be, illusionism is still a one-way, dead-end street.

There is another contradiction inherent in this painting; its immense calm and composure emit conflicting signals. We would expect the serene pictorial effect of the *Madonna of the Rosary* to present a coherent message, with a warm, understandable afterglow. In the end this may actually happen, but before we can feel this we have to unscramble the painting's forward, searching glances: we have to face the unpleasant problems of architecture and sculpture. In themselves they are enough of a trial for painting, but in the sixteenth century they were weighted with the adornment of antique idealism, making the life of painting even more difficult.

In the *Madonna of the Rosary* Caravaggio faces these problems head on. The result is a beautiful base for seventeenth-century painting to build on, and nowhere is it more noticeable than in the work of Rubens. Of course, this is hardly surprising when we recall that Rubens and other painters as well helped find this particular painting a home in Antwerp.

But what is more important for us, the *Madonna of the Rosary* reaches beyond the seventeenth century, speaking directly to painting today about fullness and volume. Caravaggio must have seen that the biggest problem in Raphael's work lay in the silhouette-like character of its figuration. Raphael's figures function as trompe-l'oeil cutouts, bright on the front with a blank, black side turned away from the viewer. This means that painting before Caravaggio was a lot darker and flatter than we had perceived it to be. This realization might help to explain why we feel that in the process of rounding out painting, Caravaggio did not create anywhere near the amount of darkness that his contemporaries imagined. In fact, we are more inclined to believe that his chiaroscuro effects may have actually lightened seventeenth-century painting.

In effect, Caravaggio was trying to create a greater sense of tactile space between his figures, and at the same time to illuminate that newly created space with reflected light from the hidden but brilliantly rounded back sides of these figures. This effort creates an open, lit spaciousness in which pigment and gesture can perform without limits, a space that is real enough to allow Caravaggio's confrontational mode of address to seem plausible. This is important because even in great painting preceding Caravaggio, such as that of Botticelli and Rogier van der Weyden, silhouetted thinness and a hidden, unperceived darkness sometimes distance pictorial impact.

When Caravaggio relit the half-rounded, silhouette-like character of sixteenth-century figuration, he revealed the uniqueness of painting. Painting is always face forward, always confrontational. There is no reverse or back side to painting. Bad paintings (that is, paintings that are less than they should be) are bland and dark on the reverse, while good paintings pull themselves miraculously inside out to ensure their forward-looking presence as we imagine ourselves moving around them. Good paintings always seem to face the viewer, turning effortlessly as we try to slip behind them to test their illusionism. But more than that, from any

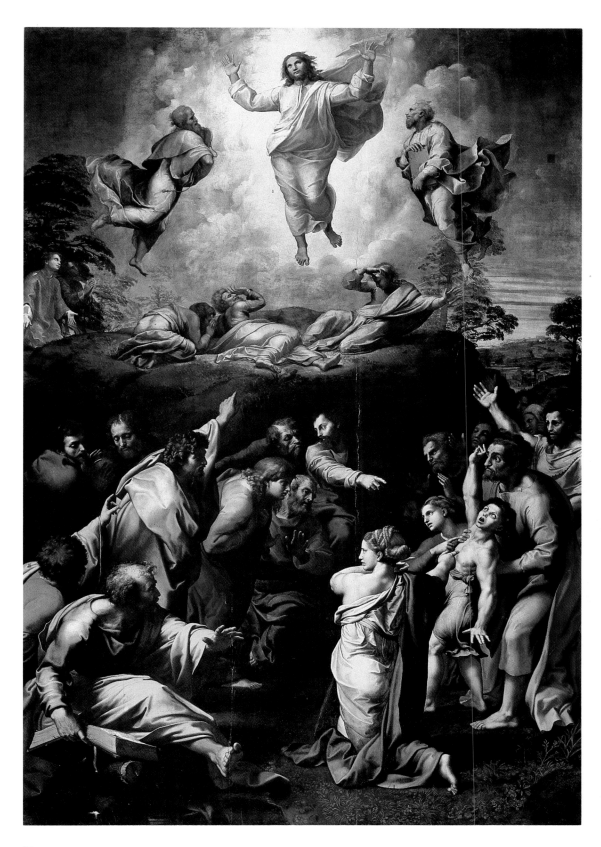

Plate 5 RAPHAEL
The Transfiguration (1518–20)
Oil on panel, 13 ft. 3¾ in. × 9 ft. 1½ in.
Pinacoteca, Vatican Museums, Rome

Plate 6 CARAVAGGIO
The Madonna of the Rosary (c. 1605–07)
Oil on canvas, 11 ft. 11½ in. × 8 ft. 4 in.
Kunsthistorisches Museum, Vienna

Plate 7 ANNIBALE CARRACCI
The Assumption of the Virgin (c. 1600–01)
Oil on panel, 96⁷⁄₁₆ × 61 in.
Church of S. Maria del Popolo, Rome

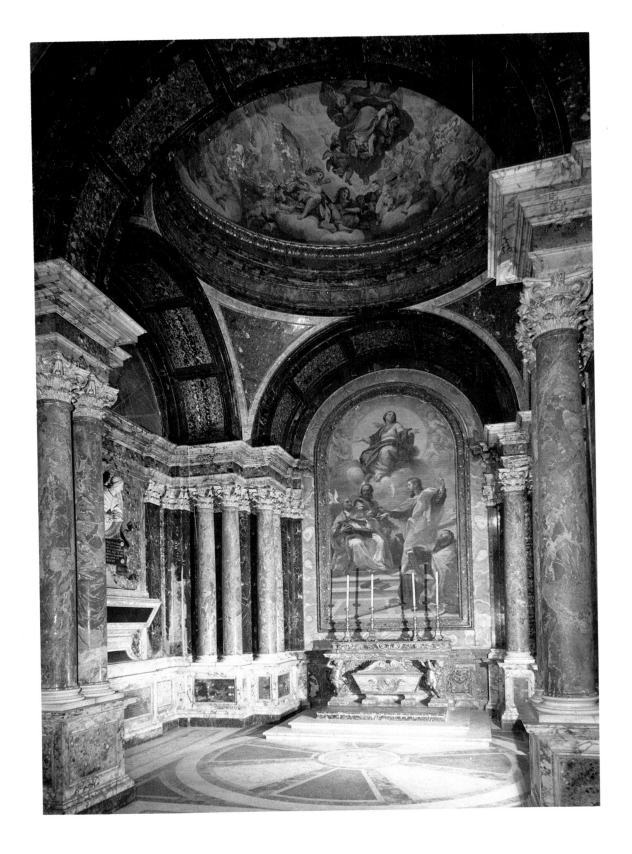

Plate 8 MARATTA
Immaculate Conception (1686)
Fresco in Cybo Chapel
Church of S. Maria del Popolo, Rome

vantage point the hidden and apparently blank parts of good painting never appear lifeless or dark. Great painting creates space and spreads the light.

The background of the *Madonna of the Rosary* dominates the painting. It takes over the top third of the painting, where a huge red drape obviously alluding to antique sculpture is tied around an equally large fluted column alluding, we assume, to antique architecture. What are we to make of these allusions to the antique? Our most immediate reaction makes us wonder why the structural core of the painting refers to sculpture and architecture rather than to painting. It is true that references to the antique are bound to exclude painting, since few concrete examples of antique painting have survived, but we feel something more purposeful happening here than exclusion by circumstance.

Although it may be a little hard to see in reproductions, the molding running under and behind the red drape describes a curved wall as the painting's background. This niche clearly reinforces the sculptural emphasis of the painting and lends some support to our notion of the painting's desire to both pivot and turn itself inside out, in much the same way as a hand-held playing card bent into a cylinder might wish to spin and then to snap itself back and forth from convexity to concavity. The niche is a touch of Caravaggio at his very best, using the artificial to enhance the real. In addition, he alerts us to what has happened to painting's relationship to architecture and sculpture. Before and during the sixteenth century, painting was at the service of architecture, decorating its walls and adorning its altars. But here in the *Madonna of the Rosary* architecture appears to be a figurative rather than a literal background for the activity of painting. The message is clear: pictorial concerns come first. In fact, they may now have become the only concerns. The decorative, ornamental, and spatial encroachments of architecture are really done away with, simply absorbed into the background. The presence of architecture, once a competitive, patronizing reality, is turned into a fiction of scenic back-

drops. In a way, Caravaggio put architecture back into its antique place. Roman domestic wall painting culled many of its architectural backgrounds and enframements from stage designs, and Caravaggio seems to have sensed this link; in any event it appears that he deliberately dimmed architecture with artificial lighting and moved it backstage so that it would not interfere with pictorial drama.

To put Caravaggio's argument with architecture into exaggerated relief, we simply have to compare the *Madonna of the Rosary* with almost any coherent section from the ceilings of the Sistine Chapel or the Farnese Gallery. The calm and dignity that Caravaggio won for painting, to say nothing of the uniqueness and power of its self-contained pictoriality, stand out as an eloquent statement against the frenzied, self-mutilating contortions that Michelangelo and Annibale Carracci forced painting to perform in the service of architecture. As inventive and beautiful as the ceilings are, they do not seem to have been accessible to the development of painting in the way that the *Madonna of the Rosary* was. For example, everything great in nineteenth-century French painting from David to Manet seems to have been touched by the Madonna's pointing finger and the Christ Child's pleased glance.

Again, Caravaggio's assertion is clear: illusionism is to be the servant of reality, not of illustrational virtuosity; but the quality of the competition raises doubts. Can we really dismiss Michelangelo and Annibale out of hand? There is pictorial power on the Sistine and Farnese ceilings, but it lies there inaccessible and untapped. Is this the price that painting must pay for deferring to the decorative and illusionistic needs of architecture, or is it just circumstance? Was Caravaggio merely an alternative, or did he indeed point to a better way?

Part of the answer might lie in the red drape hanging over the head of the *Madonna of the Rosary*—a stone curtain cantilevered over the head of painting. Caravaggio knew that sculpture dogged painting in much the same way that architecture did; he knew that real freedom and a real future for painting could be found only in the creation of its own space. But he also knew that within that new space, sculpture—both antique and medieval—was still making its presence felt. It seemed to be a question of making the figures in sixteenth-century painting relate to each other in a convincing, pictorial, nonsculptural way. In Raphael, for example, the figures still stand separate from each other even though there is a purposeful attempt to weave them together in a manner reminiscent of antique sculpture. We get the feeling that Raphael had the serpentine gestures of *Laocoön* in mind to tie his subjects together. This separateness in Raphael was a restatement in newer terms of a problem that had existed in, say, Botticelli and Crivelli, where we feel the individualizing presence of medieval painted sculpture so strongly.

These sculptural connections did not hurt painting in any serious way, but they did distance it from the viewer, and one suspects from its makers also. To get things right, Caravaggio made a big leap. In the *Madonna of the Rosary* he created the standards for classic composition. He must have realized that the biggest problem was not the cold hardness of sculpture, or its inertness, or its limited potential for movement and expression. Sculpture's problem, rather, was a limiting individuality, an inherent oneness, which restricted the possibilities for successful grouping. Sculpture was limited by its inability to be more than one thing, to do more than set one scene. Caravaggio could not have helped noticing that story telling in stone had to resort to relief and repetitive sequential extension. All over Rome, the sides of sarcophagi and triumphal columns revealed the narrative and dramatic inadequacies of sculpture.

But more than anything else Caravaggio must have sensed something equally inadequate about the late sixteenth century practice of painting, especially about the use of models in the studio. Something about everyday drawing from sculpture and from the model must have seemed misguided. Perhaps he was struck by the fact that it did not make much difference whether the models were flesh or stone; the results were always the same—that is, the paintings were dominated by separate images apparently compressed and juxtaposed rather than successfully woven into a whole. Paintings would inevitably be awkward and artificial if they were put together one piece, one gesture, one person, one statue at a time, especially if they had to accommodate themselves to a setting determined by measured perspective. Caravaggio sensed that the figurative action within the painting had to be coherent from the beginning. He also knew that what went on within the painting had to be plausible and engaging outside of the painting—that is, outside of its surface. He understood the projective imperative of pictorial drama. Perhaps Caravaggio was trying to highlight the differences in pictorial impact between Venetian and Roman painting by deliberately contrasting the public character of formal theater seen in Tintoretto and Veronese with the private character of cabaret theater created in his own studio.

How did Caravaggio enframe a "living theater" in which we see paint and feel flesh? We can only guess. The models seem to be crucial: Caravaggio was successful in making his models perform, making them do something more than merely pose. The result was a happy one—convincing pictorial drama emitting a powerful psychological resonance. We are easily engulfed by Caravaggio's painting because the models we see in front of us acknowledge themselves and each other. We sense a living group rather than individuals artificially assembled to tell a story. This togetherness at the expense of separateness accounts for the stunning quality of the *Madonna of the Rosary*. We feel that we can merge effortlessly into the picture, into any body that presents itself to our attention. Every glance out of the picture is inviting, and every bit of eye contact within the painting is supportive and reassuring. This is a painting of enormous stability and generosity.

Caravaggio found a way to use his models that would have impressed even Manet. The models live many roles in the *Madonna of the Rosary:* they are saints, they are themselves, they are their own creators, they are their own audience, and best of all, if we just look, they are we. Here we feel the true liberation provided by art. We can sense being something, someone, other than ourselves. We feel, as well, that if our eyes are alert and our senses are fully functional we can glean understanding, perhaps even knowledge, from painting.

Rubens was probably the greatest student of Italian painting we will ever encounter. It seems reasonable to assume that he got the basic message of Caravaggio's painting in Rome. Caravaggio said that painting in the sixteenth century, great as it may have been, was compromised by a spatial sensibility that was accommodating and artificial, rather than independent and real. Artists before Caravaggio made space in which they could tell a story or set an action, but the pictorial space only lived to tell that story or to contain that particular action. In effect, they came up with illustrational accommodations that seemed limited to each depicted event—a useful technique, but not a functional pictorial sensibility capable of flexibility and expansion. In a word, sixteenth-century Italian painting, Roman or Venetian, was always limited to the actual surface it worked on—fresco, slate, panel, or canvas. Caravaggio liberated painting from its literal surface and made pictorial space the surface for his action, for his pigmented figuration. This is the springboard for Rubens' modern painterliness. We can see it developing in the Chiesa Nova in Rome (fig. 9), where as a young man Rubens attacked the problem of establishing his painterly identity not once but twice, first on canvas and then on slate, in what now seems like a determined effort to both dissolve and surround the surface of sixteenth-century Italian painting with a holographic imprint of pigment.

Caravaggio's ability to convince us that he was able to paint on a suspended imaginary surface rather than on a literal, anchored one is probably what endears him most to our modern sensibility. Here he speaks to abstract painting. What painting wants more than anything else is working space—space to grow with and expand into, pictorial space that is capable of direction and movement, pictorial space that encourages unlimited orientation and extension. Painting does not want to be confined by boundaries of edge and surface. It knows from the experience of Caravaggio that if its working space is perceived as real and palpably present, the depicted action will have a chance—it will have room to move and breathe. This is why Caravaggio appears so casual and untroubled, and Annibale Carracci so tortured and unsure. Caravaggio knew that a live, real, extendable, and expandable pictorial space would absorb anything. The competing critical issues of the day, naturalism and idealism, did not mean so much to him; he could entertain both issues with ease. He had plenty of room at his fingertips.

If we backtrack a bit to Raphael's *Deposition* in the Borghese Gallery (fig. 10), we can see the interests of Rubens and Caravaggio coming together again. This is in many ways a typical Renaissance painting. It has an antique cast to its atmosphere and a somewhat symmetrical and linear feel to its organization, but the dominant feeling here is a very painterly one. We could do worse than guess that Caravaggio and Rubens were very attracted to this quality in Raphael's work. Certainly the most striking thing about Raphael's *Deposition* is a painterliness revealed by the sustained chiaroscuro effect of the figuration. This is a very rich painting; there is a full gestural expressiveness that sweeps back and forth across the panel. The splendor of figurative definition is augmented by a surfeit of color, and this in turn reinforces the painting's compositional armature in a refined, powerful way. The color travels from one edge of the painting to its opposite, holding up Christ's dead body on one side while on the other it successfully blends the supporting cast of figures into a blue-green landscape.

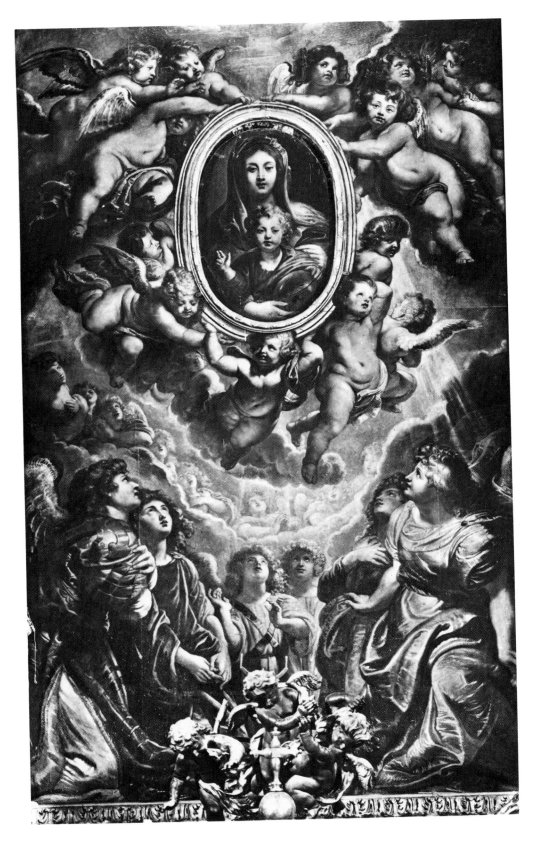

Figure 9 PETER PAUL RUBENS
Madonna among a Glory of Angels (1608)
Oil on slates
Church of S. Maria in Vallicella, Rome

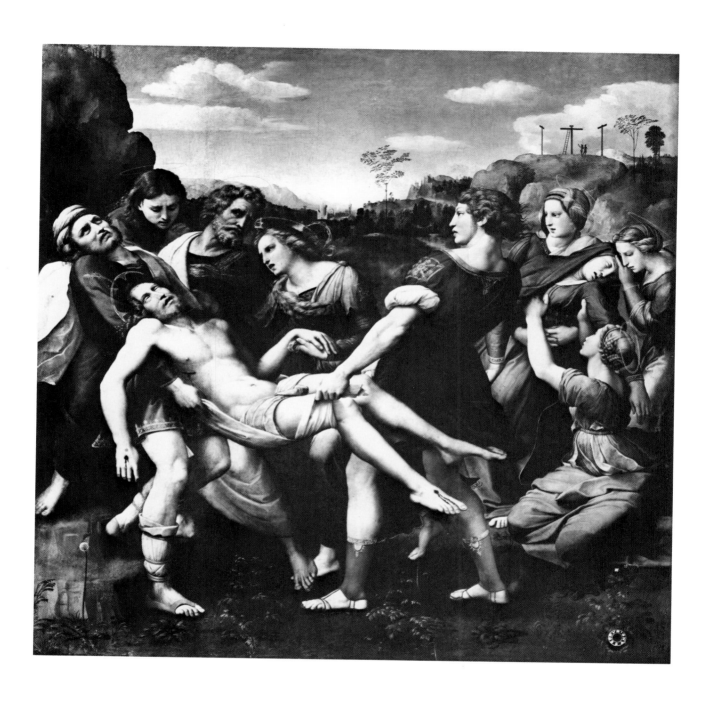

Figure 10 RAPHAEL
The Deposition (1507)
Oil on panel, 72½ × 69¼ in.
Galleria Borghese, Rome

In fact, the color in this painting is so dominant and so visible that it reminds us that color was not the sole prerogative of the Venetians during the sixteenth century. This painting and the *Madonna of the Rosary* are good examples of the fact that Rubens was forcefully exposed to color in a way that was compellingly different from his early experience with Titian. It is safe to say that what might be called Roman color—the substantial color of Raphael and Caravaggio—combined with Rubens' innate fluidity is one of the things that made Rubens' early work so special. It is tempting when we grasp these influences to see Rubens as the last great Roman painter, but in the end it is probably simpler and more accurate to call him the last great Italian painter.

It is in the *Deposition*'s dramatic figurative grouping that Raphael points to the future, engaging the best of his successors such as Rubens, Caravaggio, and Géricault. In the landscaped background Raphael dismisses the Renaissance. This essentially outmoded, naively depicted area of the *Deposition* shows us something that is probably lost forever to painting—a kind of deep, soft, receding space. The foreground dirt slips like a carpet under a host of planted feet and gradually rises to the horizon, transposing itself along the way into a mossy medieval lawn. Here Raphael provides an elegant tie between foreground and background, making the weeds and wildflowers that align themselves across the bottom of the painting catch in scale the trees and crosses outlined against the horizon. It is a pity that this kind of oscillating depth and incongruous detailing have disappeared from painting; it appears we believe with Vasari that it is the drama of figurative action rather than the subtlety of spatial perception that made Renaissance painting so gripping. At least, this is what comes through in Géricault's copy of the *Deposition*, where Raphael's weeds are among the first things to disappear. Yet Rubens, untroubled by Géricault's modifications, must have sensed Raphael as a source of Caravaggio's insight that complete pictorial drama must express the integration of spatial and figurative vitality.

But somehow pictorial space is always perceived by us as a problem for Rubens. He is often damned with praise as a great designer. His facility seems almost to have been a handicap; his line and his brushstroke, as sure and as inventive as any that have ever graced a surface, seem to be able to manipulate space but not to create it. The mature figurative paintings of Rubens seem spatially conventional—all the more so coming from the hand of such a powerful artist. It is almost as if we want to hold it against Rubens that he did not paint the *Raft of the "Medusa"* (fig. 11), even though it is obvious that Géricault could not have done it without Rubens' example and inspiration. The conventional description of Géricault's painting as half-Caravaggio and half-Rubens does not entirely miss the point. Rubens really had everything necessary to make this kind of painting, but he could not quite bring himself to rack and test pictorial space the way Caravaggio and Géricault were able to when the necessity arose.

Another important aspect of Rubens' painting has to do with our perception of reality in painting. Once Rubens steps into his own domain in his middle and late paintings he begins to dig into the heart of this matter, separating himself decisively from Italian painting. In *The Miracles of Saint Francis Xavier* and *The Miracles of Saint Ignatius of Loyola* (see plates 11 and 12) a confident, purposeful "artificiality" drives painting, creating a pictorial power that challenges us but somehow fails to win us over. Perhaps this is because we are still emotionally attached to sixteenth-century Italian painting, which at its best displays moments of poignant, palpable reality that we cannot experience anywhere else.

Raphael and Caravaggio bracket artists such as Correggio, Andrea del Sarto, and the Carracci. They all have one thing in common: an ability to reach us without raising any doubts about what art or painting should be. With Rubens

Figure 11 THÉODORE GÉRICAULT
The Raft of the "Medusa" (1818–19)
Oil on canvas, 16 ft. 1 in. × 23 ft. 6 in.
Musée du Louvre, Paris

this never happens. Although he can be very moving, even provocative, we feel that he is always elaborating and controlling the action; it never just happens in front of us. For some reason Rubens stepped back at the height of his powers and took a critical look at both Italian painting and his own youthful ambitions. He then decided to move away from it all. In Antwerp, he began quietly to carve art from the granite of his own pictorial imagination rather than from the Italianate marble of real presence.

The God-like nature of creation in painting resides in the ability to make a painting that has enough lifelike qualities to keep it alive. In the best moments of sixteenth-century Italian painting, there were always enough of these moments to make it clear that projective reality was the goal of painting and that the job of the artist was to effect successful self-effacement, both of his personality and his craft. This, it seems obvious, is the nature of pictorial illusionism—to make the action surrounded and created by painting seem real, and to make the creator of that action and activity seem remote.

Painting has always wanted to be real, and by 1600 in Italy it had the means to do it. It had possession of a convincing illusionism. In the face of this accomplishment, Rubens chose to stress artificiality at the expense of reality. He deliberately called attention to himself and his craft and then set out on a desperate adventure. His endeavor was sparked by the realization that he was undoubtedly the first artist to have seen and understood enough real art, other than his own, to allow his perceptions of art to compete seriously with his perceptions of reality. He believed he could bring to the activity of painting itself an imagination that would rival the depicted reality Italian painting had brought to the experience of art. In the process of acting on his belief Rubens fulfilled the Romantic dream; he made imagination overcome truth.

Essentially, Rubens came to believe that he could make painting about painting. To support his intentions he called on a pictorial imagination broader than any that had emerged from the sixteenth century (and this was not a

century, we must remember, of narrow pictorial vision). He worked to create painting based on the reality garnered from other paintings and also based on what he perceived to be the reality drawn from his own activity in the process of making painting. The results of his effort have yielded much of our definition of great painting.

Painting before Rubens had a basic conventional notion of reality—the existence of a significant contemporary or historical event that painting could capture. There was never any attempt in Italian painting to suggest that ultimately the actual event depicted had not been decisively and importantly real. In Rubens this core was abandoned; the connection was broken. From Rubens on, the artist would have to carry an extra burden: meaningful expression and emotion would have to be based on an enlargement of the artist's imagination, not simply on an honest attempt at a connection to real events, coupled with a competent acknowledgment of past and recent painting. In essence, no painter would ever try again to bring Christ back in the manner of Botticelli or Caravaggio; rather, he would feel compelled to give us a "moving" picture of Christ in the manner of Rubens, Velásquez, and Manet. He would have to account expressively for the known totality of the pictorial past. We can see that this trade-off—the historical past for the pictorial past—is no great bargain for the painter: one problematic idea of the past is simply substituted for another. After 1600 reality would be doomed to revelation by inspired illustration rather than by the creation of palpable presence, and reality's pictorial future would depend on the artistic ability to raise illustration to the level of art. Here fate played into the waiting hands of Rubens; with his genius we witness illustration being raised *above* the level of art.

A nice example of what Rubens' break with the Italian sensibility meant to the future of painting can be seen in a comparison of Rubens' copy of Caravaggio's *Entombment* with Géricault's copy of the same painting. Rubens' painting is a wonderful transposition which creates a small, compact oil

sketch out of a large, dramatic tour de force. He is working with painting about painting, not with, as had been the case before, painting following painting. The first thing we notice is a difference in atmosphere and feeling. It is not that there is any lessening of emotional contact or involvement, or a wandering of religious attention; it is simply that the sources of emotion and religious feeling are taken for granted to lie in Caravaggio's painting, not in Christ's entombment. Here we see the use of artificial pictorial sources, sources based on the reality that can be found in a painting rather than on actual experience, past or present.

Géricault's work resembles what we would call a copy. But here Géricault seems to be doing something more than practicing; there is an effort to capture the intensity and drama of Caravaggio's *Entombment* for himself. Géricault feels a need to test Caravaggio's space to see if it is as real, as electric and accessible, as it seems. In a sense all artists have to do what Géricault did before they can execute the license of Rubens. They have to check back, to touch base with Italian painting; they have to make sure that they can recognize pictorial reality.

Some broad questions about painting arise from this discussion about Rubens and Caravaggio. Why should we worry so much about painting at the beginning of the seventeenth century? What can painting today hope to find in the painting of Caravaggio and Rubens? And finally, why do I put so much emphasis on the spatial character of these paintings? The answers and, in some sense, the origins of the questions themselves lie in the churches of Rome. In these churches painting makes itself felt in a way that painters—really artists of any kind—simply cannot ignore. Standing in the middle of Chiesa Nova, the artist cannot help but ask himself, "Why don't my paintings look like this—like Barocci, Caravaggio, and Rubens?"

Consider painting today—Chia, Clemente, and Cucchi; Frankenthaler, Noland, and Olitski; Francis, Kelly, and Youngerman. Are they really different from Barocci, Caravaggio, and Rubens, and more important, are the differences among them as meaningful as the differences among Barocci, Caravaggio, and Rubens? The answers are probably affirmative: yes, painters today are different, and yes, the differences among painters today are meaningful and interesting. The big difference, the one we seem to have the hardest time adjusting to, lies in the way we are forced to look at these artists—the difference between our museums and their churches. However uninspired their churches are, they are never as ugly as our museums. We become aware of something ironic in this situation: the artists we praise, the artists who helped make it possible to have an art of the museums, the artists who gave us the great art of the seventeenth century, are the ones who indirectly made an end to the church as a natural repository for art. The better the artist (for example, Caravaggio and Rubens), the more they created their own space, literally and figuratively, at the expense of the space of the church. The worse the artist (for example, Carlo Maratta or Pietro da Cortona), the more they attempted to accommodate painting to the realities of church space.

In a way, the churches of Rome prepare the way for the demise of seventeenth-century Italian painting. We can already trace in these churches the dissolution of sixteenth-century Italian painting's spatial clarity, in whose place we see a morass of illustrational muralism that almost automatically denies any possibility of real pictorial presence. The only possible presence seems to be a theatrical one. The search for pictorial drama lies at the heart of the Baroque sensibility, but in seventeenth-century Italian painting the growth of mere dramatic presence and florid illustrational technique showed just how fragile and vulnerable this sensibility could be.

It may not be a new idea that by the beginning of the eighteenth century pictorial space had become afflicted with the sores of decoration and illustration, but it is worth noting that we can see a similar pathology developing in the space of twentieth-century abstraction. The limited, difficult space of Kandinsky, Malevich, Mondrian, Pollock, and Newman has degenerated into the self-effacing, almost nonpictorial space of 1970s abstraction. Recent painting appears to have resolved spatial problems in such a way that various unruly elements, such as the boxy depth of Cubism, the constricted linearity of nonobjective painting, and the optical flatness of hard-edge painting, have been tidied up by a burst of illustrative superficiality. The result is an easy-to-read, inert space, refined by a heavily pigmented surface and cropped to convenient but often intensely a-pictorial shapes. As if this were not enough, whatever spatial vitality is left is rendered oppressively dull by the application of close-valued color. These paintings have surface coherence at the expense of pictorial energy.

Some of the best abstract painting of the last twenty years is beginning to betray itself as a direct descendant of the illustrative surface decoration so profusely produced by Carlo Maratta, Pietro da Cortona, and Luca Giordano. The prim, decorative presentation of acrylic paint on tidy rectangles is probably what has made so many young artists dislike what they call formalist abstraction. Their diagnosis may not be all that bad, but their suggestions for treatment seem to do little for the patient. The interesting thing is that sometimes in the midst of manipulating contrived messages, young painters create pictorial awkwardnesses that do not totally echo the compositional norms of modern painting; that is, they do with petulant, naive energy what "courageous," studied formalist experimentation is supposed to be doing. But then, most formalist abstraction is so heavily edited with the canvas shears in order to find the picture, to create

that ineffable consensual sense of wholeness, that it is not hard to imagine the awkward, potentially fruitful parts being thrown away. In any event, it is painful to see some of the most powerful and promising painterly techniques of the 1960s transformed into a fashionable trompe l'oeil spatter which now merely measures the depth of pigmented gels.

Illustration has always been the easy way to enlist audience sympathy. It is the easy way to become an artist, but it is an almost impossible way to make paintings. We should bear this in mind when our excitement soars in front of the heady displays of current International Expressionism. Realist painting today is built on a retrograde base of Surrealist illusionism. The incongruity-based illustrational technique that is so deftly and so extensively wielded today in the name of realism still yields a pictorial space that is less challenging and less original than that of recent abstraction.

Nonetheless, a provincialism has crept into abstract painting in America, and those who believe that they are both right and advanced may be digging their own graves. What some foresaw as an embarrassment of riches is turning out to be a plethora of trinkets. The new, recent abstraction of the 1980s is unfortunately different from the old, post–World War II abstraction; the spatial impoverishment of the former has become a serious problem. Normally abstraction considers fluctuation in quality its only real problem, but it appears now that the whole nature of the enterprise is being subverted, undermined by a fundamental weakness.

Much of abstract painting today has lost touch with the fullness and mobility of the pictorial space of the past in a mistaken effort to locate art in the novel exclusivity of technique, thus fulfilling the most (and probably lowest) common definition of abstract painting, which suggests that knowledge of abstract painting is knowledge of how to make an interesting mess. Just as serious is the admission that today paintings are being made which are like a piece of something, an enframement of a section of a painted surface; in fact, most of the new suburban abstraction is just

at—a piece of an effort to make a painting. What we are left with is a lot of work which almost by self-definition less than whole. In addition, this simple glorification of technique and materials feeds the growth of an academic outlook: knowledge of how to do something is substituted for knowledge of what to do. This kind of confusion just increases the difficulties for abstraction.

In a way this argument may sound ungenerous, but something emerges from the churches in Rome that speaks directly to the genius of the great painting of the seventeenth century and at the same time to the struggles of twentieth-century abstraction. The same voice that told seventeenth-century painting to stick close to the ground, to avoid the dizzying heights of illustration, exhorts twentieth-century abstraction to break out of its spatial cocoon. It suggests that Caravaggio and Rubens, for instance, threaten to overwhelm modern abstraction, noting that in one vitally important way, modern painting lags behind the seventeenth century: it is spatially underdeveloped. Nowhere do we see enough of Caravaggio's dramatic spaciousness and compositional wizardry. Nowhere do we see pigment driven to describe and manipulate space in the way that Rubens did over and over again.

By 1970 abstract painting had lost its ability to create space. In a series of withdrawals, it began to illustrate the space it had once been able to create. The space in abstract painting, in a certain sense, became more advanced—more abstract, if that is possible. It was no longer available to feeling, either emotional or literal. This fulfilled one of modernism's great dreams: the space in painting became available to eyesight alone, but unfortunately not to eyesight in a pictorial sense, but to eyesight in a literary sense. In a word, it became available to the eyesight of critics rather than that of artists, to the critical, evaluative faculty rather than the pictorial,

creative faculty. This means that the tendency that developed in American abstract painting after 1970 is antithetical to everything that the great painting of the past stands for. This development is probably easiest to comprehend in spatial terms: what we are left with is illustrated space which we read; what we have lost is created space which we could feel. Put simply, the pictorial space of abstraction has acquired artificiality at the expense of reality. This is a mock echo of the genius of Rubens, who was the first painter to dare to be deliberately artificial. He raised the level of the mechanical activity and accomplishment of painting to heights which allowed it to compete with viewers' perceptions of pictorial reality. In a sense, he believed with Picasso that "art is a lie to tell a greater truth."

The biggest problem for abstraction is not its flatness, articulated by brittle, dull, bent acrylic edges and exuding a debilitating sense of sameness, unbearably thin and shallow, although this is serious enough. Even more discouraging is the illustrational, easily readable quality of its pictorial effects. What abstraction promised in the sixties, it did not deliver in the seventies. The engaging Mannerist space of Noland's offset chevrons (fig. 12) and beach chair stripes moved on to the proto-Baroque, infinitely controllable, but sometimes inert space of Olitski's Acqua Gel textures (fig. 13). This change is equivalent in quality as well as spatial dynamics to the one we see in Santa Maria del Popolo in Rome—the change from Annibale Carracci's *Assumption of the Virgin* (plate 7) to Carlo Maratta's *Immaculate Conception* (plate 8). Let us hope that the sterile fingers in Maratta's painting point the way out of the darkness. The finger pointing up to his source, Raphael, would not be a bad start: if Raphael could get Rubens and Caravaggio—and the rest of the great painters of the late sixteenth century, for that matter—off the ground, perhaps he can help us.

Part of the trouble that abstraction finds itself in today is not entirely of its own making. Abstract painting has always been flawed by spatial conservatism. As it abandoned some

Figure 12 KENNETH NOLAND
17th Stage (1964)
Acrylic on canvas, 93½ × 80½ in.
Virginia Museum of Fine Arts, Richmond
Gift of Sydney and Frances Lewis

Figure 13 JULES OLITSKI
Radical Love 8 (1972)
Waterbase acrylic on canvas, 98 × 42 in.
Private collection

of the mechanics of representation in the beginning of the twentieth century, abstraction became cautious in its manipulation of pictorial space. It did not want to look awkward or appear to be falling off the wall. It is interesting that in the churches of Rome we find none of this self-consciousness. A church like the Chiesa Nova has confident painting, characterized by spatial freedom and invention. There Caravaggio, Rubens, Barocci, and even Pietro da Cortona are a delight to our eyes, as well as to all our other senses.

The point is that abstraction today seems bound by an innate niggardliness of vision. It looks for support to Hofmann, Pollock, Newman, and Louis, and occasionally it has fits of insight which lead it all the way back to Matisse, Kandinsky, and Mondrian. But the truth is that these models have not been put to good enough use. It has become obvious that when today's abstract artist searches for a painting within the expanse of the pigment he has manipulated, he sees only the ordered, neat, and readable space that abstraction has derived from Cubism and Impressionism, two bastions of pictorial conservatism, two movements in which pictorial space is never awkward or convoluted—hence two movements in which the space is ordered and coherent, endearing itself to literary taste, which dotes on consistent, readable pictorial space. In a way, great as he was, this extraneous critical reflex is what hurt Berenson. It was not the incongruity of subject matter, as he thought, but the incongruity of pictorial space that aggravated him in Caravaggio's painting. He instinctively sensed the problematic nature of the separation of image from surface. Similarly today, abstract painting in its effort to be "advanced," to be smart, to anticipate critical accolades, has managed simply to accommodate itself to the neatness of literary taste. It cannot see the space before Impressionism. Essentially, abstract art has rendered itself space-blind in order to assure its visibility to an audience that can only read.

The trouble in which recent abstraction finds itself, its inability to project a real sense of space, is rooted in its subservience to the surface and spatial continuity implied by Impressionism. In order to guarantee itself the completeness and wholeness that defines or better delimits art, abstraction has shunned reality—that is, it has shunned real, created space in favor of artificial, illustrated space. The answer to this problem is not a return to conventional illusionistic space, to Albertian perspective; but some kind of turning around is in order. Certainly invention and inspiration are called for. In the aid of inspiration and invention, we could look in two places. One effort that needs to be reexamined is the best abstract painting of the 1950s and 1960s. The other place that would give us a good start for rethinking the essence and import of pictorial space would be the Rome of Caravaggio, Rubens, and the Carracci around 1600, in what might be called Freedberg Country.

Annibale Carracci

Annibale Carracci occupies an unenviable position in the history of painting. Most of his work predates Caravaggio and Rubens, but somehow it is inevitably sandwiched between theirs. Worse than this, they manage completely to bracket his efforts. The great painting of the seventeenth century and the best of modern painting to follow were built on the shoulders of Caravaggio and Rubens set ungraciously on the misunderstood body of Annibale's ideas, intuitions, and accomplishments. There is much truth to this complaint, and the literature is eloquent in arguing Annibale's case. But one thing seems to have gotten lost in the pleadings: how very difficult it is to look at Annibale's paintings.

It is not an exaggeration to suggest that twentieth-century eyes need special practice and perhaps even special training to see anything at all in Annibale's work. In the Louvre, for example, his *Madonna and Child in Glory with Saints* (plate 9) seems hopelessly remote when compared with such renowned paintings as Caravaggio's *Death of the Virgin* (fig. 14) and Rubens' *Debarkation at Marseilles* (fig. 15). A lack of physicality makes Annibale's work hard to grasp. Yet his painting is so eloquent that it seems especially unfair that his Madonna should be overwhelmed so easily, first by Caravaggio's dramatic impact, then by Rubens' elitist success. But the ephemeral, eclectic, and careful character of Annibale's art represents a great risk.

There is a lot to admire in Annibale, but the way he addressed himself to the problems of painting in his time seemed to carry with it the seeds of failure. We feel that he could see the problems, he could work on them, but he could never really attack them. Annibale gives the impression of moving on to another painting, another problem, before he had finished with the one he had just begun. This may explain why we walk by his paintings so quickly in museums:

we move on anticipating the next forceful impression, something that will develop and resolve what we have just seen. We feel a need for decisiveness and clarity when we confront Annibale.

This is certainly the case with the *Madonna and Child in Glory with Saints*. This is a beautiful and deep painting, but the fact that it is so difficult to see, so difficult to comprehend, is not in its favor. What holds this painting back is the careful, hesitant quality of its naturalism. Because its action unfolds in such a shaky progression, our instincts question the artful, naive flow of figures, diminishing in size as they travel from lower left to middle right to top center. As they move away from us, their separation creates an awkward tremor of instability. In the end we are aware that these figures are being made *observably* life-size, drawn and colored from life and then pieced into a painted setting. The result is that their average body size, instead of appearing normal, feels as though it is a Mannerist elongation of dwarfed models, a kind of unconscious caricature. Annibale's hesitancy and self-consciousness leave his delicate pictorial inventiveness without a real focus.

Yet Annibale handles with credit the problem of Mannerist succession of Renaissance accomplishment. He moves on smoothly; he is neither too boxy nor too thin. He is natural, and he is classical; he is mundane, and he is spiritual. Most of all he is discreet; perhaps too discreet to make enough pictorial presence felt. Not that it is not there, but it is so hard to dig out that we feel the effort is hardly worth it. It may be difficult to admit, but our laziness is Annibale's doom. No quiet painter can hold the attention of a culture

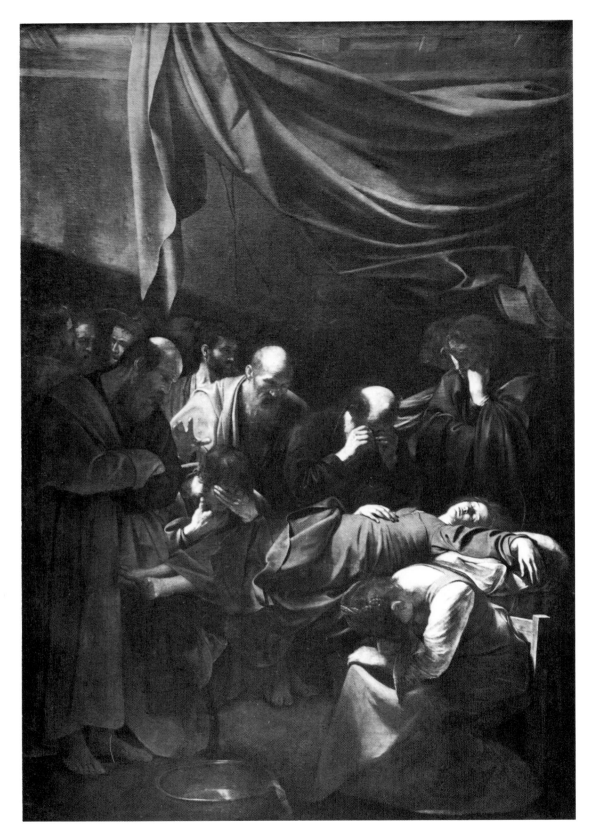

Figure 14 CARAVAGGIO
Death of the Virgin (1606)
Oil on canvas, 12 ft. 1 in. × 8 ft. ½ in.
Musée du Louvre, Paris

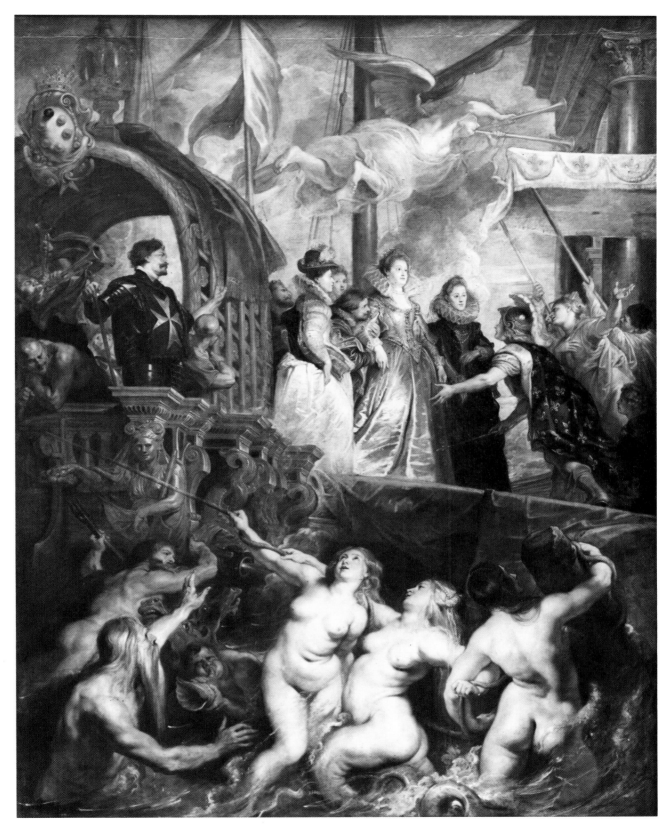

Figure 15 PETER PAUL RUBENS
Debarkation at Marseilles (1622–23)
Oil on canvas, 12 ft. 11 in. × 9 ft. 8 in.
Musée du Louvre, Paris

for long. Quiet painting, even of great originality, is sure to be merely the subject of intermittent academic revivalism. Apparently Annibale's accomplishments are suggestive, even helpful, but not firm enough to build on—at least this is the way they seem if we have to understand Annibale through the eyes of Caravaggio and Rubens.

There is a way in which Annibale's painting belongs more to the eighteenth than to the late sixteenth century. His painting gives pleasure; it gives the opposite effect from the excitement that we feel with Caravaggio and Rubens. It may be that Annibale delivers what Caravaggio and Rubens withhold—satisfaction; or better, in painterly terms, a desire for untroubled resolution. Although Annibale has a soft, somehow indeterminate spatial presence that successfully defines his paintings, its clutter inevitably reduces them to a comfortable size, no matter how great the actual size may have been. As a result, we see Annibale's paintings in a very relaxed, conventional, almost bourgeois way; he anticipates a middle-class pictorial sensibility.

Annibale's *Madonna and Child in Glory with Saints* depicts Saint Luke with his brushes at his feet, contemplating the Virgin and the attending Saint Catherine. The overall atmosphere suggests a scene in which Vuillard is about to paint his mother and sister in a turn-of-the-century sitting room. This association highlights Annibale's ability to create a very personal, intimate space within the confines of a public altarpiece. The spatial presence here, the envelopment of Saint Luke coupled with the illumination of Saint Catherine, has a clarity and a naive expansiveness which achieves a level of spiritual expressiveness not often found in painting. It is the kind of spirituality that does not call attention to itself. It is, of course, the opposite of everything that Caravaggio and Rubens stood for.

Caravaggio probably would have been contemptuous of Annibale's reticence. Indeed, given the competitive edge of Caravaggio's personality, he doubtless took a lot of satisfaction from the fact that his confrontation with Annibale in the Cerasi Chapel featured two of his strongest and most inventive efforts against one of Annibale's more dated efforts. This is not to say that Caravaggio lacked respect for Annibale's work; Caravaggio probably learned a lot from the Carracci, and from Bolognese painting in general. The influence just does not show up easily, since Caravaggio's extremely economical working methods make it hard to tell what he was looking at when he was working. However, we might get some hints from the figures revealed by x-ray in his *Martyrdom of Saint Matthew.* These figures have strong echoes of Annibale and Raphael, for example in Annibale's *Resurrection of Christ* and Raphael's *Stoning of Saint Stephen,* a theme which incidentally Annibale also took up later, indicating perhaps a particular interest in Raphael which he shared with Caravaggio.

There is one place where many believe that Annibale was able to outdistance Caravaggio: the paintings on the ceiling and walls of the Farnese Palace (fig. 16). These paintings do Annibale proud and would seem to challenge Caravaggio successfully. But Annibale's efforts in the Farnese, however beautiful and eloquent they may be, are oriented toward the antique, and as such are somewhat lost to us as painting. They remain idealized decoration that we cannot really bring into focus, an activity that in the end we cannot make convincingly pictorial. And this loss is true as well of Michelangelo's Sistine Chapel (fig. 17), great as it may be. We are very hard pressed to see ceiling and mural decoration as a coherent visual experience after we have been conditioned by the self-contained, individualized paintings of Caravaggio and Rubens that sprang up unexpectedly at the beginning of the seventeenth century. Caravaggio's explicit declaration of picture making as a unique and self-contained activity and its cataclysmic implementation by Rubens rendered past and future mural painting literally dumb.

The flatness of decorative mural painting made illusionism a necessity, but the literal extensiveness of the surfaces stretched the illusionism impossibly thin. The proliferation of intensely clever framing devices simply compounded the problem. Painting repeatedly demands a surface responsive to touch, and fresco painting, no matter how accomplished, always seems to deny tactility.

It may seem ungenerous to criticize Michelangelo and Annibale in this way, but the point I am trying to make, that the consequences of the great decorative efforts of the sixteenth century were disappointing for the future development of painting, deserves emphasis. Pozzo, Pietro da Cortona, and Tiepelo for that matter improved on the efforts of Michelangelo and Annibale, creating a more coherent and a more functional illusionism, but this was merely a mechanical triumph, a kind of illusionistic virtuosity without consequence.

Fortunately, this disappointment is not the whole story. In the magnificence of the Sistine Chapel and the Farnese Palace there is an abundance of great painting still to be appreciated, still to be reckoned with. The problem is how to gain access to it. We have narrowed our belief about what painting should really be to such an extent that almost everything good about the Sistine and Farnese decorations is unavailable to contemporary painting. For example, something as simple as a mobile viewpoint seems to be an anathema. We are so conditioned by the window of perspective that we stand motionless in front of it, waiting for painting to organize itself according to our acquired habits. It may be that we have to stop staring at painting and learn to scan a bit, trying to do with our two eyes what the average movie cameraman does with one when he tracks and zooms. Perhaps we could combine this more mobile, fluid way of seeing with painting capable of suggesting motion and extension. In theory then, if not in practice, we would be approaching painting that might rival Michelangelo and Annibale on their most difficult and heretofore inaccessible terms.

We have to acknowledge that two painters, Rubens and Caravaggio, who have an immense appeal to the modern sensibility owing largely to their contained, graspable pictorial power, found much of their strength in the great decorative painting of sixteenth-century Rome, in the work of Michelangelo, Raphael, and Annibale Carracci. The reason that Italian mural painting of the sixteenth century presents such a problem for us is that we are much more conditioned by the bounds of the fifteenth-century perspectival box than we realize. The painters of the sixteenth century were much looser with the rules than we imagine they should have been—fragmenting, distorting, and ignoring the theory of perspective whenever necessary.

Today, although we claim to be free of the bounds of perspective, we hold slavishly to a notion of a box view of a whole. It is as though Cubism has planted an ink-lined box in our brain which we immediately superimpose over any image that provokes an aesthetic response. To put it another way, the flatness of abstraction today, its sense of surface, has nothing whatsoever to do with any sense of surface of past art; it is simply the forwardmost plane, the windowed picture plane of the fifteenth-century perspectival box. It is this way because abstraction is historically self-conscious, a recent development that is instinctively cautious and conservative, apparently unable to shake the trauma of separation from representation; consequently, spatially, if not in other ways, it remains especially timid—almost retrograde.

The result of modern painting's restrictive view of flatness has been a negative reaction to the yielding surface of painting. Painting today is trying to be deliberately messy in order to deny the fragility and limits of the surfaces available to art. This is why the creation of grafitti has become such a natural expression of the current art-making sensibility. Art wants real, durable, extensive surfaces to work on; it does not want to be limited by the refined surfaces of recent abstraction, inertly pliant and neatly cropped cotton duck. Whether they know it or not, most of the young painters are reaching for the stucco of Rome. Let us hope it is for the stucco of sixteenth-century Rome rather than seventeenth-century Rome.

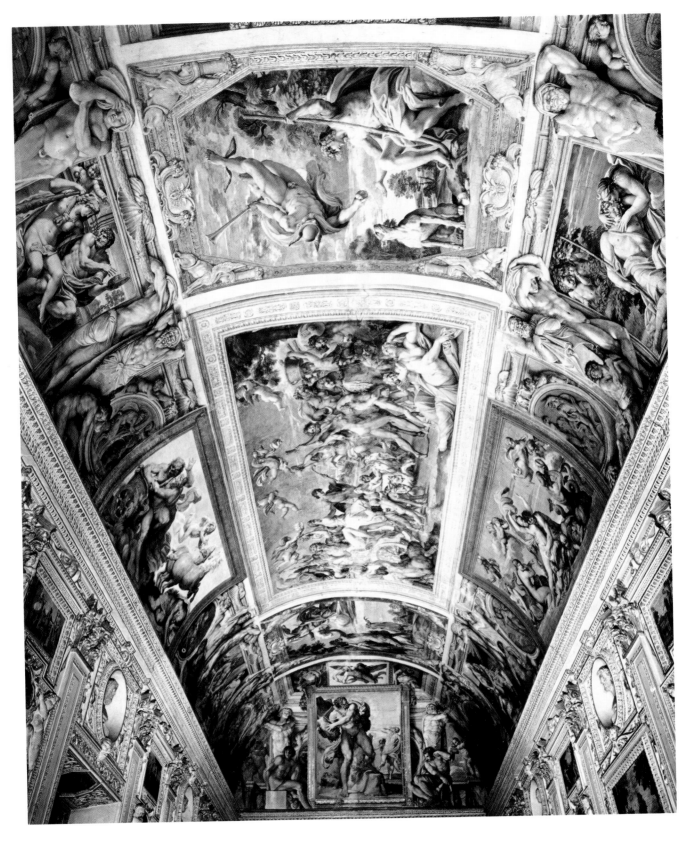

Figure 16 ANNIBALE CARRACCI
Farnese Gallery (c. 1597–1600)
Ceiling fresco
Farnese Palace, Rome

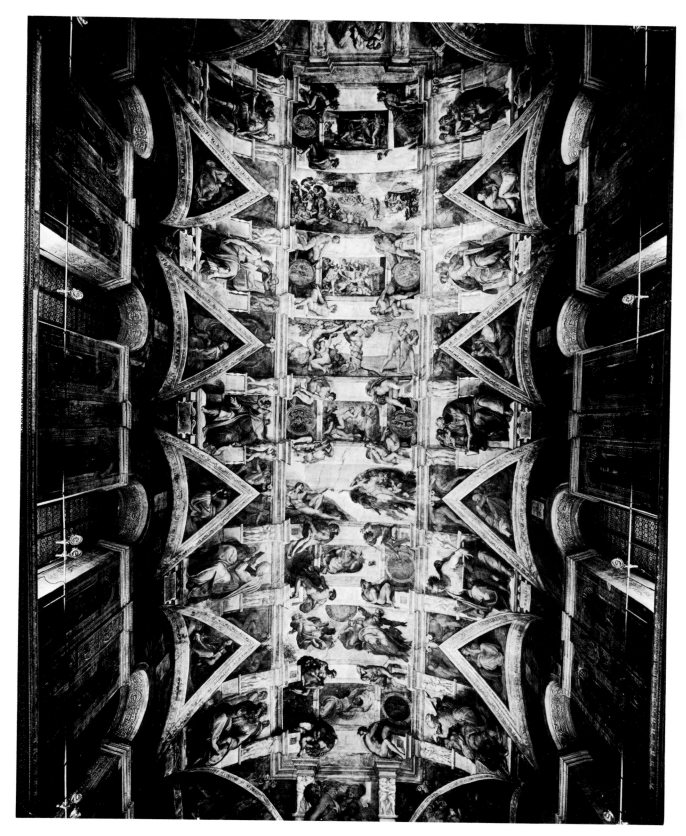

Figure 17　MICHELANGELO
Sistine Chapel (1508–12)
Ceiling fresco
Sistine Chapel, Vatican, Rome

In one way Michelangelo in the Sistine Chapel gives us an object lesson about the perils of painting in the sixteenth century: he stresses the limits of the enframing window. The trompe-l'oeil architecture and statuary painted around every scene dwarf most of our sense of pictorial happening within these devices. All the activity takes place around the painted pictures. The message here is clear—that measured space catering to our idea of proper visual orientation is overcome by a natural flow of painterly pictorial energy expressed ironically as trompe-l'oeil sculpture. Mannerism becomes inevitable because painting wants to break the bounds of mechanical measurement—or for that matter, any kind of rational, objective measurement.

In case we missed the message on the ceiling, Michelangelo reinforces it on the wall. The *Last Judgment* shares the messiness, the serpentine shallowness, that we see around us today—but, of course, on a slightly higher plane. This anxious messiness shows that contemporary painting needs reform, much as Mannerist mid-sixteenth-century painting needed reform, but we need reform in the energetic manner of Rubens and Caravaggio rather than in the mild manner of Annibale's well-meant and gifted academicism.

Annibale was a truly inspired painter, but when he tried to do more for painting than just make it, he got into trouble. In a sense, no one needed the Bolognese to reform painting toward the end of the sixteenth century. All the Carracci had to do was to make art; to paint on a level with Michelangelo, Raphael, Titian, and Tintoretto and still acknowledge the insights of the likes of Correggio, Parmigianino, Bronzino, and Rosso Fiorentino. In a way they did get it right, but perhaps their academic sense of completeness—the fact that they could not leave anything out, like, say, Barocci's lovely, oscillating color—made it impossible for them to become focused enough to attack painting in the way that Rubens and Caravaggio did.

Acknowledging Annibale Carracci is the long way around to Rubens, but it is the route of choice because Annibale so aptly exemplifies a nagging notion we have about the difficulty of looking at painting in general and individual paintings in particular. This difficulty confronts us when we think of Rubens: his work in general, and his paintings in particular. In the case of Caravaggio, once we have grasped his intensity the paintings open up to us; the success and convincing realism of the illusion lead us into painting. With Rubens it happens the other way around: painting always comes first, and the sense of the painting is so present that it becomes very hard to distinguish any other reality. In a world made up only of painting, there is little room for us. Sometimes painting guided by Caravaggio becomes so intensely self-involved that we feel like voyeurs; whereas its opposite, painting described by Rubens, becomes so completely pictorial that it turns self-consumptive in front of our eyes, announcing a world of its own, a world excluding us. This gives us an uneasy feeling in the face of Rubens' work: we feel that his painting revels in its own glory, and the truth is we want it to revel in our glory.

This total pictorial immersion seems strange to us at first because the fullness, completeness, and largeness of Rubens' scale of working make the paintings hard to read. There is very little conventional adjustment of pictorial space, very little accommodation to the idea of organizing observed nature into a pictorially manageable format. This brusqueness makes the illusionism that is there a bit artificial, and it reinforces our sense that these works have an abstracted, almost dislocated quality that is thrust gratuitously upon us. But herein lies their most enduring and original quality: by being so completely motivated by painterly and pictorial qualities, these works are very close to the spirit and intent of twentieth-century abstract painting. The basic construc-

on and illusionism of Rubens' paintings create a self-contained, expansive whole that appears accessible to and certainly instructive for painting today.

We can see Caravaggio manipulating his illusionistic gifts to create a real figurative presence in painting, indulging his talent for naturalism in the salvation of idealism (exactly what Annibale wanted to do but could not quite find his way to do); then a few years later we see Rubens, eyes barely uplifted from Caravaggio's drama, working toward the creation of a real presence for the activity of painting itself, quietly downgrading idealism by letting his naturalistic impulses drive painting. Rubens' success scrambles the ambitions of Annibale and Caravaggio, leaving a great gift burdened by a great responsibility.

Grasping the halter of seventeenth-century culture, Rubens tells us that the ethical imperative in painting is found in recognizing what God wants us to do, and what God wants us to do is create for ourselves. Here the difference between the Catholic and Protestant viewpoints is underscored. Both Catholic and Protestant would argue that naturalism in painting reflects our observation of what God wants us to be. We record and study what we see. But these words—*record, study,* and *see*—have different meanings. For the Protestant sensibility these activities lead to a search for accuracy, a desire for understanding that is expressed in an inevitable displacement of painting in favor of craft, ensuring, in turn, an unavoidable pictorial impoverishment. For the Catholic these same activities—the absorbed record of what we see—lead to the responsibility of creation, a desire for knowledge expressed in a commitment to the *potential* of painting.

This is the core of Rubens' greatness: as much as he gave, as much as he accomplished, the potential for continued development is always there. We desperately want painting to be real and true, but most of all, although we will not admit it to ourselves, we want it to be stable. In this sense Rubens

will always leave us unsatisfied. He gives us an enormous amount; but it is not there to be possessed, it is there to be used. We acquire working capital, not savings.

The momentum that Rubens gave to painting still runs freely today, and it will continue to do so as long as we want to create painting. That is, the momentum will serve us as long as painting seeks to be universal—as long as it remains Catholic and does not become Protestant and provincial. It could be that the Jesuit Counter-Reformation did more for painting than painting did for it.

Confidence drives painting. Perhaps nothing could help dispel the manic diversity that surrounds and engulfs painting today better than the broad sweep of Rubens' brush. His sureness about painting, anchored as it was in the service of God, would be a boon. It was his reaction *to* the painting preceding and surrounding him, rather than *against* that painting, which propelled his work and the painting that followed him. It is this kind of positive, progressive moment that seems so hard to find today.

In looking at Pollock's work, we can see a good example of the kind of problem that faces abstraction now, particularly in what we call overall painting. To go anywhere with the thin paint skeins that Pollock activated, we have to give them more moment and definition. We have to imagine a kind of tubular displacement and disposition of fluid pigment, as if it were coming out of a hose and could hold itself together, keeping its definition until it chose to disperse itself for dramatic effect, and then regaining its definition and composure in order to move on again to drive painting toward completion. This is the way in which Rubens activated Mannerist entanglement and shallowness; he made it flowing and expansive, creating in his Last Judgments a sureness

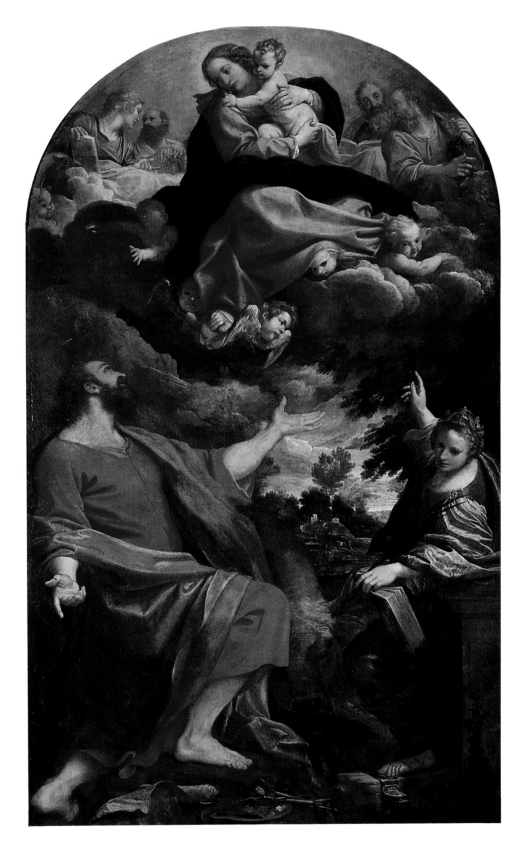

Plate 9 ANNIBALE CARRACCI
Madonna and Child in Glory with Saints (1592)
Oil on canvas, 13 ft. 2 in. × 7 ft. 5 in.
Musée du Louvre, Paris

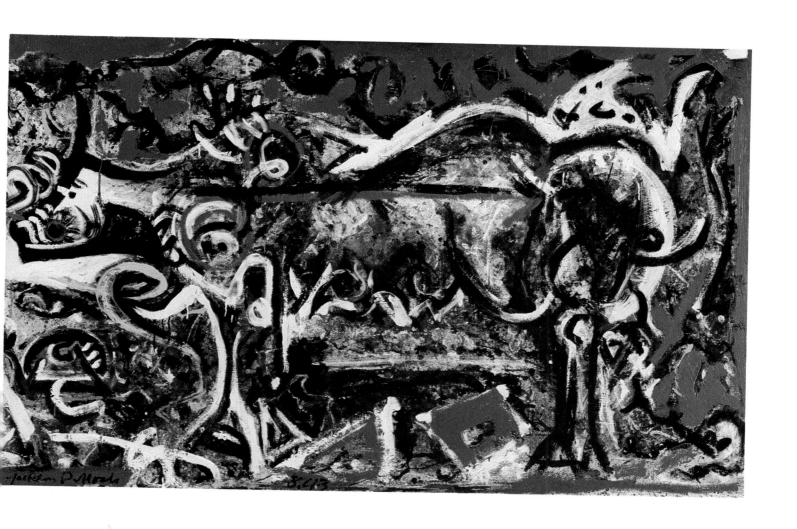

Plate 10 JACKSON POLLOCK
The She-Wolf (1943)
Oil, gouache, and plaster on canvas, 41⅞ × 67 in.
Collection: The Museum of Modern Art, New York
Purchase

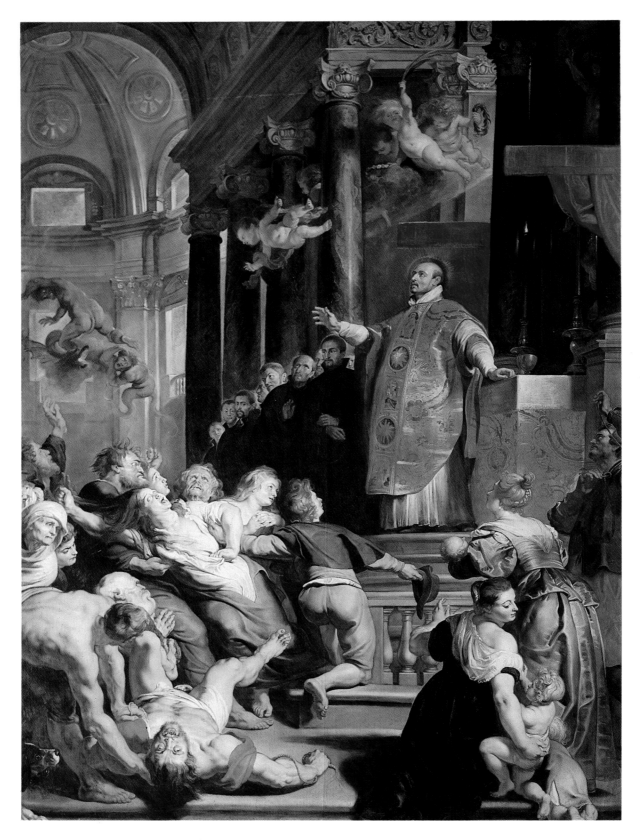

Plate 11 PETER PAUL RUBENS
The Miracles of Saint Ignatius of Loyola (c. 1618)
Oil on canvas, 17 ft. 6½ in. × 12 ft. 11½ in.
Kunsthistorisches Museum, Vienna

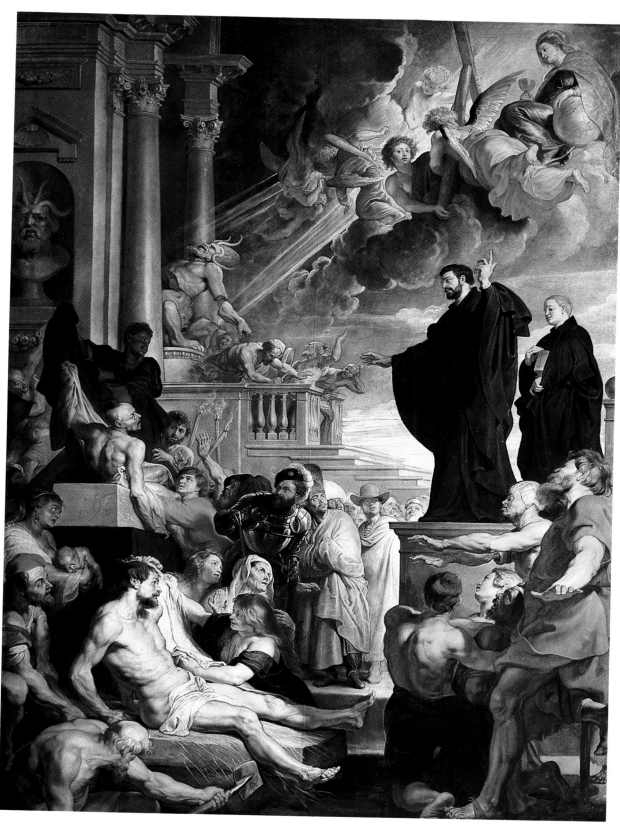

Plate 12 PETER PAUL RUBENS
The Miracles of Saint Francis Xavier (c. 1618)
Oil on canvas, 17 ft. 6 in. × 12 ft. 11 in.
Kunsthistorisches Museum, Vienna

for pictorial coherence that was at such peril in Michelange-lo's *Last Judgment*. In Pollock it is not the coherence that is at stake, but rather the depth of the available space and the expansiveness of delimiting boundaries. A fear is aroused that shallowness and constriction will be our perpetual com-panions. Today, running around and dripping paint on bare canvas does not carry with it a sense of aesthetic excitement, does not create enough of a pictorial sensation or illusion. More important, it does not create enough working space. We want paint to build a pictorial space that accommodates the reach of all our gestures, imaginative as well as physical. This is what Rubens' paint does with the bodies in the *Last Judgment,* where pictorial construction simply overwhelms pictorial drama.

Of course we do not have access to the kind of figurative illusionism that Rubens had at his disposal. On the other hand, we do not have its limitations either. We should be able to expand Pollock's pictorial space and to follow the lead of his paint skeins. Painting desperately needs the liter-alness, immediacy, freedom, and clarity of the drip paintings. They represent the kind of bright, confident explosion of painting that Rubens so often ignited.

Great painters are great because they give momentum to culture. They are also great because their work has a seem-ingly endless potential for growth; even after they are gone, we sense that their work is expanding and that new things are to come. Sometimes great painters slide into each other, creating new forces and new possibilities; and even though we appreciate the newness we are, in fact, more impressed that the echoes and resonances of these creations still em-body both the past and the present. The reason we can imagine Rubens pushing Pollock is that the *Laocoön* ripples through both of them.

There is a good reason for linking Rubens to Pollock, for linking the power and sense of pictorial potential developed at the beginning of the seventeenth century with similar aspirations confronting twentieth-century abstraction. Ru-bens always suggests expansion. Indeed, he suggests a para-dox that abstraction sorely needs to comprehend—uncon-tained wholeness, wholeness that is not neatly bounded or trimmed. Looking at Rubens, we see Pollock's painting as tight. This realization underscores the problems facing what is now called formalist abstraction. An exaggerated idea of Pollock's freedom, his working method, has been over-whelmingly influential and very thoroughly absorbed, but somehow the aesthetic stature of the actual paintings keeps being questioned. Succeeding painters confront Pollock with restless, competitive anxiety. They want to use the potential they sense is there, but they do not want to be controlled by the niceties of Impressionism and Cubism that formed Pollock. The splayed-out, lava-like quality of paint-ing today indicates a desire to move with the freedom and abstractness of Pollock without succumbing to a result that can be reduced to a whole defined by a coherent, continuous surface. It is as though painting today believes that primitiv-ism is the only safe way to guarantee pictorial drama. Pol-lock's refinement and his harnessing of energies seem to be an understatement, posing an unnecessary limit to the picto-rial potential that he discovered and developed.

It is amazing that Pollock's accomplishment, so universally felt, has provoked so much confusion and produced such unsure results. Still, we know that we need to use Pollock. We see the potential: in the speed of the moving line, in the encapsulation and entanglement of shallow space, and in the sheer beauty of the painting's literalness, what amounts to the embodiment of its abstraction. Interestingly enough, the potential we feel in Pollock is much like the potential we would ascribe to Italian Mannerist painting in the late sixteenth century—the painting whose potential Rubens realized so beautifully.

There is another way in which painters today seem to engage Pollock that arrests our attention. We have already noted their confident attachment to primitivism, and—if we are not overcome by the aggressive posturing of youth—we can see some legitimate sources for their appraisal in Pollock himself. The drip paintings may present them with problems, but they apparently find the early and later work quite accessible. A generous view of what is going on in painting today could find a lot of feeling for Pollock's early work, for example, *The She-Wolf* (plate 10), as well as an interest in Pollock's later work such as *Frogman* (see fig. 27), whose stained black figuration remains challenging to this moment.

That these paintings have a core of irrepressible human figuration does not bode well for abstraction, but at least the younger American painters seem to recognize the value of tension and conflict in both Pollock's early and late work. Unlike their European contemporaries, they do not seem to see this work simply as a sanction for yet another return to representational figuration, sensing instead something that leads back into the heart of painting. Perhaps what set off Pollock's imagination will come through again in painting, and it is certainly possible that some of what comes through will help to reassert and rebuild abstraction.

These thoughts about Pollock come from thoughts about Rubens. Our immediate impulse is to reverse the flow to see what Pollock can tell us about Rubens, but it becomes too difficult. Rubens is such a complete and overpowering artist that it is impossible to approach him casually without risking confusion, even bewilderment. When we think about his work we have to consider organization; we have to think of broad periods of equal substance—early, middle, and late. With Pollock the sequence is uneven; the question of potential is focused on the drip paintings (fig. 18). Rubens, however, does not force such selectivity. Everywhere we look, we see potential for painting. The early, middle, and late paintings all burst with potential energy—to be sure picto-

rial energy, not physical energy. Still our imagination is tempted to confound the two. For example, if we put a Poussin and a Rubens on the middle of an inclined plane, we know the Poussin will come shooting down like a slug of lead. With Rubens, however, there are more graceful options (fig. 19): we recognize that he has the weight to slide down the plane, as well as the strength to regain the top. If need be, he could even drag Poussin back up the ramp. Rubens is weighty, but he is never inert. He is always capable of generating energy more than equal to his mass, always capable of moving himself and others.

There is something special about artists who have complete, sustained careers. The work from each stage of their development contributes to succeeding art; it is not confined simply to contributing to its own development. It is clear that any stage of Rubens' work will yield energy that is usable today. But our closeness to Pollock makes us less sure that this is true of his work. We know that American regionalism, Picasso, and Surrealism all had an influence on Pollock's early work, but the drip paintings produced after the Second World War somehow obliterated these mixed sources. Now since these sources, including the early work, are in a sense no longer there, the effect of the drip paintings is to call into question—albeit somewhat after the fact—the efficacy or value of trying to use these consumed sources, or even of trying to gain access to them directly from the early work itself. What I am suggesting is that we were left stranded when Pollock's success killed off his pictorial sources, that the drip paintings consumed American regionalism, Picasso, Surrealism, and Pollock's own early paintings in an effort to ensure abstraction's dominance over the realism of the day, and perhaps of the past. In effect, the mirror of our progress reveals the picture of American abstraction destroying its roots.

We see a strong contrast when we compare the potential of Pollock's early work with that of Rubens' early work. Pollock's early work seems to have come into being only to be consumed by later, more necessary work. This is very differ-

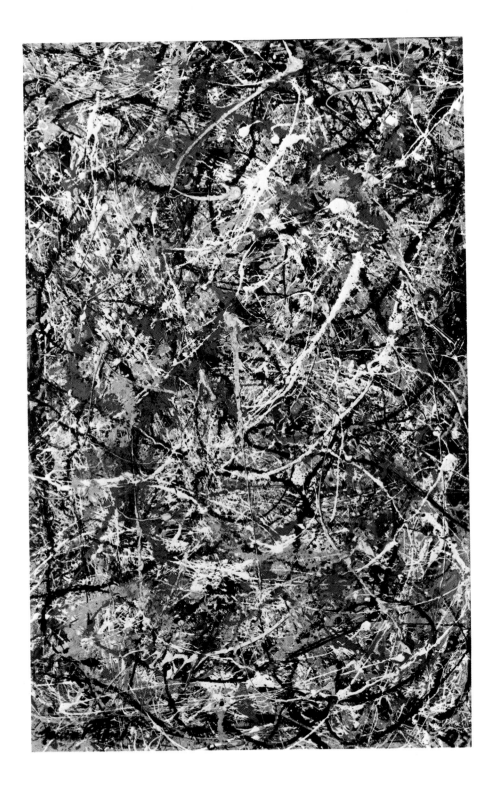

Figure 18 JACKSON POLLOCK
Number 3, 1949: Tiger (1949)
Oil, enamel, metallic enamel, string, and cigarette fragment on canvas
 mounted on fiberboard, 62⅛ × 37¼ in.
Hirshhorn Museum and Sculpture Garden, Smithsonian Institution, Washington, D.C.

Figure 19 PETER PAUL RUBENS
Three Graces (1638–40)
Oil on panel, 7 ft. 3 in. × 5 ft. 11 in.
Museo del Prado, Madrid

ent from the case of Rubens, where the early work successfully perpetuated itself and its sources (for example, Tintoretto and Caravaggio) so magnificently. This conforms to the way we believe art should behave. Of course, the story of the demise of Pollock's sources is an exaggeration, but one that reflects a widely shared fear—a fear that abstraction will uncouple us from the glories of the past, a fear that modernism's adventuresome self-involvement will turn out to be just that, leaving the past untouched and ungraspable.

The question becomes even more difficult in Pollock's later work, in the figurative black-stain paintings. If this work is informed and driven by the drip paintings, as seems obvious, is there something here that we are missing? Is it possible that the only useful thing about these paintings is the mechanical device employed by Pollock, the staining technique picked up by Frankenthaler and Louis? The results produced by this development have been correctly praised, but perhaps not properly appraised. Not much thought has gone into consideration of the obvious fact that Pollock stained with black, not color. If we remember Picasso in *Guernica*, and acknowledge Motherwell's intuition about the pictorial power of black, we might guess that Pollock had a sense of powerful pictorial drama in mind in his loosely associative, instinctive Rorschach figuration driven by black staining—a kind of essentially abstract, blackly veiled Goya paying homage to the sources that were consumed by the drip paintings. But it is certain that the one thing he did not have in mind was the colored abstraction of the 1960s; not that this wasn't a brilliant and inventive leap, but we should not forget that there is still a lot left behind in the late Pollocks and that the best may still be to come—especially since the first discontinuous leap has come to such a pale, freakish end. But even here there is cause for hope. We have only to look at what Rubens did with Franz Floris.

Rubens certainly was in touch with the Mannerist sensibility of Italian painting before he came to Italy, and this familiarity may have helped him to absorb it and to build on it as well as he did. He brought a sense of motion to what he saw that has propelled painting ever since. The sense of painting that we have today is formed by the space that Caravaggio created being set in motion by the force that Rubens supplied. It is important to see Caravaggio and Rubens in this way because it tells us how we think about painting, especially how we think about why things seem right in painting and about why we think certain paintings are great.

To put it simply, our notion of what aesthetically proper visual organization of painting should look like is based on the notion of a perspectival box, a container for measurable space. This container is basically a free-floating cube, although our senses will tolerate a sphere. Painting has to be organized in such a way that it remains poised within the limits of these notions; otherwise we tend not to like it. This explains why Giotto and Botticelli do not satisfy us. The justification for the aesthetic harmony that we experience in the face of Giotto's flatness and Botticelli's stiffness is unconvincing, and it will always remain that way. Although we acknowledge that these two painters have made great art, we will never see their deployment of pictorial space as resolved. They will always belong to a tolerant notion of art that accommodates the activity of painting before it became the activity we know today—the activity of making coherent pictorial objects, pictures that do not conflict with our present notion of visual focus and organization.

We like Caravaggio because he took the action in the box and brought it up and out, lighting it in such a way that we experience it as immediate pictorial action kept easily in focus. We like Rubens because he enlarged Caravaggio's vision. He put Caravaggio's presence into motion in an expanded space, a space, however, whose ambitions we ignore

in favor of its generalities because they politely conform to the space we like—the balanced, measurable, seemingly undistorted space born with Alberti.

I call attention to this simple notion to help explain why abstraction does not have real access to as much of the history of art as would seem likely. Painting that could be very useful as a source—for example, painting at Lascaux, painting in Egyptian tombs, ancient and Byzantine mosaics, medieval manuscript illumination, Islamic tile decoration, to say nothing of ethnic and Oriental art—all this work is incompatible with our understanding of coherent pictorial structure. Abstraction in the twentieth century never really makes use of what it has seen because it has instinctively withdrawn into a post-Renaissance shell—a soft, neat version of what Rubens and Caravaggio had made into a dynamic spatial caldron for pictorial figuration.

What this means is that abstraction cannot accept anything that has a sense of the unbalanced. Everything that we see as pictorial must be correctly weighted; all the action within the depicted space must be evenly distributed. The reason for this seems to be that we cannot imagine any contained spatial whole that is not balanced. Deformed space is a concept alien to our bodies; we demand balance and even distribution. It is as though we cannot bear that the boat should tip or that the ball should fly untrue. Disorganized space encourages our overwhelming fear of eccentric motion.

It is interesting that the first artists to use perspective did not seem to feel the imperative of measured spatial coherence. In Italy and elsewhere they went on painting the way they always had, with the usual slapdash adaptations to new devices and ideas; and by the end of the sixteenth century the die was cast. Mechanical perspective was pretty much spent, along with a lot of dramatic variations supplied by the great Mannerist painting of Tintoretto and Michelan-

gelo. It merged with atmospheric perspective and the light of developing chiaroscuro to create a new flexible box of averaged pictorial space. This notion of space that had developed by 1600 is one that we like and will not let go of. This is the notion that, to be right, the space in painting should be weighted and balanced in such a way that its dispersal averages out for us in a coherent manner—that we can take the action we see in a painting and feel that its distribution makes sense. This notion implies that we can take what we see in a large altarpiece such as Rubens' *Assumption of the Virgin* and put it in a hand-held glass ball, where reduced it is manageable and seeable in one glance.

Almost everyone who looks at pictures is quick to note how little the appearance of things in paintings has to do with the way we actually see things. However, if anyone were to attempt to make things look in painting the way they look when we record our perceptions, the result would be labeled perceptual psychology, not art. For some good reasons, then, our idea of art has come to be framed by the conventions of the early seventeenth century, which have left us a boxy, coherent whole whose interior transitions and displacements are beautifully averaged out. It is in its ability to smooth the transitions between separate pictorial areas and actions, culminating in its mastery of the landscape, that seventeenth-century painting clearly demonstrated its control over the energies that the sixteenth century had sent shooting through the alleys of perspective.

But our admiration for this knack of spatial averaging which smoothed over the rough spots of Renaissance painting might be mistaken. We have formed a large part of our basic notion of modern painting around the least of the accomplishments of the seventeenth century. But its greatness has to be more than its ordinariness. In the end, it comes down to this: abstraction has left behind the tradition of figurative painting that began with the Renaissance, and instead has taken with it the worst illustrational bias that Western figurative art had developed: its notion of averaging effects, of

smoothing over spatial transitions. This has had disastrous effects because it forced abstraction to start out cautiously. Abstraction has come to be in need of extraordinary effects rather than average effects—in need of bold displacements rather than smooth transitions. In spite of all that has been said about the "radical" visual orientation of the early twentieth century, its aesthetic instincts seem essentially conservative, and we appear content now to accept this, to look for manageable and stable space that we can hold in our hands. Recently the only new ideas introduced into that space have lost themselves in a fluff of atomized color that blends harmlessly into its own background, erasing whatever incidental figuration may have been emerging.

Let me put this another way. No one wants abstraction to turn itself around to accommodate the innate taste for illusionism; but abstraction has to recognize that the coziness it has created with its sense of reduced, shallow illusionism is not going anywhere. Caravaggio and Rubens made manageable pictorial sense out of the dynamic illustrative diversity of sixteenth-century painting, building a strong base for future painting. What we need today is a similar base for the future of our own painting. The question is, where will we find the building blocks for this base? In one sense it seems obvious that they should come out of the diversity of twentieth-century painting. Unfortunately this diversity seems to be riddled with weaknesses; we are likely to be working with blocks of styrofoam rather than marble.

There was a substance to the problematic illusionism of Correggio, Giulio Romano, Tintoretto, and the Carracci, to name a few examples. We believe that there is substance to the equally problematic illusionism of Cubism, Surrealism, and Abstract Expressionism. But the fact is that the abstract painting of the last twenty years has not been able to pull things together in the way that Caravaggio and Rubens did at the beginning of the seventeenth century. Somehow painting today, especially abstract painting, cannot bring itself to declare what Caravaggio and Rubens demonstrated again and again—that picture building is everything.

Abstraction seems to be lost in a dream in which the materiality of pigment reveals painting. It puts too much hope in the efficacy of clever, random gestures. What is needed is a serious effort at structural inventiveness. What Morris Louis did for a while twenty years ago, following the lead of Barnett Newman, remains more of a promise than a fulfillment. But if his promise were read rightly—if the structural potential of his spatial dynamics were understood and the disjunctive intensity of his color appreciated—his painting could lead to a new beginning. As it stands, those who are most taken with his work do the least with it.

Morris Louis (fig. 20) was nearly the last abstract painter to hint at the potential that abstraction might have for creating a full and expansive pictorial space like that of Rubens. If we stop for a moment and think of Rubens at his most successful, we begin to recognize the development of a definition and delimitation of painterly ambition that sets an important example for the future of abstract painting. We need ambition to drive abstraction out of its miasma of self-satisfied materialism; and if by chance abstraction's current obsession with the tactility of pigment should turn out to be a step in the right direction, Rubens would be a natural: the perfect teacher to show us how to keep painting moving, how to keep it from lying inert on the surface of the past.

In Vienna two magnificent paintings by Rubens, *The Miracles of Saint Ignatius of Loyola* (plate 11) and *The Miracles of Saint Francis Xavier* (plate 12), show us an artist working at the height of his powers. These paintings are often overlooked because they do not have an immediate appeal to our contemporary sensibility. Work from both earlier and later periods is clearly more popular; we assume that the religious emotion elicited by *The Descent from the Cross* and the sensual interest aroused by *The Three Graces* are somehow more

Figure 20 MORRIS LOUIS
Alpha Gamma (1961)
Acrylic on canvas, 8 ft. 9 in. × 12 ft. 1 in.
The Detroit Institute of Arts
Founders Society Purchase, Dexter M. Ferry Fund

acceptable than the overt propagandistic bias of *The Miracles of Saint Ignatius* and *Saint Francis Xavier*. But we would be making a big mistake to dismiss these paintings too quickly simply because we believe that artists are at their best going against the grain of society. The truth is that in these paintings of St. Ignatius and St. Francis, Rubens was doing what society most wanted him to do. He believed what society believed, and he had the ability to put before it a stunning vision of its own beliefs and hopes. As in all great painting, a miracle was recreated. We have only to go to Vienna to see this particular miracle preserved.

Belief served Rubens well, and it seems natural to suppose that his religious convictions were a source of his tremendous confidence. But we cannot help wondering if there was something more than the sure support of God that drove Rubens' confident and ambitious attack on painting. It is possible that he noticed how closely the necessities of religious belief matched those of artistic vision. For the man in search of belief, the biggest problem lies in accounting for the world that he senses must surround the world that he sees. Rubens knew that for the artist, the same accountability held true. In order to be convincing, painting had to account not just for the real world but for the other worlds—heaven and hell.

In another less obvious sense, perhaps, Rubens knew that painting in trying to create its own contained pictorial reality had to account for the uncontained, nonpictorial reality that surrounded it. To put it another way, Rubens knew that the success of painting depended on its ability to reach out, to create pictorial space which would in turn appear to be expanding into the real space surrounding it. Rubens recognized that Caravaggio's declaration of a truly independent space for painting was a sticky proposition. Ever the statesman, he saw the need for an independent pictorial space to establish its ties with the everyday space of perceived reality.

What is remarkable about Rubens' perception is that he was able to act on it without recourse to dominating illusion. His work always declares itself as painting. The loose brushwork and slippery line drawing that actually make up the figures in his paintings are never overcome by the sense of real presence embodied in them, as is the case with Caravaggio. It is one thing to be successfully "real" as Caravaggio was and to be able to extend that sense of realness into an enlarged sense of pictorial space, one that seems to break the boundaries of the picture surface; it is quite another thing to be as unabashedly artificial as Rubens was and still to be able to extend that sense of driven painterly activity into a similarly enlarged, engaging pictorial space. Obviously, abstraction today is taken with the example of Rubens because his naked painterliness seems more accessible than Caravaggio's rabid realism. Somehow we are more confident about what we can do with raw pigment than we are about what we can do with raw illusion; a preference is registered for tactile over depicted reality. Even realist painting is a witness to this bias today.

Since this discussion about the pictorial intensity of Rubens and Caravaggio and the value of this intensity for twentieth-century abstraction has been an argumentative one, we might do well to look at Rubens' two great paintings, *The Miracles of Saint Francis Xavier* and *The Miracles of Saint Ignatius of Loyola,* and let them speak for themselves. If we feel that the mere presence of these paintings is not enough, we can fall back on the techniques of art history and summon support for the paintings from earlier sources. In the case of these two paintings from Vienna, it would be natural to look to the two major sources—northern and southern, Flemish and Italian—of Rubens' inspiration.

Figure 21 JULIO GONZALEZ
Reclining Figure (c. 1936)
Iron; height 9¾ in.
Musée National d'Art Moderne, Centre Georges Pompidou, Paris

The architectonic backgrounds in *Saint Francis Xavier* and *Saint Ignatius* suggest the northern painting of Rogier van der Weyden, Jan Gossaert, called Mabuse, and Albrecht Altdorfer, although the actual models seem to come out of Genoese and Venetian painting. Rubens put to use some of the lightness and solidity of northern painting in an attempt to round out the theatrically flat quality of Venetian painting and also, perhaps, to diffuse and restage the harsh lighting of Caravaggio. The paintings in Vienna seem to present Rubens at his most independent, and it may be that going back to his northern roots makes him seem especially free of Italian painting. The mixture of hotness and coldness in the color of these paintings draws an easy applause from the north and the south. But more than this, the sense of hotness and coldness carries over into the whole tenor of the painting. The religious emotion swings back and forth from detachment to engagement, echoing the sensibilities of Rogier van der Weyden from the north and Caravaggio and the Carracci in the south.

North and south, hot and cold seem obvious to the point of begging comment, but in Rubens their entanglement amounts to something worth noting. The sense of temperature given to this colored pigment and the swirling articulation of space that envelops it are remarkable, creating a bouyancy that belies the weight of the paintings' organization and depicted structure. In these paintings a modest amount of flesh is capable of moving a massive amount of marble. This sense of corrected imbalance, the feeling that the perched figure is as heavy as the pedestal it stands on—or the other way around, that the pedestal is as light as the figure it supports—gives Rubens a powerful picture-building technique. There is a sense here of sculpture's strength wrapped in a gauze of pigment. It is as if a thorough cleaning of these paintings would bare a Gonzalez-like skeleton (fig. 21), showing us how Rubens made painting leap from platform to platform.

All painting is suspended from the platforms of its various grounds, the most common of which are the foreground, the middle ground, and the background. Most of us tend to understand the way that we see and the way that we look at painting in these terms. We tend to think of seeing in terms of locating things in front of us, and it seems natural to organize our information in terms of distance. When we apply this sense of organization to painting, what we often fail to notice is that we severely limit painting's sense of space. We assume that since we are willing to look off into the distance to the pictured horizon, we have given painting plenty of room. Some will even look beyond the horizon to sight infinity as vision's abstract target. The crucial point, however, is that we almost always limit our view of painting to the distance in one direction.

The one thing more than anything else that both *Saint Francis Xavier* and *Saint Ignatius* do in Rubens' painting is to remind us that we should see ourselves on a pedestal if we want to be true viewers of painting, because elevated on a pedestal we will surely be reminded of the space all around us—the space behind us, next to us, below us, and above us—in addition, of course, to the space in front of us, which we have so often taken as being the only space available to us as viewers. No one makes it clearer than Rubens how dearly painting wants to use all of the space that is available to the human imagination.

Picasso

During the first twenty years of the twentieth century almost everything that happened in painting pointed to the growth of abstraction and its seemingly inevitable triumph over realism. Sixty years later, after a number of ups and downs, abstraction appears to be in a dominant position, but it still falls far short of victory.

For abstraction, the most important change of direction in painting in the twentieth century was made by Picasso when he turned away from Cubism (fig. 22) to his classical figure paintings of the 1920s (fig. 23). Picasso must have sensed that Cubism was played out; he saw that its dissipated and fragmented planes would inevitably lead to a flattening out of the space available to painting. At question here was the role of volume in the scheme of pictorial representation. The focus of attention was on the human figure. In Cubist practice the figure had been worn down by the pumice of structural analysis. However, the dissolution of the human figure was not the only loss; the emphasis on and consequent proliferation of planar representation had begun to dissolve the space around the human figure as well as the figure itself. If Picasso had cared to look, he would have had examples of this erosion of pictorial space close by: Kandinsky and Malevich would have provided very clear evidence.

Kandinsky (fig. 24) took the landscape—or better, our sense of the space around real things, what we might call our sense of the natural atmosphere—and dissolved it into a pigmented gesture, what we now call "pure painting." This fruitful act of liberation gave us the first really great abstract paintings. They had openness, freedom, spontaneity, clarity, purity, and just about everything else that the modern visual sensibility prizes. But Picasso, a man whose visual sensibility surely was equal to the thrust of modernism, saw the danger here of materiality—the danger that the new, open atmo-

spheric space of abstraction would be clogged up and weighed down by the mass of its only real ingredient: pigment. Picasso's concern articulates the fear that abstraction, instead of giving us pure painting, would merely give us pure paint—something we could find on store shelves as readily as on museum walls.

If Kandinsky was filling up the landscape with pigment, Malevich was doing even greater damage to the figure inhabiting that landscape. First he flattened it like a pancake, and then with incredible dispatch he obliterated it. His method was simple substitution: he replaced the complex spatial coordinates of the human figure with a modest planar configuration. *White on White* (fig. 25), Malevich's abstract masterpiece, the touchstone of modernist flatness, still represents the solitary figure framed by a landscape, albeit clothed in pigment and severely compressed. This painting is probably what Picasso feared most—a painting with nothing but inert pigment and condensed pictorial space. In short, it is painting with nothing to work with, painting with no space to work in.

Now, by suggesting that Malevich's *White on White* was basically as much a figure in a landscape as it was a white rectangle askew on a slightly larger rectangle of almost the same color, and by insisting that Picasso's turning away from the abstract implications of Cubism to the volumetric realism of the classical figure paintings was a crucial event, I know that I am expressing a highly idiosyncratic viewpoint. But even if my emphasis and some of my examples have been exaggerated, I think that a basic point still comes across: that abstraction—or better, perhaps, abstract figuration—is bound to be tied to human figuration. As bland

Figure 22 PABLO PICASSO
Ma Jolie (Woman with a Guitar) (1911–12)
Oil on canvas, 39⅜ × 25¾ in.
Collection: The Museum of Modern Art, New York
Acquired through the Lillie P. Bliss Bequest

Figure 23 PABLO PICASSO
Woman by the Sea (1922)
Oil on canvas, 23¾ × 19¾ in.
Collection: Minneapolis Institute of Arts

and as lean as Malevich's efforts were, there is a human presence behind his rectangles; and as wild and artificial as Kandinsky's gestures were, there is a strong sense of observed nature emanating from all that pigment.

Our perception, at times, that abstraction and realism are bound together, almost like Siamese twins, is something that worries us, as it certainly bothered Picasso. For us the problem is that abstraction seems haunted by realism. For Picasso, abstraction appeared to smother pictorial reality. We fear that the twins can never be separated, while Picasso feared that one would devour the other.

If the major innovative goals of abstraction, heightened materiality and spatial purity, were to be achieved at the expense of human figuration, surely the gains were not worth the loss. The glory of the human figure is precisely its spatial versatility, and nothing confirms the glory and value of the figure more clearly than Picasso's post-Cubist paintings. Yet abstraction has dared to try to get along without the human figure. Today it struggles, at least partly, because it has failed to come up with a viable substitute for human figuration, for the spatial vitality and versatility provided by the human figure. It was not so much the loss of the human figure itself as it was the loss of what the figure did to the space around itself that has been so hard to replace. Spatial inertness has become a true concern for abstraction. Habitual dependence on materiality and flatness threatens to give us a very stagnant pictorial space.

Contrapposto (a figure with the hip up, shoulder down) and foreshortening (big feet obscuring a little head) are tried conventions that demonstrate how the human figure has helped articulate pictorial space in ways that abstraction now finds hard to simulate. The dictionary defines *contrapposto* as a representation of the human body in which the forms are organized on a varying or curving axis to provide an asym-

metrical balance to the figure. The other technique from the past, foreshortening, reduces or distorts the human form in order to convey the illusion of three-dimensional space. Over the years representations of the human figure have successfully absorbed these devices, creating in the process a dramatic and diverse pictorial space that abstract figuration has been hard-pressed to match. This is not to say that abstraction has not tried; Kandinsky and Hans Hofmann, for example, made every effort to articulate their brushstrokes and knifed masses of paint with some of the flair and attack that such devices from the past imply, but still they have not been able to create an equivalent of the depth projected by the lush and rich Mannerist space of the sixteenth century. The advance beyond easel painting, with its emphasis on flatness and its glorification of the mechanics of paint manipulation, still has a way to go before it catches up to the pictorial dynamism of the past.

To recapitulate: consider the human form—skin, bone, and flesh. Consider the painting—surface, structure, and pigment. With a little license, the first gives us the ingredients for what might be called human or "figurative" figuration; the second gives us the ingredients for abstract or "nonfigurative" figuration. Blended together, these ingredients have yielded great painting. The question is, can we get along with half of the recipe? The skin, bones, and flesh that we have thrown out stand for a great deal in terms of visual power. In a pictorial sense, the volumetric and spatial contortions the human figure is capable of articulating are uniquely wonderful. Furthermore, the range of tactile, painterly sensations which the figure can carry remains surprisingly great. These effects are not easy for abstract figuration to replace or to supplant. In addition, abstraction suffers greatly from a diagrammatic, brittle quality. Its joints are often stiff and arthritic. It is as though we can feel the pain in the welded sockets of abstract sculpture when images of Rodin's flowing, erotic marble limbs drift through our memory.

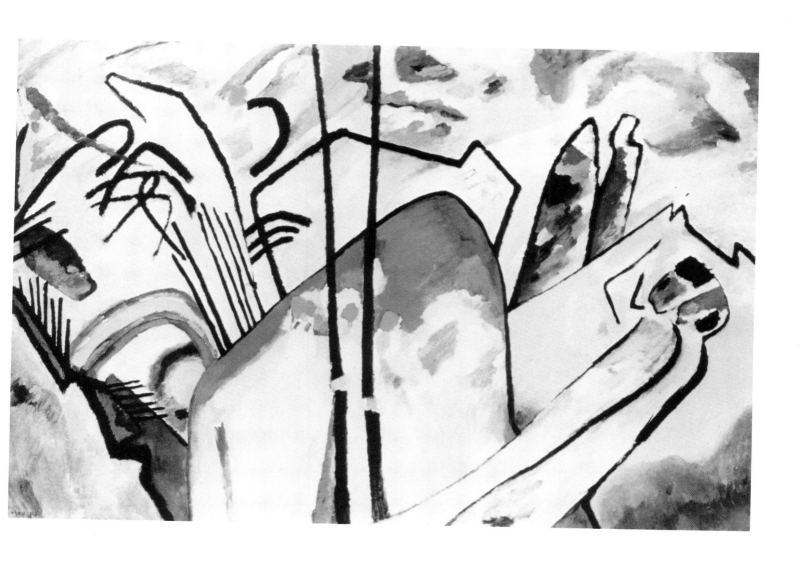

Figure 24 WASSILY KANDINSKY
Composition IV (1911)
Oil on canvas, 5 ft. 2⅔ in. × 8 ft. 2½ in.
Kunstsammlung Nordrhein-Westfalen, Düsseldorf

Figure 25 KASIMIR MALEVICH
Suprematist Composition: White on White (1918?)
Oil on canvas, 31¼ × 31¼ in.
Collection: The Museum of Modern Art, New York

Sex is no joke. When Picasso left the arid desert of Cubism behind, he never looked back. His women of the 1920s and 1930s, awash in painterly volumetric rendering, left planar analysis with its future of modernist flatness standing on the beach. It is very hard for abstraction, or abstract figuration, to be sexy, and if it's not sexy, it's not art. Everyone knows that.

The success of Picasso's painting from 1920 on comes from the unabashed rendering of volume, and this is what has proved to be the most difficult thing for abstraction to deal with. What Picasso left behind—Cubism, the fragmented structure of solid figures—has been duck soup for abstraction. It appears that it is easier to take things apart than it is to keep them together. The real problem is that abstraction cannot have rendering; it must be literal. For example, the employment of the simple device of shading a surface to give the illusion of roundness or depth seems to be anathema to the modern visual sensibility. It just never looks right. Yet this experience has become no more than a powerless contradiction in the face of an obvious imperative—that abstraction must have a viable sense and expression of volume, because without them the space available to abstraction is simply too closed, too dull, too unimaginative.

The irony here is that the last really vibrant and exciting pictorial space was the Cubist space that Picasso had left behind by 1920. What abstract painting has to do is to take what Picasso left behind—Cubism—and develop it to include what Picasso went on with—a dynamic rendition of volume. That is, abstraction must go on with what painting has always had—line, plane, and volume, the basic ingredients. The problem is that in the twentieth century modernist painting has not yet been able to put all three together. This does not mean that its accomplishments are suspect; it simply means that there is still a great deal of room for growth and improvement. Abstraction must find a more robust way to deal with the space around line and plane—our sense of exterior volume; it must also find a more convincing way to deal with the space that line and plane can actually describe—our sense of interior mass.

It might be objected here that the consideration of time—the often discussed fourth dimension—should be taken into account by abstraction. To this I could offer some arguments, but suffice it to say that abstract painting has pretty well integrated a proper sense of time into its mechanics of perception, its way of seeing things. In fact, this is the one area in which it is superior to any form of representational painting. For the most part realism today can only look through a viewfinder out the window of perspective. It is the fixed focus and limited—one might almost say unique—point of view that most separates realism from abstraction. The field of vision of realism is closed; that of abstraction is open.

So far abstraction has struggled to get by without the associative spatial dynamics of figuration. It has been hardpressed to give us anything resembling what Picasso did in the *Bather with a Beach Ball* (1932; fig. 26). But abstraction has not been without resources; it has gone so far as to give us painting whose pictorial drama is provided by what is not there. Malevich has given us two shades of white for figure and ground, and Mondrian has stretched landscape so taut across the painting surface that only pigmented traces of its structure remain. But brilliant as these maneuverings have been, we feel that there is something lacking; flatness and materiality (that is, pigmentation for its own sake) still close up pictorial space. Volume and mass—things that seem so real, and things, not so incidentally, that seem so natural to sculpture, need to be rediscovered, reinvented, or perhaps even reborn for abstract figuration. This is what Picasso said when he became a post-Cubist painter. Not surprisingly, thirty years later we find this same message reiterated by Jackson Pollock, in his *Frogman* of 1951 (fig. 27) or *Sounds in the Grass* of 1946 (fig. 28).

Figure 26 PABLO PICASSO
Bather with a Beach Ball (1932)
Oil on canvas, 57⅝ × 45⅛ in.
Partial gift of an anonymous donor and promised gift of Ronald S. Lauder to
 The Museum of Modern Art, New York

It was realism, hammering home the lessons of the past, driving the concerns of volume, mass, and three-dimensional rendering relentlessly forward, that denied abstraction the promises of its future. A future that Cubism had seemed to assure sank under the weight of Picasso's retrenchment. The huge stone feet of the classical seashore bathers, sinking in the sand, should have crushed their way through the paintings' ground plane, and the mass of figures themselves should have forced out all the viable pictorial space. These paintings should have failed. Realism itself should have collapsed with this effort, and if it had not been for Picasso's genius, it would have. Can we imagine a credible Surrealism without Picasso's bathers and bulls propping it up from behind?

If realistic figuration had failed after Cubism, it would have left the way open for Mondrian's extension of Cubism toward abstraction. Unfortunately, Mondrian's effort to make do with the more abstract, basically descriptive elements of art-making had to contend with the flamboyant success of Surrealism. Still he persevered. Mondrian tried to make paintings with line and plane alone, using only the descriptive elements of volume, the elements that defined its boundaries. This was a search for reality without substance, a search for a visual world charged with enough energy so that mass would not be missed—so charged, in fact, that the mere depiction of mass would appear to be an awful and inappropriate intrusion. In short, this was a search for a world in which figuration, human or abstract, would not be necessary.

At least, this is what we would have to believe if we thought that Mondrian's neo-plasticism was the *only* way to true abstraction, that the best that Cubism had to offer was quasi-abstract figuration, and that ultimately the future of Cubism would always be bound to depicted reality and to three-dimensional expression.

But, we ask ourselves, can there be abstraction without some kind of figuration? Can there be art with only two-dimensional depiction? The answer to the first question is probably no, because art, even when limited to line and plane, will yield shape, and the shape itself becomes the figuration. The answer to the second is probably yes—there can be art with only two-dimensional depiction, if we are not too fussy. In this case we have to accept some substitution—basically energy for mass, something we can feel for something we can see. If Picasso's mass, his pictorial power, was drawn from structural considerations through Cézanne with line, plane, and volume, Mondrian's strength, his pictorial energy, was drawn from surface concerns through Impressionism with color, light, and rhythm—the other basic ingredients of painting.

Surrender to sensation was the source of Mondrian's success. It enabled him to extend abstraction after confronting Cubism, while Picasso's sense of physicality bound him to retrenchment in the face of his own great discoveries. Mondrian was able to go on because what he saw in his own work, as well as in the work of Kandinsky and Malevich—materiality and flatness, the same things that Picasso had seen—did not seem so destructive or threatening to him. If he saw that these developments, the consequences of Cubism, were a threat to the depiction of reality as defined by its essence—three-dimensionality—he was not worried. He was confident that he could accept the structural limits of two-dimensional depiction, that is, accept the obvious flatness of the canvas surface, and build from there without recourse to illustrational illusionism. He felt that he could replace the lost sense of reality, the loss of depicted volume and mass, with energy derived from his handling of color, light, and rhythm, which, correctly focused, would appear to be equally real—or at least, real enough for painting. Of course, throughout the development of Mondrian's later

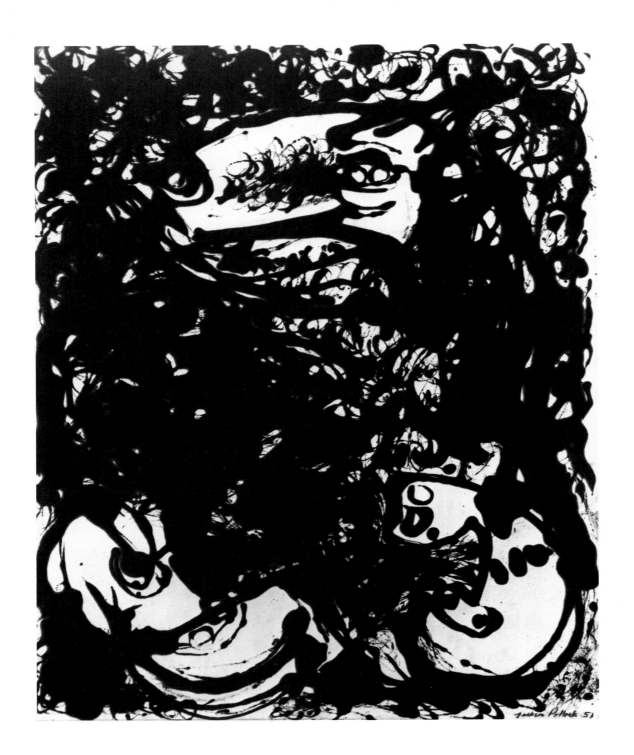

Figure 27 JACKSON POLLOCK
Number 23, 1951 (1951)
Enamel on canvas, 58⅞ × 47¼ in.
The Chrysler Museum, Norfolk, Virginia
Gift of Walter P. Chrysler, Jr.

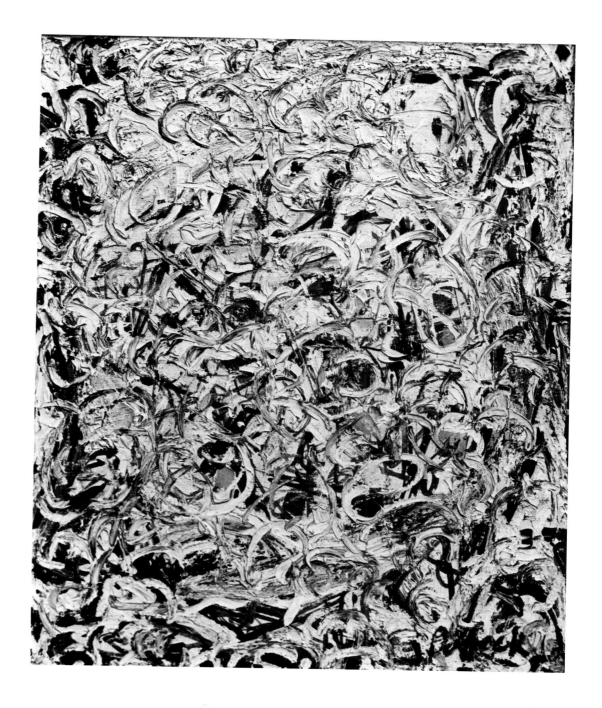

Figure 28 JACKSON POLLOCK
Sounds in the Grass: Shimmering Substance (1946)
Oil on canvas, 30⅛ × 24¼ in.
Collection: The Museum of Modern Art, New York
Mr. and Mrs. Albert Lewin and Mrs. Sam A. Lewisohn Funds

painting there were hints and suggestions of volume and mass. It is not as if these things were ever really lost; it is, rather, that their representation by the devices of conventional illusionism was properly suppressed in order to get on with the business of abstraction.

Pure color is the beginning of Mondrian's sensationalism. Its application reveals the intensity of hue as a pleasure and a tool in its own right, as well as a surprising conveyor of feelings echoing volume and mass. Bright, radiant light follows, created by a preponderance of white pigment and numerous high-contrast encounters with the black bars cutting across the painting's surface. This surprising light, emanating from a background which has the ability to assert itself as foreground, is hard to pin down, but it does seem to suggest that color travels as it radiates, which in turn suggests that color has some graspable pictorial substance of its own. Finally, Mondrian pulls it all together with rhythm, the painter's ultimate tool. *Broadway Boogie-Woogie* (plate 13) is a measure of all abstract painting.

It is here that Mondrian rattles the bones of human figuration for the last time; it is here that the white rectangle steps out of the background landscape into its own space. It is here that abstraction is truly born again. Mondrian has shored up the shallow space of abstraction so that color and shape can float freely; their extension in any direction, and of any duration, is fully supported. This is what Mondrian's paint-encrusted black bars did when they successfully spanned the surface of the painting: by spanning the pictorial surface rather than dividing it, the structural bars became the infinitely flexible and extendable supports of abstraction. These supports helped build modern pictorial space, replacing the traditional structural underpinnings of realism, the horizon line and the ground plane.

It is here too that abstraction may be able to find a cure for the redundant painterliness and sterile, self-limiting two-dimensionality that plagued abstract painting in the 1970s. Two of Mondrian's paintings from the 1940s, *New York* and *Victory Boogie-Woogie*, have the live-wire armatures, the hot-blooded structure both to support the collapsing space of shapeless materiality and to anchor the lightweight atmosphere of shallow, arcanely colored surfaces. With help like this, anything is possible.

A modest leap of the imagination will link Mondrian's late paintings with the famous drip paintings of Pollock, especially paintings like *Number 1, 1948* (fig. 6) and *Number 28, 1951* (fig. 29). What is interesting about this link is the way in which it shows us the marriage of rhythm and structure, the salient feature of *Broadway Boogie-Woogie* being repeated a few years later with what appear to be surprising results. From Mondrian's very tight and worked-over painting came Pollock's very loose and expansive painting, painting in which everyone could discover "freedom."

This link manifests itself in the playing off of various pictorial elements against each other in both Mondrian's late paintings and Pollock's drip paintings. The rhythm of sensation and mass (color and pigment) mingles with the beat of descriptive two-dimensionality, where the moving line dressed as a black bar defines a plane, and the moving plane, in turn, defines a volume. In this dance abstraction may discover its potential to overcome modernism's spatial inferiority.

There is no doubt that Pollock, like Mondrian, enlarged the space available to abstraction by spanning the surface of painting with his enameled tracery. But how is this tracery tied to the edges of its support? Can the paint skeins be self-supporting? Do they float from the edges of the picture surface, or do they float in front of them? We cannot help noticing that these are the same questions that come to mind when we confront Mondrian's grids, as in *Composition in White, Black, and Red* (1936; plate 14). It seems possible that what we can say for Pollock's tracery we can say for Mondrian's gridwork. In any event, we do not know exactly

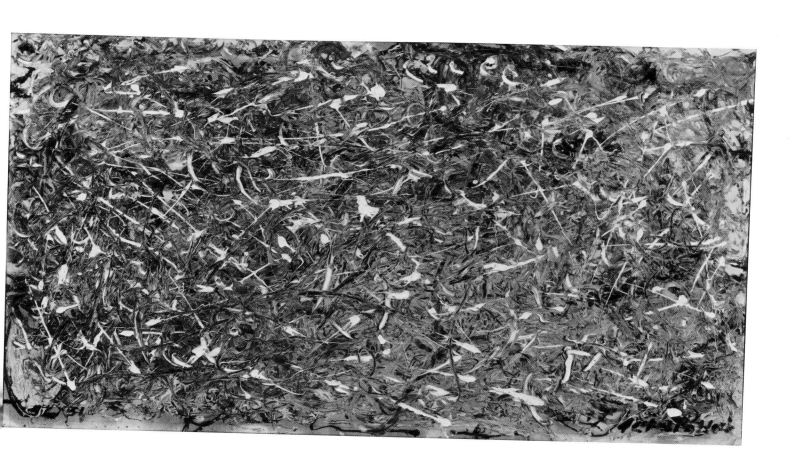

Figure 29 JACKSON POLLOCK
Number 28, 1951 (1951)
Oil on canvas, 30⅛ × 54¼ in.
Collection: Mr. and Mrs. David Pincus

how the enameled tracery is tied to the edges of its support. The paint skeins appear to do two things at once: first, they float, billowing up from the surface of the picture apparently attached only to the edges; and second, they float freely in front of those same edges parallel to their surface, apparently unattached.

The question of where the paint skeins are in relation to the painting's surface is an important one because it seeks to define the working space of abstract painting. The fact that this working space is defined by a contradiction which allows the paint skeins to be in two places at the same time should give us pause. The notion that we see the paint skeins sometimes on the canvas surface and sometimes floating in front of it leaves the space surrounding the skeins with an ambiguous but strangely compelling set of coordinates which essentially describes a location in motion. Here we have Pollock's tracery (plate 15) lifted free of the painting's surface, bringing loosened bits of the background with it. This lifting is close to the final twist. Up pops the ghost of the draped figure (plate 16), which had been caught and partially hidden in the webbed extravaganzas. She surprises Pollock so that he grabs his black-and-white baton (silhouette and ground) for support. As he regains his composure, he turns his stick into a weapon, prodding her back into the painting's surface, thereby reenacting the ring-around-the-rosy of twentieth-century painting—abstraction and realism chasing each other's tail.

Perhaps the one thing Pollock really could not do was to break with the easel picture. When Mondrian realized that the freeing of his spanning grid had the simultaneous and equivalent effect of freeing the background, he put these discoveries to work in *Broadway Boogie-Woogie* and *Victory Boogie-Woogie,* but he did not live long enough to face, as Pollock had to, the inevitable consequences of these ideas. It is certainly possible that Pollock never saw that Mondrian's

grid could be "in front of itself," and that paintings like *Blue Poles* and *Autumn Rhythm,* which seemed so expansive and so surely to be pointing to a wider vision, were anomalies. But we have to wonder, because it seems wrong to sell Pollock's talent short.

In the end, it was left to Barnett Newman to break definitively with easel painting and to account finally and determinedly for the emergent binocular vision of twentieth-century abstraction. It is a vision that gives us more room, confirming the potential spatial fecundity that Mondrian and Pollock suggested when they made us realize that with our two moving eyes we could sense more than one spatial location at a time for shapes and their silhouetted backgrounds. The marvelous thing about this is that through the magic of abstract art we can almost digest this space as one experience, with one stare. But herein lies the rub: abstraction has, no doubt, enlarged our vision, but Picasso's realism still challenges us to strengthen it.

———————————————————

In order to understand Picasso's realism of 1920, it is helpful to take a quick look at some of the momentous painting preceding it. Picasso's *Still Life with Chair Caning* (1911–12), Kandinsky's *Painting with Black Arch* (1912), and Malevich's *Black Cross* (1915) are representative examples of the pictorial intensity from the second decade of the twentieth century. The differences among these paintings are obvious; each declares its individuality in terms of identity and purpose as clearly as we could wish. What may not be so obvious is that they have a common goal: all three of these paintings strive to be real. Yet one of these paintings is at a tremendous disadvantage when it comes to converting paint on a brush into reality on a surface.

If the problem were posed as a quiz, asking which painting of the three would have the most difficulty shedding the restraints of illustration, most of us would answer Picasso. Some of the more clever might choose Malevich on the grounds that a search for fundamentals is bound to be

Plate 13 PIET MONDRIAN
Broadway Boogie Woogie (1942–43)
Oil on canvas, 50 × 50 in.
Collection: The Museum of Modern Art, New York
Given anonymously

Plate 14 PIET MONDRIAN
Composition in White, Black, and Red (1936)
Oil on canvas, 40¼ × 41 in.
Collection: The Museum of Modern Art, New York
Gift of the Advisory Committee

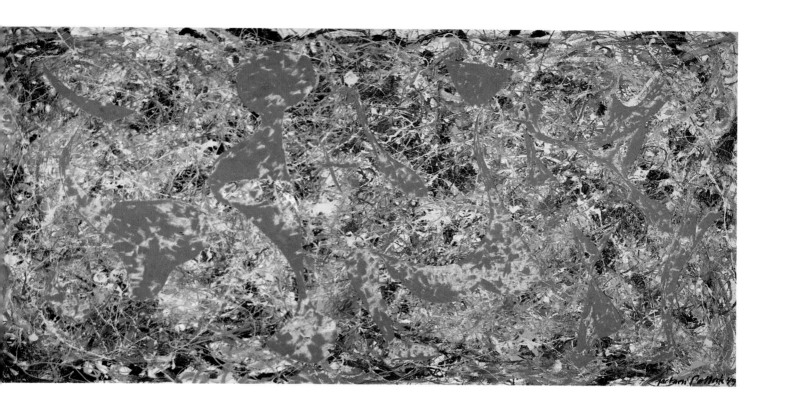

ate 15 JACKSON POLLOCK
ut of the Web: Number 7, 1949 (1949)
il and enamel on masonite, cut out, 48 × 96 in.
aatsgalerie Stuttgart

Plate 16
Wall painting frieze (c. 50 B.C.)
Villa of the Mysteries, Pompeii

expressed in terms of illustrational generalities; but few would guess Kandinsky. However, it now seems clear that Kandinsky was the one who was disadvantaged in the struggle to be real. In their acceptance of materiality, Picasso and Malevich both came to terms with the surface of painting. In a casual manner they could make concrete the efforts that contained their notions of observed and ideal reality. Both Picasso and Malevich were able to make pigment coincide with their convictions about pictorial presence, to paste their vision on a temporary portable surface, creating in the process an amalgam that we now perceive as a permanent, fixed surface for art. They troweled pigment onto a self-sustaining surface which they had willed into being.

Toward this end Kandinsky is never as convincing as Malevich or Picasso. He never seems to push the paint as hard; he never seems to penetrate the surface as successfully. Consequently his efforts never seem as engaging or as real as those of Picasso and Malevich. He always seems to be giving us a picture or an illustrated abstraction of what Picasso and Malevich would have made into an immediate physical reality.

Although this assertion might appear to demean Kandinsky, that is not my intention. The freedom from materiality that Kandinsky sought was an important freedom, one that expresses what painting today so sorely lacks—pictorial expansiveness. Kandinsky came to his sense of expansiveness indirectly. In trying to lighten and at the same time to color what he observed, Kandinsky formed a trenchant, pictorially useful vision of the unruly nature of sensory perception. He knew that what he saw and what he had an urge to depict were but small parts of an expanding whole, what we think of as a knowable universe. Yet he became as excited about what he could see, limited as it was, as he was about the opportunities for representing it when he realized that the limits to perception in art are largely self-imposed. He saw that by simply ignoring the stationary pose of the artist at work, the fixed point of view, he could set the orientation of his own point of view completely free. Instead of using his easel to prop up a window on the world, Kandinsky used it to support a windshield moving through the universe. We see Kandinsky in front of his easel, at the controls (fig. 30), confidently aware that both he and his painting are in motion.

Kandinsky always took a limited, planar slice out of the imaginary spherical whole that stands for our intuition of what we know and see. In this sense he always had to give us a picture of what he saw. It follows, then, that he had a very difficult time shedding his illustrational cloak. He was always separated from the action of painting by his point of view. On the other hand, the flexibility and maneuverability of his point of view opened up endless possibilities for painting. Malevich and Picasso gave us the hard reality of accomplished, incontrovertible material creation, but it is Kandinsky who gave us a bright, expanding vision which in turn gives us hope that we can revivify our dulled surfaces.

Picasso's *Seated Woman* (Paris, 1920; plate 17) has to be a shock to any person of refined sensibilities, to any person who prizes his "eye." In a word, the painting must shock a critical art audience, one such as ourselves. Yet to see how this shock works we have to separate working artists from the viewing public, because even though it is possible to imagine the public slipping into a stunned, placid silence, it is difficult to imagine a tempered reaction from Picasso's practicing professional competition, especially from those committed to abstraction, to what seemed to them to be the inevitable consequences of Cubism. To Mondrian and Kandinsky, Picasso's *Seated Woman* must have cast a dark glance backward. To an inveterate polemicist like Malevich, the aggressive spirit of Suprematism, Picasso's woman must have appeared as a reactionary icon, a stony, academic goddess gazing out over an impossible future. But surprisingly

Figure 30 Kandinsky in front of his painting *Dominant Curve*, 1936
Courtesy Musée National d'Art Moderne, Centre Georges Pompidou, Paris

enough it was Malevich, not Mondrian or Kandinsky, who was seized by the same enigmatic force of the past that beset Picasso.

The background that explains the seated woman of 1920 is Picasso's trip to Italy in 1917 in pursuit of Olga. Rome and Naples pretty much describe everything that goes into this seated woman; she is both Caravaggesque and classical. Her introspection and absorption derive their intensity from the mysteries of Pompeii, while her projective drama emanates from the fire of seventeenth-century Neopolitan painting, from the Caravaggio, Reni, and Ribera of Capodimonte. Her classicism, manifested in a Roman guise of monumentality and gigantism, springs from the fragments adorning the Capitoline courtyard.

This small picture gives the impression of introspection on a large scale, suggesting stolid bemusement fueled by a billowing, wistful remembrance of the excitement and potential brightness of Cubism. Painting sits painted in and into a dark corner. Picasso has taken another look at the past, a look back beyond the accomplishments of Cubism to reinforce his basic perception of painterly reality, which asks weight and mass to define the essentials of what we see. As a result he decides that he prefers distance and space to remain in the background, to remain discreet atmosphere. He does not want space to be the surface of painting; he does not want unnecessary, weight-reducing, trivializing notions of surface and space to dilute the force of pigment hand-driven to create a monumental image of art. Picasso feared that the future might dematerialize the past. He saw the artist's job as one of hardening and compressing pigment into a gesture posterity would find difficult to erode.

Although reworking was part of Picasso's working method, this seated woman seemed to give him a lot of trouble. This appears to be a painting that did not come easily. What is supposed to be so obvious and easy about representational painting—the manipulation of high contrasts, the deployment of light and dark—presents a rather awkward struggle throughout the bottom half of the painting. Confronted

with this overworked passage, the connoisseur in us is likely to say that this split, caused by the differences in handling between top and bottom, is what makes the picture. However, it could be that these differences are simply calling attention to a real problem. In any event, what happens to the bottom half of the toga brings out two obvious facts. Picasso knew that the past use of chiaroscuro was part of a general problem for painting, as witnessed by his quoting of Le Nain in 1917 in a pointillist mode, and he knew that the present use of chiaroscuro was part of a specific problem for painting, as evidenced by the struggle from top to bottom in this seated woman of 1920. Equally obvious, of course, is the fact that Picasso could not or would not ever desert the contrary alternative, the other structural part of the problem for painting—the abstract, planar, dimensionally impoverished modality of Cubism. Nonetheless, the seated woman, whether through ignorance or omniscience, gives us the impression she knew one thing for sure: that the planar mode would never again dominate. She believed that from 1920 on the image of art would be wrapped in the swaddling cloth of volume and mass fashioned from the remnants of classical drapery, the drapery once entwined about the initiates of Pompeii and the mythologies of Guido Reni, the same drapery later to emerge from Pollock's webbing.

This description of the seated woman's prophetic vision holds itself within the bounds of critical thought, but there is a further extension of her vision that cuts into the real world in an unsettling way. There is a brutal simplicity in this painting, an echo of imperial Rome and seventeenth-century Naples, which makes Picasso seem both cruel and clairvoyant at the same time. Picasso's view of the past, his view of Western culture as seen through the medium of his experience of art in Italy in 1917, denies all of the highly prized subtlety and complex genius of what grew to be the combined greatness of Western and Italian painting. Picasso has seized upon the most blunt, dull, and obvious mechanics

of art making to succeed his investigations, his inspired discoveries of Cubism. How could he see a future for the broken, empty, blank monumentality of imperial statuary? How could he see a future for the cliché of chiaroscuro, especially in the aftermath of Cézanne and Monet?

Two things stand out. One is the idea that "what's good is good." Picasso knew what every father preaches: the fundamentals will never let you down. The other is that innovation must remain a mirage. Picasso taught himself the difference between progress and change; he saw that in the aftermath of necessary change, progress was slow. There is in the seated woman an expectation that for painting to continue, a strong base must be built. Picasso declares that pictorial strength must always be made explicit, that weight and volume, light and dark must be clearly present, especially if painting is to meet its future intact.

At Royan in June of 1940, the *Woman Dressing Her Hair* (plate 18) came to realize everything that the seated woman of 1920 had foreseen. The fundamental barbarity of Fascism is portrayed here in a fusion of obtuse Roman imperialism with the bigoted savagery of Naples. In Italy in 1917, Picasso came to a view of the past emphasizing the primitive fundamentals of pictorial invention which both supports and constrains our efforts to this day. In classical Rome he found the encouragement to petrify pigment, to give it an enduring, stonelike weight. In Naples he was reminded of the power of light and dark to reveal action, to encapsulate stroke, to immortalize gesture. With this recycled power in hand, Picasso was able to block out a convincing space for modern pictorial drama.

"What saves me is that every day I do it worse," said Picasso, and he was not joking. If we look at the mother of the seated woman of 1920, the *Seated Female Nude with Crossed Legs* (1906; plate 19), we see the beginnings of a progression of similar work which spans the generations from mother to daughter to granddaughter—from the *Seated Nude* (1906) to the *Seated Woman* (1920) to the *Woman Dressing Her Hair* (1940). The progression seems to trace a history of self-parody; each painting threatens to become a rehash of what had come before, beginning with a monumentally dull restatement of Cézanne, continuing on through a retreading of Italian art and all of Western visual culture by association, and finally ending in a restyling of Cubism as a kind of aggressive, semiabstract, new realism. In front of our eyes, Picasso keeps his word. Indeed, from generation to generation he makes it worse, yet stunned as we are we manage to applaud.

In the 1928 painting *Girls in the Field* (plate 20) Malevich follows Picasso in an uncanny way, echoing Picasso's basic concern about the depiction of weight and volume at the expense of planarity. Malevich seems also to be very concerned with difficult, old-fashioned pictorial problems such as shading and lighting; in this painting he tries to do it in the manner of Picasso, lighting the features and clothing of his peasants from different, contradictory directions. While Picasso sought to hold onto a dark strength from painting's past, Malevich was seeking to project the mechanical core of that strength into the future. Picasso's disregard for the future, his disinterest in his successors, his total involvement in the issue at hand make his accomplishments seem more definitive and impenetrable than perhaps they really are. If we look at Malevich in 1920 we see a confusion in the face of growing pictorial problems, but the struggle takes place within an aura of bright hope; everywhere the pigment radiates a sense of positive direction, whereas Picasso's seated woman seems to drift off on a gray mental cloud, pointed toward some random assignation.

Kandinsky easily avoided the gravity of the situation that overwhelmed Picasso and Malevich in 1920. One way or another Kandinsky kept things moving, kept painting in motion. He evaded the problem that Picasso and Malevich thought so pressing. Kandinsky was never worried about

Plate 17 PABLO PICASSO
Seated Woman (1920)
Oil on canvas, 36¼ × 25⅝ in.
Musée Picasso, Paris

Plate 18 PABLO PICASSO
Woman Dressing Her Hair (1940)
Oil on canvas, 51¼ × 38¼ in.
Collection: Mrs. Bertram Smith, New York

Plate 19 PABLO PICASSO
Seated Female Nude with Crossed Legs (1906)
Oil on canvas, 59½ × 39⅜ in.
National Gallery, Prague

Plate 20 KASIMIR MALEVICH
Girls in the Field (1928 and 1932)
Oil on canvas, 42⅛ × 49⅜ in.
Ministry of Culture, Moscow

guaranteeing pictorial reality; he never believed that painting lived or died with the viewer's conviction that in looking at painting one must have a convincing, palpably real experience. While Picasso and Malevich had something to prove, Kandinsky had something to suggest. He argued that painting should not become bogged down in the creation of concrete, monumental artifacts. He used his antimaterial, antisculptural bias to insist that painting develop its own sense of motion, that it concentrate on moving its component parts and the accompanying space around them.

The *Red Oval* of 1920 catches Kandinsky at a wonderful moment, working in Russia in the midst of a turbulent, productive art scene. The first thing that engages our attention in this painting is not the red oval but the yellow quadrilateral that surrounds it. Kandinsky's yellow quadrilateral is a reference to Malevich's *Yellow Quadrilateral on White* (1916–1917). With impish abandon Kandinsky has converted Malevich's industrial rug into a magic carpet; he transposes the floor covering of nascent modernism into a tapestry, outlining its future development. If one looks at the two paintings side by side, it is not hard to see that Malevich's *Yellow Quadrilateral* serves as an outline for Noland's diamond-based stripes and chevrons of the 1960s, while Kandinsky's *Red Oval* gives a premonition of my own reliefs of the 1970s. This is a slight reversal of our expectations. If anything, one would have expected the concrete sensibility of Malevich to show up in my literalist work, just as one would have expected the antimaterialist feeling of Kandinsky to come through in the color-weighted abstraction of Noland.

One thing this dichotomy might suggest is that Malevich's painting of 1917 was the ultimate expression of a planar ambiguity fostered by Cubism—an ambiguity that was causing doubt and concern for all of the best painters across western Europe. By 1920 Picasso and Malevich were beginning to question the weightlessness of the two-dimensional plane itself. Kandinsky seemed to share the same worry, but instead of turning to a mode delineating volume in an exact, literal way, he emphasized the ambiguity of the plane and launched it smartly into the pictorial space of the future.

Of all the things that dog the ambition of abstract art in the twentieth century, illusionism seems to be the most sticky item. Everyone has had his say about the mechanical aspects of illusionism that have retarded modernism's growth. Everyone knows that the future belongs to surface and color, self-generating and self-sustaining abstractions bound together in an undeniable presence that makes itself felt as art. Everyone knows that illusionism gets in the way of an uncluttered, pure expression of surface and color. But everyone also knows that the few rare moments of uncluttered, pure expression of surface, say Malevich in the distant past and Louis in the recent past, enjoy their success not on the basis of what they leave out, but on the basis of what they put in. Malevich and Louis are convincing not because they eschew the illusionism of the past, but because they incorporate an important, fragile aspect of that illusionism—an aspect that contains a different, more ephemeral, but ultimately necessary kind of illusionism. It is the illusion of vitality that sustains painting. This is the illusion without which painting cannot live.

Still, it might be argued that the illusion of life in the art of the past actually resides in the devices of mechanical illusionism that abstraction is so anxious to abandon. It is hard to find a better example than Picasso to illustrate the vitality ingrained in the traditional mechanics of illusionism. But then, nearly anything we say about Picasso's classical bathers can be said about Malevich's 1920 *Girls in the Field*. What we see in Picasso and Malevich are three traces of mechanical and psychological illusionism which abstraction in the person of Malevich hated to leave behind and which realism in the person of Picasso could not give up. The embodiment of these leftovers, the albatross of semiabstraction, was a reality in 1920 and is still flourishing in the 1980s.

The first gift of illusionism that modernism wants to reject is the pictorial illusion of three-dimensionality. It is obvious that three-dimensionality carries our basic notion of visual reality, anchoring our perceptions. In painting, volume is suggested by shading, which in the past combined light and dark contrasts with subtlety and effect. But in the twentieth century, in the drive toward literalism, shading became brutal, almost ugly in effect, testing our tolerance for "bad," naive technique. For a time in the 1960s abstraction had largely eliminated the device of shading, but something has brought it back. The temptation is to say that the return of shading is a misbegotten revival, a desperate attempt to shore up a popular taste for pictorial realism. However, a more generous view might be that the elimination of the sense of volume and mass in pictorial representation simply creates a void that ultimately must be filled. The progressive wing of abstraction has only deferred the day of reckoning; it is clear that abstraction has to come to terms with volume.

The second benefit of illusionism that modernism struggles to do without is the space created between the objects which are rendered successfully in three dimensions. In effect, the intangible gift of shading is the space created around the objects it represents. Malevich obviously likes what happens in the pictorial space behind his peasants. Traditional illusionism is good at creating what abstraction often lacks—interior space.

In addition to volume and interior space, abstraction must pick up on another aspect of illusionism: its success at caricature, at catching everyday associations, recognizable sparks of life. In a sense, abstraction has to humble itself. It has to realize that although the gesture of creation may be real and direct in execution, as realized art it lives only as a representation; it will never be as literal or as independent as it dreams of being.

One thing that seems clear about all three of these aspects of illusionism—the successful depiction of volume, the creation of interior space, and the power of caricature—is that they are very comfortable in a realist pictorial setting. Because they lend themselves to a limited, bounded mode of pictorial expression, they are easily accommodated as a picture. Thus they create a relaxed situation for realism, but an anxious one for abstraction. It is possible that the stubborn necessities of realism suggest that the expansive literalism of abstraction may not be suited for pictorial expression. Abstraction cannot accept limitations graciously; it refuses to tolerate the pictorial boundaries so comforting to semi-abstraction. It has no stake in the continuous surface that guarantees wholeness for conventional art. But abstraction must find a way to expand the boundaries willed by the pictorial past. It has to create a working space in which both the limits and the accomplishments of the past can be envisioned as expanding in a meaningful way under the pressure of our everyday efforts.

A Common Complaint

A common complaint holds that abstraction is emotionally impoverished. We often leave abstract painting wondering if we have seen anything worth seeing. It is a legitimate question, especially so if we acknowledge that our aesthetic instincts are rooted in the pictorial art of western Christendom, an art that has always made its mark by supplying meaningful information in the guise of aesthetic effort. Still, merely posing the question highlights a basic confusion confronting the viewer. The truth is that we expect to experience something worthwhile in the face of the general run of art, while in the face of great art we anticipate something definitive. This declaration explains how our accumulated experience bears on our expectation of new experience, accounting for much of what we bring to painting and helping to define what we expect from it.

More of a conceit is revealed here than we like to admit. We imagine ourselves as innocent in the face of painting, and we are quite upset when it disappoints us. The knowledge that abstract painting is relatively new and that its terms of self-definition and ambition are quite different from the art of the past is small comfort. The excitement of the pictorial past haunts the invention of the pictorial present.

Probably the most annoying characteristic of abstraction is its tendency to defend and explain itself in terms of problems. We assume that if pictorial problems have to exist at all they should be buried, or at least subsumed by an overall pictorial image whose force leaves us satisfied. We expect to experience aesthetic fulfillment on a level that denies the necessity of understanding complex pictorial mechanics and qualitative distinctions. While this attitude certainly makes a good definition of an ignorant, know-nothing pictorial sensibility, it also makes a good start at describing what great art actually does. At its most exhilarating moments,

great art is manifestly indifferent to the niceties of composition and the issues of quality; however, even in the midst of these moments it is never indifferent to the creation of viable pictorial space, the vehicle of motion and containment. This is the bone that the viewer's inspired ignorance will inevitably choke on. Great painting will sweep us away knowing or unknowing, but if we do not know where we are being swept to and from it will all be for naught.

It is assumed that the expressive force of the great painting of the past overcomes any necessity of acknowledging its continually problematic relationship to the growing organism of art history; that its true value lies in this victory over the past, which is in itself a definition of pictorial greatness. There may not be any worthwhile purpose in denying this assumption, but it is clear that it is very hard to articulate the sense of value we feel in front of great painting without explaining the problematic nature of a painting's own internal relationships of discovery and creation, as well as its developing external involvement with the whole history of art. This seems particularly true of twentieth-century abstract painting, where so much explication still seems necessary just to identify the expressive force that we sense in front of great painting. With Kandinsky and Mondrian, for example, it appears that only pictorial dynamics are at hand. Human dynamics—something we could readily identify with, something that would really touch us—seems unavailable, essentially remote to abstraction. The loss of this added, somehow necessary element creates a sense of despair.

Titian's *Flaying of Marsyas* (plate 21) and Caravaggio's *David and Goliath* (plate 22) are examples of painting from the past that do what we are afraid twentieth-century abstract paint-

ing will never be able to do: they are able to hit us with a pictorial force that we feel is independent of explication, and as such they are in no way dependent on illustration. In other words, their pictorial force completely subsumes any sense of dependence on pictorial technique.

One thing that these paintings have in common is their brutality. It may be that their florid sadism springs from a perversion hidden in the creative process. Certainly this thought comes to mind as both paintings declare their greatness at the expense of their immense effort and complication. By exploiting the dramatic potential of depicted savagery, these paintings put a tremendous burden on the immediate viewers. The savagery in these paintings cuts two ways: on one hand, it reveals a pictorial force so obvious that we can all see and share it; on the other hand, it demeans its own effort by denying to our understanding the importance and even relevance of each painting's component subtleties. In effect, this savagery challenges us by scrambling our equilibrium. Suddenly perversion dominates pictorial effect, and indifference rules both compositional nicety and aesthetic quality. We begin to ask ourselves if some of what we want from the great art of the past might not be worth leaving there. But it cannot be that easy. Wrapped in the expressive fabric of these paintings are the pictorial problems that we want at the same time to avoid and to solve—the articulation of surface and the creation of space. In order to grow and endure, painting must understand the mechanics of its expression.

The surprising thing about these paintings is that these familiar involvements should create such panic in the vision of artists, that surface and space should engender images of flaying and decapitation. A more normal explanation would reveal the causes of erupting pictorial brutality in our individual and collective psyches, showing that art is merely a mole betraying our interior selves. But within the enterprise of making art itself, this largely descriptive, commonsense explanation begs the questions of growth, discovery, and purpose, questions which the artist accepting his role as a creator cannot avoid. The artist is alert to the terrors of second-hand creation, his inevitable and undeniable role; he senses that he is a contradiction, a puppet-creator, half flesh, half wood, inflecting lines with tendons pulled by external strings.

In the *Flaying of Marsyas,* a painting of uncontestable gruesomeness, Titian appears to lay bare the steel heart of the sixteenth century, to show up the Italian Renaissance for what it really was—progress at a tremendous, barbarous cost, not unlike our view of the first eighty years of the twentieth century. The ideals of classic paganism and humanized Christianity are reduced to a bloody, blotted amalgam. Yet there is something about this painting that objects to a generalized view, almost as if it protests any dilution of its assaultive brutality. This picture forces us to take it personally, to identify it as a personal statement by Titian, first about himself and second about anyone, including ourselves who would hope to succeed him as an artist. This painting is more accurate about showing the personal costs inherent in the mechanics of painting than it is profound about describing the human condition in sixteenth-century Italy. By stripping away a surface created by the artist's gifted touch, Titian reveals the blood-filled sinew and bone of pictorial technique, showing us how difficult it is for the artist to nurture and manipulate the body of his creation without mutilating it.

Although he admitted he had never seen the painting in the flesh, Panofsky objected to it anyway, arguing: "It is admittedly difficult to attribute this painting to anyone else (although in view of the *Pietà* in the Accademia one might think of the very versatile Palma Giovane); but it is equally difficult to accept Titian's responsibility for a composition which in gratuitous brutality (the little dog lapping up the blood) [fig. 31] not only outdoes its model, one of Giulio Romano's frescoes in the Palazzo de Tè at Mantua . . . but

Figure 31 Detail of Plate 21 (Titian, *Flaying of Marsyas*)

also, and more importantly, evinces a *horror vacui* normally foreign to Titian, who like Henry James' Linda Pallant, 'knew the value of intervals'" (Erwin Panofsky, *Problems in Titian*, New York, New York University Press, 1969, p. 171).

This objection raises some interesting points. In the first place this painting is more than gratuitously brutal; it is overwhelmingly brutal. As I stood in front of the painting in London where it was recently on view, it was almost impossible to focus my attention. I glanced at the painting, then quickly turned my head down and away, averting my eyes. I was only able to look up in snatches, picking up isolated sections of the painting here and there. The idea of studying a picture of such cruelty became embarrassing. Naturally, my first reaction was to blame the anxiety on the proximity of other viewers, but then it seemed more than that. I realized that if the crowd disappeared I still would not want to face the painting. The reason for my distress now seems obvious, and I think that it may account in part for some of Panofsky's uneasiness as well. If painting as a manifest, tangible, consuming enterprise is really a part of our life, there is no way we can face up to Titian's assault. In this instance the brutality of a collective society and a collective psyche cannot be laid off; it is too well focused on the artist and the act of making art. Panofsky's sympathetic defense was to deny Titian's authorship. My defense was a cranky vision in which neophyte art students were forced, eyes open and uplifted, to kneel for several minutes in front of the *Flaying of Marsyas* in an attitude of uncomfortable, prepaid penance.

Although this might appear to be a peculiar reaction to a powerful work of art, it nonetheless acknowledges Titian's intentions. He clearly meant for us to understand the perils faced in a lifetime committed to the making of art. For the professionals who were to follow him, he warned that the artist's gifted touch would violate, perhaps irreparably, any surface that it graced. He showed that the articulation of surface can be as destructive as it is creative, that a blurred,

pulsating surface often announces the exhaustion of space. It may be that this is part of what Panofsky sensed when Titian's pictorial intervals shrank under his inspection.

This painting has been seen as an extended metaphor depicting the triumph of high art, in the person of Apollo, over low art, played by the victim, Marsyas. The whole scene is witnessed by King Midas, whose features here form Titian's self-portrait. It has also been seen as alluding to the Redemption, with Marsyas as a crucified Christ and Apollo as the risen Christ. There is no reason to challenge these views of Titian's painting, but there is reason to consider as well a view that sticks closer to home. We are looking, after all, at a painting made by a painter surveying a career of perpetually successful work. It is not unreasonable, therefore, to see him telling us something about himself, his endeavor, and its future. Painters, even though their chances of breaking out of the cocoon of the present are no better than anyone else's, are more interested in the future than we might guess. Titian shows us a concern for painting beyond the usual worry about individual success and immortality. He shows a concern for the future which points out all the brutality and vulnerability inherent in the endeavor of painting. Yet in front of the *Flaying of Marsyas*, we want to believe that beauty of presentation overcomes the cruelty of revelation. We concentrate on our knowledge that the artist is blessed, that while he works, he remains at least one step removed from reality. As a result we prize the pulsating surface, the work in flux, the unconsummated suggestion because they obscure the finished cruelty, the immediate gesture of sadism. We pretend we are interested in color, in brushstrokes, and in overcrowded composition, but in the face of this painting it does not work. The sham is obvious.

In the end we are left like Midas and Titian—bewildered, involved observers wearing asses' ears for undefined sympathies, unsure whether we have been witnessing necessary

urgery or gratuitous torture. The skin of a defeated artist is cored and peeled away, his body is openly violated to reveal he anatomy of pictorial creation rather than the details of uman suffering.

Roughly thirty-five years later, near the untimely end of his areer, Caravaggio gave us another equally unsavory view of n artist's summation of his experience in art, here forcefully ombined with his view of the future assumed in that summation. Titian, naturally enough, expressed his vision in erms of pictorial surface, while Caravaggio followed suit in erms of pictorial space. Both knew and expressed what nodern painting agonizes over today: that disembodiment the crucial element in making the success of painting. o put it another way, there has to be a convincing exchange f vitality between the viewer and the painting if both are o live, and the truth is that this is a risky transplant of enrgy, one that is constantly threatened by systemic rejection. However, even this radical surgery is not enough: both aravaggio and Titian call our attention to a subsequent peration which must be endured to ensure the vitality of rt—the transfer of responsibility between generations of reative artists.

n Titian's *Flaying of Marsyas* this concept is an implicit overre; in Caravaggio's *David and Goliath* it is an explicit decration. There is no mistaking the message of young David's isplay of the older warrior's head. To see this painting only n the level of a victory of good over evil, or the eventual iumph of Christianity over paganism, is to ignore the nessage the artist sends about his personality, his craft, and neir common endurance. The ultimate strength of this ainting rests on its insistence in telling us about the durality of painting in the face of the corrosive threats of the rtist's individual personality. All the things that make this ainting so revealing in terms of psychology have to be arnessed to the gait of pictorial impact—an impact that is nmediately felt and perpetually recoverable. It is the nerve f this sensation that Caravaggio touches today. *David and oliath* gives us an intuition that great art can do more than

provide an example of its own greatness; that its sense of continuing usefulness can, in fact, supply something like the notion of reproducible proof we prize so highly in other areas of human thought.

By offering us the elevated, protruding head of Goliath, Caravaggio freed the encrusted pictorial space that Titian was beginning to pierce at the end of his life. In passing he melded the Gothic and Renaissance sensibilities of western Christendom into a pictorial space which continues even now to absorb us. If we imagine a single Renaissance vanishing point moving toward us, encircling the condensed pictorial experience of the past, we can see it transformed at the limits of our focused recognition into Caravaggio's face. As we register this perception we see Goliath's head (Caravaggio's pictorial will, as it were) pass by us as an exploded point about to disperse itself into a continuum of movable pictorial space, going beyond us to create the space of our pictorial present and future.

If this view of human pictoriality seems too far-fetched, perhaps we can see Caravaggio's suspended, rotatable head absorbed into the present in a more palatable, rational way. If we keep Caravaggio's face in mind as a suspended point comprised of a condensation of our pictorial past, we can see it beautifully integrated into the art of the present in Stanley William Hayter's powerful account of Kandinsky (*Magazine of Art*, May 1945). He points out that

so far Kandinsky's use of space has been discussed as a static frame in which pictorial elements could be organized, but the interrelation between these elements and the space in which they are presented cannot be ignored. It should be obvious that such relation must modify the space itself, that a point in a closed volume sets up tensions throughout the volume, that the antithesis between space and object is illusory. When, as the development of movement as flow or direction in his work evolved about 1920 into the integration of motion in the space, that space acquired a further series of dimensions.

Hayter continues with a wonderful, succinct account of Kandinsky's genius:

In the traditional art of the West motion had been represented almost exclusively as arrested; depicted as that position of an object which called for a conclusion by the observer as to its consequence. Kandinsky, however, figures motion as an element itself without invariably representing that which moves or has moved . . . Sometimes a series of points, traces like trajectories or orbits describe this movement; often an unbalance of tension between the forms demonstrates the motion. (p. 177)

My reason for introducing Kandinsky as an aid in understanding Caravaggio is not as arbitrary as it may seem; it is the same reason that a painting as profound and savage as Titian's *Flaying of Marsyas* still has to be seen as a meditation on the life of an artist engaged in a struggle with surface and touch. If it were not seen in this way—or if Caravaggio's *David and Goliath* were not seen as an essay explaining a lifetime involvement in the creation of projective, spherically informed pictorial space—these paintings would be understood merely as successful illustrations. They would not reveal their true and purposeful aim as painting—painting as self-contained art rather than as moving, edifying narrative craft. They would not realize the difference that creates the continuous soul of art, the difference between realized, immediately available visualization and after-the-fact representation. It could be argued that it is not necessary to be so literal about the mechanics of painting, that Titian's *Flaying of Marsyas* meets these criteria on the level of allegory, vividly encapsulating the contest of high art against low art. But allegory is only metaphor; it keeps its distance, and it does not really clarify the distinctions between art and illustration, between visualization and representation. In addition, unappealing as the thought may be, it is Titian's primal engagement with the physicality and the manipulation of pigment that creates the clarity necessary for artistic progress. Metaphor merely signifies a temporary location for painting—its humble origins.

The connection of the past to the present should not be seen defensively, and it should not be seen as diminishing any of the sustaining and projective power of the past. Caravaggio could not have known what Kandinsky's painting would look like, but he surely knew that the painting of the future would be contained in a pictorial space capable of being surveyed from within by a rotatable, live eye that could see 360 degrees in any direction. His problem was that he could not imagine this freedom except at a great cost—in this case his own head.

David pushes Goliath's dismembered head at us as he pushes it at Caravaggio to remind us that we should not separate the artist from the mechanics of his work, from the structure of his art, and to remind Caravaggio himself that it is the body of his own work that he will be judged by, not the body of his hysterical psyche. But more than this, both we and Caravaggio are confronted by the nightmare of the management of pictorial space. As Hayter points out, the antidote, the first, initially reassuring step, is obvious enough. Painting wants to deal with the modification of pictorial space in a closed volume. In a sense, since a point in a closed volume sets up tensions throughout the volume, we are already moving toward a solution. By exploiting this possibility, Caravaggio's head of Goliath creates articulate, expressive pictorial space.

But as Hayter enlarges his description of the potential for movement in Kandinsky's space, it becomes harder for Caravaggio's head to follow. The contentions that in the pictorial space of abstraction the antithesis of space and object becomes illusory and that the integration of motion in space allows space to acquire a further series of dimensions begin to lose us, testing our comprehension as they challenge Caravaggio's pictorial cosmology—although in Caravaggio's defense it could be argued that an elision of space and object is implied, and that, furthermore, the body of pictorial space actually does support the severed head of the self-vanquished artist. In a similarly forced vein, the glance of David can be seen as a different, distinct, continuing extension of time

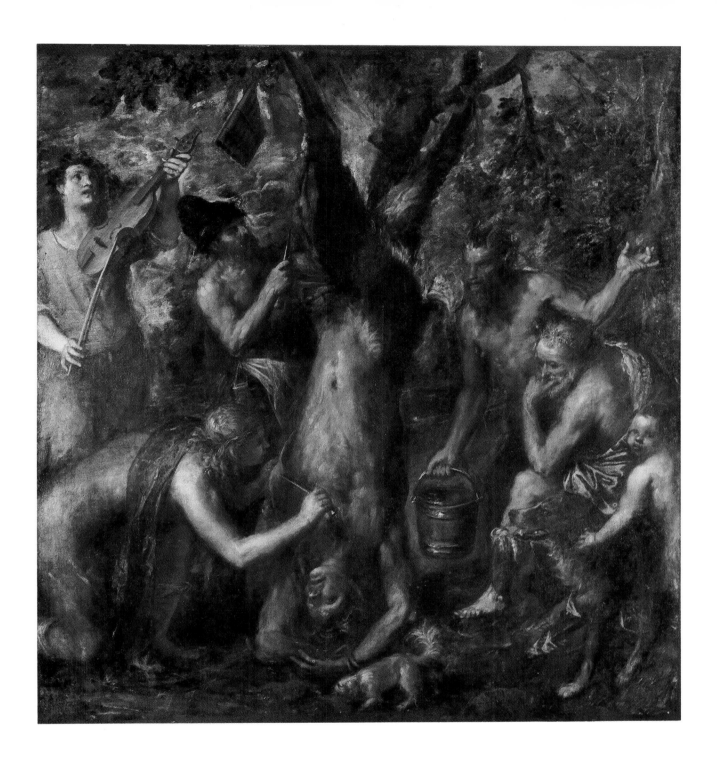

Plate 21 TITIAN
Flaying of Marsyas (c. 1570–76)
Oil on canvas, 83½ × 81½ in.
State Museum, Kromeriz, Czechoslovakia

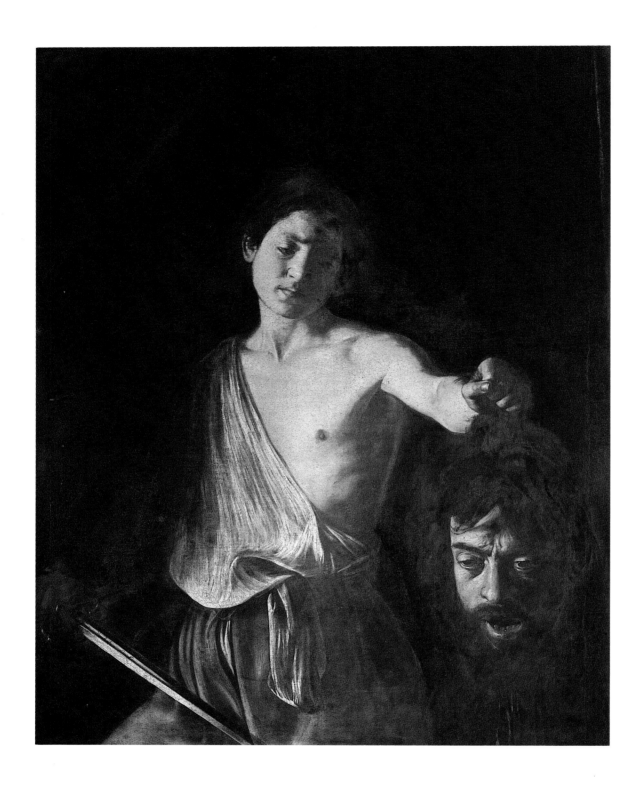

Plate 22 CARAVAGGIO
David and Goliath (1610)
Oil on canvas, 49¼ × 39⅜ in.
Galleria Borghese, Rome

Plate 23 WASSILY KANDINSKY
Ambiguity (Complex/Simple) (1939)
Oil on canvas, 39⅜ × 31⅞ in.
Musée National d'Art Moderne, Centre Georges Pompidou, Paris

Plate 24 WASSILY KANDINSKY
Composition IX (1936)
Oil on canvas, 44⅞ × 76¾ in.
Musée National d'Art Moderne, Centre Georges Pompidou, Paris

at odds with the fading temporal measurement expressed in the disjointed vision of Goliath, where one eye is fixed while the other forces a last blurred look at what it had experienced as reality. However, when Kandinsky begins to figure motion as an element in itself, without representing what moves or has moved, he seems to have confounded the past, to have put himself beyond Caravaggio's desperate stare.

Looking again at Hayter's account of Kandinsky in the context of the genius of Italian painting, it is hard at first to imagine how an unbalance of forms demonstrates motion, and how in turn a series of points successfully describes motion. The notions tend to become abstract in a mathematical rather than a pictorial sense. Still, there is something about great Mannerist painting, culminating in the pictorial force of Caravaggio and Rubens, that accommodates itself to these notions. Furthermore, there is something intriguing in itself about motion being generated by an unbalance of forms; it holds our interest in the way that the generation of energy from fluctuations of temperature in ocean water might. Somewhat more to the pictorial point, though, is the thought that the head of Goliath can be sent spinning by the force implied in the multiple, moving visions caught by the glances within and outside of the painting—glances from the eyes of David, Goliath, and Caravaggio perpetually reactivated in the eyes of successive viewers, glances whose energy turns the perfectly poised head of Goliath suspended from David's hand the way air currents almost automatically turn a Calder mobile suspended from its fixed point.

There is a pedestrian quality to the incessant defense of abstraction against the accusations of emotional impoverishment; yet this constant argument does occasionally yield fruitful results. Sometimes when we are forced to look around to try to see things differently, newer, more varied insights present themselves to us. In a sense, if each new generation must doubt Kandinsky, perhaps we will keep learning more and more about Kandinsky as new connections to the past, new relevances for the present, and new hopes for the future emerge. Nonetheless, it does seem annoying on the face of it that Kandinsky must be defended. The truth is my argument that Kandinsky is an apt and committed successor to the work of Titian and Caravaggio on a deep and brutally realistic level will convince none of the detractors of abstraction, and for that matter, probably few of its advocates. In terms that are simple, but sometimes difficult to deal with, the detractors of abstraction deny its connection to the past, while its adherents often celebrate this broken connection as invention.

Kandinsky's lowest moment was reached in London on Tuesday, June 30, 1964, at 9:30 P.M., precisely as the catalogue directed. The preface for the sale catalogue written by Sotheby and Company tells the story:

The late Solomon R. Guggenheim, benefactor of the Museum, collected no less than one hundred and seventy works by Kandinsky during his lifetime. Many were bought directly from the artist himself.

The Guggenheim Foundation has, on numerous occasions, exhibited some of these paintings, or sent them on travelling exhibitions throughout the world. However, it has always been impossible to show the collection in its entirety owing to lack of space.

Taking this into consideration the Trustees of the Foundation have decided to offer fifty paintings by Kandinsky for sale rather than keep them in the vaults of the Museum. They have taken care to choose the best examples from each period which could be released without diminishing the standard of the Museum's permanent collection.

There is an amusing echo here of Hayter's perception about Kandinsky's painting. We can imagine that the lack of space alluded to by the Guggenheim was caused at least partly by the pushy tendency of Kandinsky's pictorial space to acquire a further series of dimensions as it integrates motion in space. Another item that catches our attention is the conflict about value revealed in the notion of offering for sale the contents of a vault while at the same time maintaining a standard by diminishing the collection.

Still, the Guggenheim trustees do not deserve any special credit for their inability to appreciate Kandinsky's value to the future. In 1964, at perhaps the apogee of American abstraction's worldwide success, there was no one who thought that Kandinsky had made great paintings after, say, 1921, when he left Russia for good. That is, no one in New York really prized the work from Kandinsky's last twenty years. In fact, in some ways the situation was worse than that: early Kandinsky watercolors were called great because they were like Helen Frankenthaler.

It is ironic that just when second-generation abstract expressionism had taken a nose dive and a new, more rigid form of abstraction was taking hold, no one could appreciate the later work of Kandinsky. As fancy, extreme compositional ideas for the organization of abstract configuration came into vogue, Kandinsky was still seen as too prissy and academic. The most obvious reason to explain the difficulty the art world had in the 1960s—and perhaps still has even now—in seeing and understanding Kandinsky's post-1920 work is that his later work appears "dated" while his earlier work remains "fresh." There is a tremendous irony in this contradiction. The closer his work was to representation (figs. 32, 33), to expressionistic landscape, the more we see it as relevant to our idea of what abstraction should be and has come to be. The farther his work was from representation—the more fundamentally abstract it was (figs. 34, 35)—the more irrelevant it becomes to our idea of abstraction, the more it seems to be a schematic version of nineteenth-century pictorial mechanics. Basically we see Kandinsky as a late nineteenth century painter, as we see most of the other early abstract painting of the first half of the twentieth century. That is to say, for us abstract painting begins after the Second World War in New York City. After 1945 abstract painting became truly autonomous and self-sustaining. The change in pictorial gesture and scale that manifested itself in New York after World War II marks the beginning of twentieth-century painting—a painting that is not so directly beholden to nineteenth-century ideas and accomplishments, a painting that holds its fate in its own hands.

The adjusted peripheral vision of recent art history watches the sweep of Rubens' brushwork, the driving force of two hundred years of painting, exhaust itself in the daubs of Monet and then promptly extinguish itself in the facets of Cubism. This is an abbreviated way of calling our attention to the fact that, for abstraction, the light of Impressionism and the structure of Cubism were not enough. An additional element, a catalyst was needed: a burst of pictorial energy similar to that created for the seventeenth century by Rubens' space-expanding gestures. This energy was provided in the late 1940s by de Kooning and Pollock, who resuscitated the spirit and the articulate swipe of Rubens' brush. This new track of paint marks the beginning of twentieth-century abstraction. The new gesture born in a gallon can and risen from a tin alloy bucket created the real, permanent space of abstraction—a space equivalent in grandeur of dimension and creative possibilities to the pictorial space of Caravaggio and Rubens. What we failed to see is that it was the loss of the palette, not the easel, that changed the face of what we see as painting. The size of what one dips the brush into counts for more than the size of what one paints on; that is, the load of pigment carried determines the scale of gesture more than the dimensions of the area to be covered.

We might do well here to look at what has become a basic confusion for painting in the last quarter of the twentieth century. What we want to understand is the relationship of abstraction to the meaning and future of modernism; whether abstraction is more than a necessary ingredient in the development of twentieth-century art. We already know that there is no longer any serious competition between abstraction and realism in the sense of a battle between nineteenth-century academicism and twentieth-century modernism, and we already know that the pictorial accomplishments achieved in the establishment of abstraction form the core of our thinking of how painting should be conceived and understood.

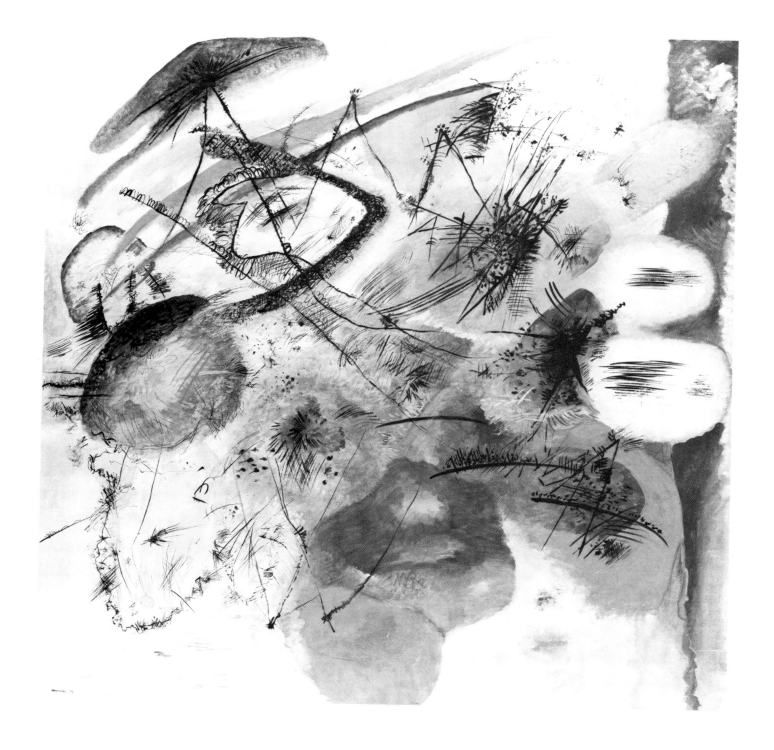

Figure 32 WASSILY KANDINSKY
Black Lines (1913)
Oil on canvas, 51 × 51⅝ in.
Solomon R. Guggenheim Museum, New York

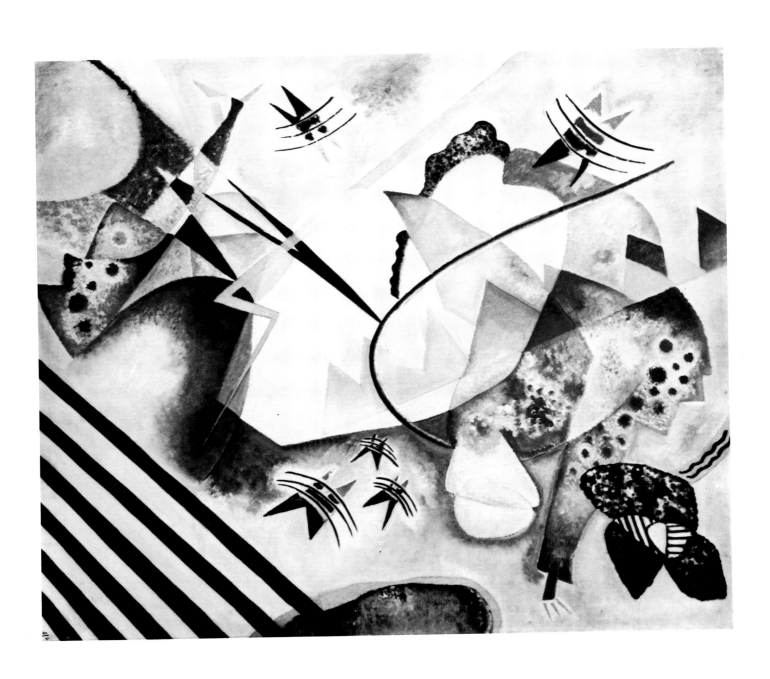

Figure 33 WASSILY KANDINSKY
White Center (1921)
Oil on canvas, 46¾ × 53¾ in.
Solomon R. Guggenheim Museum, New York

What we have, then, is a basic agreement about what painting should be in the twentieth century. What we are worried about is the balance among and the future development of the ingredients of that painting. Modernism is the painting of the twentieth century, and abstraction forms the core of its pictorial growth and strength. Realism is an attitude that embraces the mechanics of twentieth-century abstraction while still seeking possibilities in the semiabandoned techniques of mechanical and representational illusionism. For abstraction, the problem is simple: it must decide about and act on its future. It has to decide if purification by exclusion is the road to the future; if the emphasis on surface and materials can pave the road to Shangri-la.

If abstraction has doubts about its ability to survive on its own, it has to take another look at where it came from, to reconsider its relationship to the mechanics of representation. After all, the gestures of abstraction are no more than the revealing magnification of the gestures of its heritage. It may be that some of the cyclical obstinacy of realism in the twentieth century suggests that abstraction should make a better accommodation to the illustrative urge; or perhaps it simply indicates that realism stirs because its bones have not been picked completely clean.

One way to look at the possibilities for an accommodation between abstraction and realism—or, to put it differently, the possibility that abstraction might be able to find possibilities in overlooked, overworked representational techniques—is to consider the devices of shading and skeletal structure, two devices that have danced throughout all of the numbers abstraction and realism have written together, two devices that Kandinsky has handled with touching genius, and two devices that still provide painting with an amazing amount of its momentum—as well as, of course, with an inordinate amount of its worry.

Kandinsky hints that the goal of painting is to rise above these devices, to defuse their literalness and achieve a purer artistic, abstract expression (*Concerning the Spiritual in Art*, trans. M. T. H. Sadler, New York, Dover, 1977, pp. 30–31):

The impossibility and, in art, the uselessness of attempting to copy an object exactly, the desire to give the object full expression, are the impulses which drive the artist away from "literal" colouring to purely artistic aims. And that brings us to the question of composition. . .

A good example is Cézanne's "Bathing Women," which is built in the form of a triangle. Such building is an old principle, which was being abandoned only because academic usage had made it lifeless. But Cézanne has given it new life. He does not use it to harmonize his groups, but for purely artistic purposes. He distorts the human figure with perfect justification. Not only must the whole figure follow the lines of the triangle, but each limb must grow narrower from bottom to top. Raphael's "Holy Family" is an example of triangular composition used only for the harmonizing of the group, and without any mystical motive.

Kandinsky had a dream that the efficacy of abstract pictorial expression would give full expression to the object; that is, that the object could become more real by being freed from literal representation. It turned out to be a lot harder than Kandinsky thought, or perhaps more generously, it turned out that the pictorial component of abstract expression turned out to be a lot different from what he imagined it might become. Kandinsky conceived pictorial space as an examined slice or plane of a larger spatial whole, an idea that represented the most advanced cosmology of his day. He gave us a much better window, a more mobile window, from which we could see created and creatable pictorial worlds, but magnificent as this window was, it did not satisfy for long.

Figure 34 WASSILY KANDINSKY
Horizontal Blue (1929)
Watercolor, gouache, and blue ink on paper, 9½ × 12½ in.
Solomon R. Guggenheim Museum, New York
Hilla von Rebay Collection

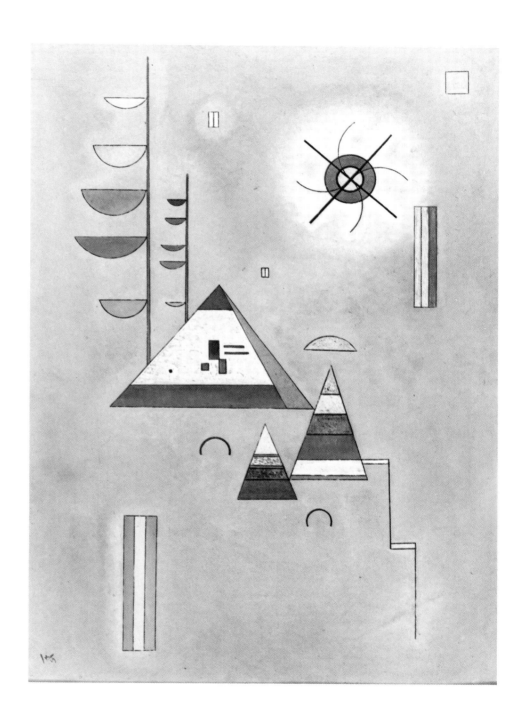

Figure 35 WASSILY KANDINSKY
Pink Sweet (1929)
Oil on board, 27¼ × 18⅞ in.
Solomon R. Guggenheim Museum, New York

When he came to examine things closely, Kandinsky showed us the problems nagging abstraction (or, as he called it, pure artistic composition). He is probably a bit off the mark in noting the *Holy Family*'s lack of a mystical motive because Raphael's composition could more accurately be described as pyramidal rather than triangular (fig. 36), and as a consequence Raphael's strong reference to the pyramid might actually have just the mystical motive that Kandinsky found wanting. In any case, mysticism aside, the pyramidal quality suggests solidity, and perhaps Kandinsky's concern represents a fear of the power of that solidity to warp and weigh down the pictorial space of abstraction.

Kandinsky was right to appreciate Cézanne. The emergence of triangularity in the *Large Bathers* (fig. 37) was an unconscious step in the right direction, a step about to break through the crust of the future's pictorial surface. However, agile and muscular as it may have been, Cézanne's triangle could not shake the pyramid anchoring Raphael's composition. The dogged perseverance of this pyramid illuminates the mystical dead weight which Kandinsky and all abstract painting following him have always had difficulty accounting for, and which in the end we, if not they, cannot live without. This mystical weight is the leaden ballast of Cubism buried before our eyes under the shield of fragmented volume, reminding us that if abstraction is to prosper it has to lift the burden of figure and ground.

Kandinsky knew that composition was the heart and soul of art. By expressing a preference for the triangle over the pyramid, for Cézanne over Raphael, he was preparing the way for a compositional preference which he largely invented and which to this day underlies most advanced painting. This preference, which might be called the principle of weightless composition, reveals a horror of solid form, a fear of the weight of material objects. It reminds us that Kandinsky's goal was to elevate art—to soar, much as he admired him, far above Cézanne.

One way to see Kandinsky's weightless composition in action is to look at the transformation of his linear design instincts into suspended structures that imply the ability to rotate and travel in a free-floating manner. It is as though he wants to raise the Holy Family and bend the landscape out of sight at the same time. In the process of bending the landscape away from us as well as from the Holy Family, Kandinsky intends to undermine the viewer's ground plane, our literal support, in order to free our vision—or in this case, more specifically, our point of view. The suggestion is that as we experience the potential motion of the suspended linear structures, we experience the potential mobility of our point of view.

Kandinsky realized that on a number of levels the attempt to elevate art conflicts with the desire to be grounded in reality. It was more than the binding relationship to the ground plane that weightless composition intended to correct. Kandinsky knew from his experience of Impressionism and Fauvism that twentieth-century art was infatuated with the reality of pigment, that it was stuck to the plane of pictorial surface. This reality of pigment, the inevitable weight of the touch of the artist's hand, was something Kandinsky hoped to deny. He expected to paint and compose with a new freedom, seeking to dissolve the ground plane of the past into a surface of contiguous weightless relationships.

If we can understand this vision we grasp a salient point, one that explains what Kandinsky was trying to do in his late paintings (fig. 38). In the process we take hold of something that has eluded us for a long time—the basically levitational and rotatable nature of abstraction. At the same time, we can get a very good picture of where painting is today and what it might hope to do in the future.

In Kandinsky's late paintings a lesson of composition asserts itself. It advocates the last system of pictorial composition that could function without the complete domination of at-hand, physical gesture, a dominating bodily gesture which expresses the desire to limit pictorial space to the actual,

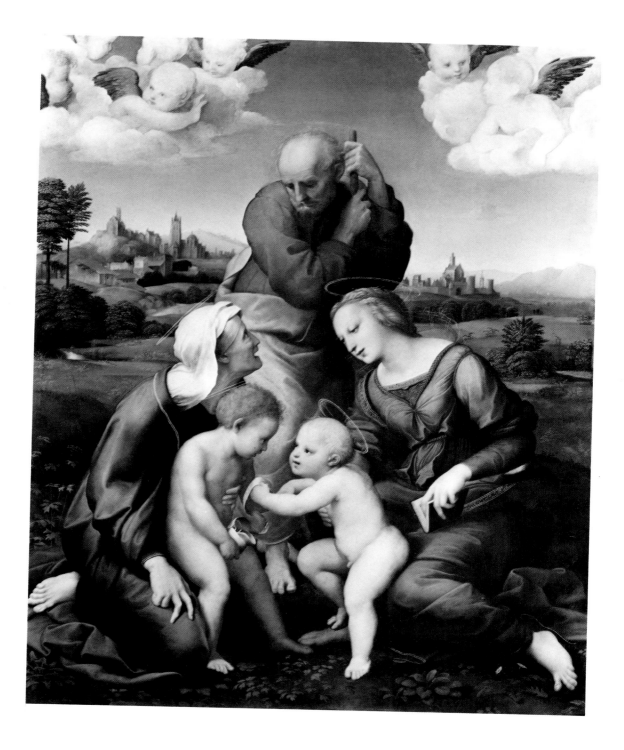

Figure 36 RAPHAEL
Canigiani Holy Family (c. 1506)
Oil on panel, 51½ × 42⅛ in.
Alte Pinakothek, Munich

Figure 37 PAUL CÉZANNE
The Large Bathers (1906)
Oil on canvas, 82 × 99 in.
The Philadelphia Museum of Art
W. P. Wilstach Collection

Figure 38 WASSILY KANDINSKY
Composition X (1939)
Oil on canvas, 51³⁄₁₆ × 76³⁄₄ in.
Kunstsammlung Nordrhein-Westfalen, Düsseldorf

available working space. This gesture is the triumph of a pragmatic, American pictorial intelligence. This development has created a decisive and original space, but in spite of this, in recent years it seems to have lost its bearings.

By being literally on top of the pictorial surface and then falling, at least figuratively, inside the body of our work, we have changed our location and distorted our point of view. When we think of a coherent point of view, a privileged access for pictorial expression, we are forced to use our memory. Our eyes are bleary from the surface fumes. In some ways, though, it is not such a bad thing that our immediate perceptions are forcibly tempered by a recall mechanism of our visual imagination. Up close we are still confident. We have plenty of room to work, but our distanced view of the past induces the fear that our expression is isolated. Our enlarged tactile working space searches for an accommodating pictorial space. We have a sense of directed effort, a sense of engagement, but the boundaries surrounding our activity are unclear; their dimensions and strength are unknown. As always, discovery and definition create impossible tasks, but then again painting has always been more serious and difficult than we expect.

In spite of our apprehension of similar compositional interests and goals, we often fail to see a connection between Kandinsky's late efforts and the successful efforts of postwar American abstract expressionism. It follows then, almost without saying, that we tend to see little relevance in Kandinsky's late work for our present predicament. Yet Kandinsky's effort is more than an ironic foil. It is true that the differences between his early work and his late work give the most telling account of abstract expressionism's success, but this does not tell everything we need to know. It seems clear that it would have been much harder for abstract expressionism to find its true, close-up, reachable surface if it had not been for the example of the late Kandinsky. Most assume that abstract expressionism's debt to Kandinsky comes from the abundant release and freedom of the gesture drawn from the abstract landscapes. Although this is obviously true, it is not so obvious when and how these gestures got to the new surface of painting.

It could be argued that if it had not been for the example of Kandinsky, the scattered gestures of expressionism would have hardened into the compressed planes of Picasso, Malevich, and Mondrian, or would have simply dispersed themselves into the turpentine washes of Matisse. Kandinsky supplied the imaginative leap, the missing pictorial ingredient, the necessary ingredient for modernism's most meaningful step. He created an example of atomized, dematerialized space which could be conceived of as an endless spattering of pigment in motion. Kandinsky may have taken his indirect example from Klee's spray gun, but the real power of this shot comes from an extension of the original ammunition. What happened in the 1930s was a dispersal, a magnificent redeployment of Kandinsky's brushstrokes of the previous thirty years.

Thus the pictorial space in Kandinsky's later paintings, which we often perceive as a drawback and an annoyance, had a positive effect on painting. This moving, particulate, yet totally pigmented space made it possible for artists like Tobey, Pollock, and Hofmann to imagine themselves set free, floating among the colored substances they had hurled into action. In a sense they closed their eyes and jumped into their work. It surprised no one that they hit the floor. But by knocking themselves out chasing paint thrown in frustration at the ineluctable surfaces of European modernism, they found their own dizzying space and their own independent pictorial identities; they found comfort and support in a void of doubt.

These artists must have garnered a sense of meaning from some of the more baffling examples of Kandinsky's late work, such as *K622, Allusion,* and *Ambiguity (Complex/Simple)* (plate 23). If it had not been for the promise of these late

Figure 39 MARK TOBEY
Form Follows Man (1941)
Gouache on canvas, 13⅝ × 19⅝ in.
Seattle Art Museum
Eugene Fuller Memorial Collection

Figure 40 HANS HOFMANN
Spring (1944–45)
Oil on wood panel, 11¼ × 14⅛ in.
Collection: The Museum of Modern Art, New York
Gift of Mr. and Mrs. Peter A. Rübel

paintings, it is doubtful that the accomplishments of the earlier ones would have come to fruition. Although he appears to have lingered self-effacingly in the background of painting in the 1930s, Kandinsky himself ultimately formed the background that enabled expressionism to display abstraction properly. To Tobey (fig. 39), Pollock, and Hofmann (fig. 40), he was known and understood. From their hands, Kandinsky's ashes were scattered to form the new surface of abstraction.

In the process of laying groundwork for the future, Kandinsky exhibited much of the same terrifying courage that Titian and Caravaggio showed in the *Flaying of Marsyas* and *David and Goliath:* the courage to show what painting is in terms of personal cost and ultimate fear. For Titian it was obvious that the success of creation, the vitalization of painted surface, would cost him his skin. Caravaggio never doubted that fate would have his head to mock the power of the pictorial projection he engendered. Similarly, Kandinsky never flinched in the face of his successors' taunts of sterility and senility. From what we have a hard time seeing as other than academic whimsy, he created a heroic container, a pictorial space resilient and flexible enough to ensnare the future.

There is a strong suggestion of this ambition in *Composition IX* (plate 24), a curiously organized painting with six separate parts, each outlined as a plane, but each also capable of extension. From left to right a yellow triangle, a blue diagonal band, a red diagonal band, a red-violet diagonal band, a yellow-orange diagonal band, and finally a light green triangle are linked together to form the surface of the painting. The disposition of these component planes and their method of cohesion are ambiguous, but at the same time very forward-looking. The diagonal planar repetition in this picture creates a moving continuous surface which suggests that a faceting, a kind of fragmentation is taking place on an unfamiliar scale. It is as though the obvious posture of Cubism is being fed into the wringer of abstraction. The results are draped on a clothesline, exhibiting an alternative to the usual rectangular pictorial whole. The lateral movement in this painting suggests extensibility of the kind that appeared in the sixties, for example in the work of Motherwell and Noland and also in my own work. What is really interesting, though, is how unique Kandinsky's method of cohesion remains. The flow and touch of the planar colors still represent an untapped marvel.

Kandinsky did something in *Composition IX* that we might consider obvious and unmemorable, perhaps even undesirable: he put a series of disparate geometric and organic figures into motion, floating in front of the colored planes. These figures are a miracle of balance, movement, and placement. Yet they do not particularly appeal to us, and as a result there is a tremendous temptation to see the painting without them, to see the painting as a wonderful dispersement of planar color, prefiguring the abstract triumphs of Barnett Newman and, later, of Morris Louis. If we do this, though, we miss a sophisticated display of pictorial motion that is not only an accomplishment in itself but also an achievement from which we could benefit. The figures have a kind of directionless, weightless motion associated with freedom from gravity. This unfettered, almost purposeless motion is a perfect foil and support for the motion imparted to color, whose tense, controlled dispersion makes up the background. The motion guiding the figures is random and independent, at odds but also somehow interwoven with the diagonal thrust of the truncated rainbow backdrop. As the color and figuration both move, we see them released into the abstract space of a white, imaginary pictorial wall.

No one exploited this new perception of a figure's relationship to background better than Barnett Newman (fig. 41). The strength of his painting comes from the ability of the stripes (or, as he liked to call them, "zips") to attach themselves to and into the background. They fit beautifully, zipping the space together. Newman sets up the motion of

Figure 41 BARNETT NEWMAN
Dionysius (1949)
Oil on canvas, 69 × 48 in.
Collection: Annalee Newman, New York

his figuration counter to the motion of the space supporting it. In this he is more direct and less ambiguous than Kandinsky. When the stripe travels from top to bottom, the space around it moves from side to side; when the zip cuts from side to side, the surrounding space floats up and down. Convincing as this effect may be, the complexity and delicacy of Kandinsky's spatial movement hunger for rediscovery. It may be that what makes Morris Louis's late paintings so appealing is their peculiar Kandinsky-like understanding of Newman. Louis brought a determined looseness to Newman's abstraction that Kandinsky would have applauded. Louis had the opportune sense of contiguous touch that is so necessary to link the moving elements of abstraction. This touch enabled him to exploit separation in a way that modern painting admires but cannot seem to imitate.

Although *Composition IX* is not a large painting by recent standards, it is clear that Kandinsky saw his scaled-up effort in this painting as a confrontation with the compositional traditions of the past. Basically, *Composition IX* quietly disrupted the spatial conventions of Western painting—their continuous, whole backgrounds. It represented a definitive break with the restrictive, narrative flatness of mural painting and the stationary, enframing limits of easel painting. We feel that Kandinsky appreciated his ability to temper painting to the service of abstraction; in the face of his own accomplishments, he magnanimously pointed the way to the future. What *Composition IX* added to the lessons of its eight predecessors was a program for the future success of abstraction.

The Dutch Savannah

Quality in art is always in jeopardy; often it is effectively neutralized. In its place, excitement becomes everything. No artist ever perceived quality without experiencing doubt, but all artists experience unattended, unqualified excitement (plates 25, 26). This is why and how art endures. The sparked realization of creative effort will always drive art. The most obvious and difficult truth the artist reveals to the viewer is that the latter is, in fact, after the fact. Although it is clear that the exclusion is only momentary, it is significant. The viewer is shut out for an instant in order to receive a surprise, the gift of participation without consequence.

The viewer of art becomes part of an audience for already existing pictorial drama. The modification and qualification of that pictorial drama by the experience of its audience, which its creator, or creators, are now part of, cannot affect it or account for its meaning with any certainty, in spite of what those who do not make it think. The collective experience of the audience is really limited to fantasizing, perhaps hoping to affect subsequent dramas; but whenever the audience pictures itself as an active, affecting participant, it risks unraveling itself. It induces a circumstance in which it has to abandon its privileged role as viewer to undertake an initiatory role as creator, one in which it must act rather than speculate, re-act rather than spectate.

This means that there is an inviolable autonomy to art which offers its creators a sensation so irresistible, so desirable, and so exciting that it assumes the character of instinct, as if it were something guaranteed by genetic imprint. The sensation is one that the artist experiences as the first and only necessary viewer; it occurs in the unrecoverable moment when the artist looks at what he has made and sees it as alive. This assertion will no doubt be dismissed as a delusion; but remember that it is the mechanism of art that is being described here, and this mechanism successfully accounts for what exists and what endures.

If the quality of art never threatens its existence, what are we worried about? If vitality is the only necessary ingredient for art, bad or even meretricious art will never imperil pictorial life. Where there's life, there's art. Furthermore, observation shows that ultimate issues do not engage us in the way that particular, essentially picayune issues do; for example, the mismanagement of the planet and the threat of a nuclear holocaust do not move us in the same way that the quality-of-life issues do. We want steak on the table and masterpieces in the museums. In these matters we believe that effort and care make a difference, and that their application can influence the outcome.

Faced with the present predicament in painting, we believe it is important to declare ourselves, to take a stand, to make an effort to do something about the situation. The only serious worry we entertain is not so much about the ultimate success of our efforts, but about the effects of our efforts on others. In effect, we worry that our success might preclude or mask other viable possibilities, that our successors might be confounded or intimidated. But this is probably as fatuous as it is unlikely. De Kooning's genius (fig. 42) did not discourage me from painting black enamel stripes (fig. 43), and my success as a minimalist did not deter Joseph Kosuth from painting with a typewriter on a billboard (fig. 44). Success perpetually skimmed from the top exerts in the end little influence on the sediment of invention that lies below, about to be loosened by the next generation's creative surge.

Figure 42 WILLEM DE KOONING
Suburb in Havana (1958)
Oil on canvas, 80 × 70 in.
Collection: Mr. and Mrs. Lee V. Eastman

Figure 43 FRANK STELLA
Tomlinson Court Park II (1959)
Black enamel on canvas, 84 × 109 in.
Collection: Robert A. Rowan, Pasadena, California

Figure 44 JOSEPH KOSUTH
The Seventh Investigation (Art as Idea as Idea)
Proposition One (Context), Part B (1970)
Billboard, Chinatown, New York
Photograph courtesy of Leo Castelli Gallery, New York

My insistent defense of abstraction must seem by now to be somewhat less than disinterested. This may be true; but it is also true that the general, public perception of abstraction, even when it is sympathetic and informed, is a limited one, and part of my effort here is aimed at expanding that view, in the hope that the audience will relax and enjoy painting for something like what it really is for the people who make it. For me, speculating about abstraction serves the purpose of explaining contradictory feelings. It explains why I love and embrace abstraction on a practical, performing level, yet remain wary of it on a theoretical level. These contradictory feelings do not create a conflict for me; that is, I do not experience any special anxiety because I am trying to make abstract painting. I do not have a secret desire to put Donald Duck or naked women in my paintings, although I know they harbor a secret desire to be there. Evidently, part of the character-building quality of abstraction resides in holding the line.

Similarly, I have no difficulty appreciating (and, up to a point, understanding) the great abstract painting of modernism's past, the painting of Kandinsky, Malevich, and Mondrian, but I do have trouble with their dicta, their pleadings, their impassioned defense of abstraction. My feeling is that these reasons, these theoretical underpinnings of theosophy and antimaterialism, have done abstract painting a disservice which has contributed to its present-day plight.

There is nothing wrong with the antimaterialist ideal that abstraction was born with. In practice, the paintings it produced were strong. But there is a fear that the notions informing and supporting that ideal contribute on occasion to disheartening extremes which become hard to overcome, such as those manifested in Malevich's *Red Riders* (fig. 45) and Kandinsky's *Sky Blue* (fig. 46). When we see paintings such as these which are very peculiar and difficult to explain, there is a tendency to dismiss them as crackpot art, art made by artists with specialized, deservedly unfashionable beliefs. It becomes difficult to gauge who is leading whom. Is theosophy making abstraction trivial, or is the spiritual impulse being caricatured by abstraction?

It is hard to judge if my feelings about the origins of abstraction, nurtured by Kandinsky, Mondrian, and Malevich, represent anything more than a prejudice against Northern spiritualism bound to a preference for what Moravia calls Mediterranean fatalism. When I think of what is wrong with painting, one painting, Paulus Potter's *Young Bull* (1647; plate 27), trots confidently into the ring. This is a wonderful, appealing painting, but it is too abstract, too thin; essentially it lacks a dimension, or even two. Compared to Caravaggio's *Conversion of Saint Paul* (1600–01; plate 28), the pictorial space of Potter's *Young Bull* ends at a horizon line backed up against the priming. This painting is always paint-film deep; the illusion is never deeper than the glazes.

To put it simply, as present as the bull may be, as much as we may want to touch him to see if he is as real as he looks, we never feel that we can walk around him, that we can get into the painting, the way we are sure we can move around St. Paul's horse and look into the eyes experiencing conversion. In the same way that he fails to project the spatial roundness and fullness of Caravaggio's pictorial world, Potter also fails to project an imaginative largeness, actually a kind of an imaginative inclusiveness. The viewer will always be an observer here, never an involved participant, so much so that this successful effort at establishing a barrier has the effect of reducing the depicted subjects to the status of laboratory animals—gilded rats in a glass cage—an image which implies that Potter's precision helped to create the distance abstraction now finds so hard to shorten. Furthermore, the viewer as observer rather than participant brings with him a new awareness of pictorial limits. Potter's way of seeing produces an inevitable emphasis on edge—the cropped

Figure 45 KASIMIR MALEVICH
Red Riders (1928)
Oil on canvas, $35^{13}/_{16} \times 55^{1}/_{8}$ in.
Ministry of Culture, Moscow

Figure 46 WASSILY KANDINSKY
Sky Blue (1940)
Oil on canvas, 100 × 73 in.
Musée National d'Art Moderne, Centre Georges Pompidou, Paris

edges of a piece or section of the real world, edges that are harmful to the development of an expansive pictorial sensibility, edges that are fortuitously missing from Caravaggio's theatrical, rounded space.

The power of the *Young Bull* is contained in his pictorial presence. There is no question in front of this painting of avoiding the issue of bullhood, as there is no hope of side-stepping the horseness in Caravaggio's *Conversion of Saint Paul*. Horse and bull make a strong visual impression. But only one of these paintings, Potter's *Young Bull,* has served as a model, as a kind of inspiration, for the development of abstract painting. The particularized, inclusive, and diversely focused realism of Potter became Mondrian's patrimony, and indirectly that of Kandinsky and Malevich as well. This realism appealed to them in a way that the generalized, exclusive, and singly focused naturalism of Caravaggio did not. Modernism's preference for Potter's realism represents something more than an inevitable prejudice for barbarian animism over Greco-Roman stability, for nascent, observational science over weary, antique pedantry.

At first it may seem odd to insist on realist painting as a model for abstraction, but as we look deeper it becomes easier. I suggest that abstraction has its roots mainly in the northern, realist, landscape tradition, and that the classical, Mediterranean, figurative antecedents of Western painting have not really taken hold in abstraction. Basically, the argument is that we have access to the dirt supporting Potter's bull, but we have lost touch with the man under Caravaggio's horse. It may be that this is not so much a loss as it is an opportunity, or even a mandate for increasing the breadth of sources and therefore the productivity of abstraction. In any event it is clear that Mondrian, Kandinsky, and Malevich sensed the penetrating power of the new observation, the focused realism of the north. It was a model for an intensity they hoped to turn against realism, against materialism. The thin, sharp, clear presence of Potter's cropped panorama

represents a material intensity which they hoped to subvert and turn to their own use, perhaps capitalizing on the abstract quality suggested by its magnified surfaces. The fathers of modern abstraction made an opportune choice: they saw a future for abstraction growing from the surface of observed realism rather than out of the invention of artificial naturalism. They preferred the illuminating gift of transparent glazes to the material revelations of chiaroscuro's high contrast.

By prizing Potter over Caravaggio, Mondrian, Kandinsky, and Malevich finally put nineteenth-century French painting and its source, Italian Renaissance painting, to rest. In the process they created fundamental distinctions in composition and psychology which essentially define contemporary abstraction and clearly underscore its developmental problems. A straightforward way to see the consequences of abstraction's instinctive preference for seventeenth-century realism is to take a look at Potter's *Young Bull* between the extremes of the beginnings and what many now see as the end—between Lascaux and the Bronx, between the blow pipe and the spray can.

One thing that ties Paulus Potter's *Young Bull* to the animation of Lascaux (plate 29) and the graffiti of New York (plate 30) is a sense of forced interval, a sense of disjointed, awkward pictorial space surrounding the markings and figures. Basically, in order to sustain any aesthetic effect, all three of these examples of painting depend on a generous reading of the art of the childlike, the disturbed, and the naive. That is, they all favor an art with a primitive bias. Nonetheless, the spatial interval described here makes an aesthetic mark which is so strong that it raises itself far above the concerns about its origins. It makes us notice and marvel at the effect. It is this effect of unexpected spatial interval and displacement which allows Paulus Potter's *Young Bull* to compete so well with Caravaggio's *Conversion of Saint Paul*. On the face of it, Caravaggio's humanist drama should blow away Potter's contrived Polaroid. But this is not what has happened, and I submit that it is Potter's display of magical intervals rather than his creation of acute, realistic presence which

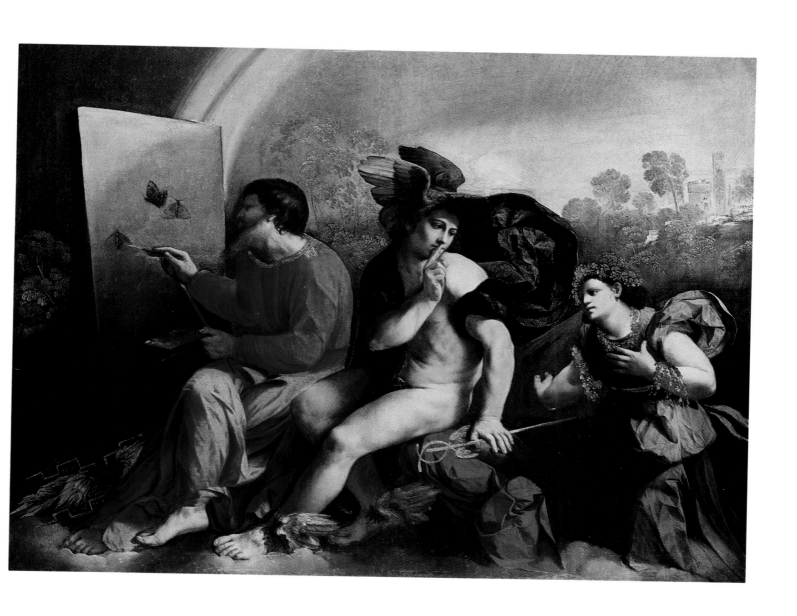

Plate 25 DOSSO DOSSI
Jupiter, Mercury, and Venus (c. 1530)
Oil on canvas, 44 $\frac{1}{16}$ × 59 $\frac{1}{16}$ in.
Kunsthistorisches Museum, Vienna

Plate 26 FRANK STELLA
Diavolozoppo (1984)
Oil, urethane enamel, fluorescent alkyd, acrylic, and printing ink on canvas,
 etched magnesium, aluminum, and fiberglass, 139⅛ × 169¾ × 16⅛ in.
Collection: Frank Stella

Plate 27 PAULUS POTTER
The Young Bull (1647)
Oil on canvas, 7 ft. 9 in. × 11 ft. 1 in.
Mauritshuis, The Hague

Plate 28 CARAVAGGIO
The Conversion of Saint Paul (1600–01)
Oil on canvas, 90½ × 70 in.
Church of S. Maria del Popolo, Rome

Plate 29
Red Cow and Chinese Horse (c. 15,000–10,000 B.C.)
Paleolithic mural
Axial gallery, caves at Lascaux, Dordogne, France

Plate 30 "Working Space"
Graffiti, New York City

has allowed the *Young Bull* to stand so proudly for so long. We love the discovered awkwardness of this painting when we compare it with Caravaggio's overwhelming, invented coherence.

Potter's painting endears itself to us by snapping flat at the edges, by keeping its illusionism thin. In Caravaggio's painting we are confronted with a rounded, spherical whole containing an enclosed, limited, definite activity; somehow it is a gift that abstraction cannot warm up to. There is something more here than a classical/anticlassical opposition. We like the surprise and freshness of the awkward intervals in Potter's pictorial space, but even more than this we appreciate its lightness, what in the 1960s would have been called its implicit declaration of flatness. This flatness assures us of aesthetic control even in the face of chaotic pictorial invention. Coherent as Caravaggio's world of pictorial space may be, it remains a threat; it may burst its bounds at any minute.

Not surprisingly, then, it is Potter's restrained kind of realism, tempered by modern abstraction, that serves as a model for recent painting. In spite of its outward, surface bravado, the most popular art produced today by younger painters still elicits a concern with interior boundaries. The assault on exterior boundaries, the possibility of dissolving conventional edging, particularly of the kind suggested by Caravaggio, seems slow in coming, largely, I suppose, because of the inherent limits of illusionism, expressed by abstraction's reticence to illustrate itself. Unrestrained in this way, recent representational painting seems to establish bold projective gestures in order to play them off against conventional illusionistic space. There is here, however, a sense in which the outward movement never becomes anything more than a foil for the conventions it was trying to elude, for it appears that most of what is called the best painting today dumbly accepts the static outline of traditional easel painting. Although he stood behind at least half of what easel painting was to become before the advent of Impressionism, Caravaggio had an illuminating idea about what it should be. I believe that Caravaggio meant painting to grow outside of itself. His illusionism overcame technique, mandating, in effect, that our technique should overcome illusionism.

Could this be the lesson so well hidden in a wall painting such as the "Miracle of the Lower East Side" (fig. 47) or in Pollock's *Out of the Web* (see plate 15)? Perhaps the lesson suggests that we are continuing to profit from Potter's genius but we have yet to capitalize on Caravaggio's potential—the potential of a pictorial illusionism whose dramatic abstraction makes it fuller than Potter's observed realism. Again it seems that creation can add to analysis even if the results of creation (as in Caravaggio's case) are patently artificial, and the results of analysis (as in Potter's case) are apparently reproducible triumphs.

The intervals that catch our attention on the stone walls of Lascaux and the aluminum siding of subway cars are interesting because they come about as the result of an art-making effort applied to vague and indefinite boundaries. This is what ultimately makes them more interesting than most art we see, but it does not explain the success of the loose, awkward, refreshing intervals created by such art at certain unpredictable moments. The arresting quality of these moments is their ability to resist our efforts to organize them. When we encircle any group of marks or shapes with a boundary, we divide them into parts that make up a new whole. In this way we guarantee the wholeness and completeness of art. We have a notion that naive or bad art breaks down into parts that are irrational, unable to add up to a sustainable whole. In fact, this is more of a feeling than an actuality. What this feeling expresses is our unwillingness to sort out and organize crudely arranged parts. Basically, bad art makes us do more than we want to do. In great art all the relationships sparkle, radiating coherence. The balance between positive and negative is always exquisite; the displacement and redeployment of space always constitute a marvel.

Figure 47 "Miracle of the Lower East Side"
Graffiti, New York City

This marvel occurs in the caves and in flashes on subway cars, but we are anxious in these circumstances because our faculties for containment and judgment are stretched beyond their capabilities. In both cases the gesture travels too far and too fast for the stationary critical process. However, this description of how we want to contain and qualify art does more than reveal the power of the ungaugeable pictorial intervals which seem to lie at the extremes of art history; it gives a good indication of what abstract art should do in order to overcome its present state of apathetic stagnation. Clearly, abstraction has to move; it has to extend itself.

It would seem normal to accept disconcerting, awkward, almost unartistic intervals in paleolithic art and in modern graffiti while questioning their value, if not their existence, in work such as Paulus Potter's *Young Bull*. In fact, it is tempting to say that Potter comes after Lascaux and before graffiti, and to leave it at that; as if to admit that in Potter these same warped, appealing qualities—spatial incongruities conversant with the deep past and the apparent present— beg explanation. Potter's painting is difficult to grasp, especially if we cannot register the disposition and flow of dimly perceived negative intervals which contribute so much to the pictorial whole. Perhaps the awkwardness and asymmetry that appear in Potter could be explained by compositional practices, instincts almost, common to the relentless Mannerist sensibility of the art of the lowlands that preceded his work from, say, Bloemaert and Spranger to Francken and David Teniers. However, I suspect that it would be easier to recognize the pictorial value of Potter's awkwardness by simply enlisting the aid offered by analogies from the past and the present. Here what might be called fanciful art history appears to be an appropriate tool. Whatever the approach, the *Young Bull* remains a painter's painting, difficult to analyze, difficult to understand.

Unlikely as it might seem, it is possible to see this painting as direct painting modeled from studio life rather than as a more indirect version built from elaborate preparatory drawings. Velásquez and Manet come to mind almost immediately. Imagine this arrangement for Potter's painting: a few tree stumps and a plank are nailed together and placed to the left of center under a skylight to await the bull. Before he is led in, a painted landscape drop is strung up across the back wall. Eventually the bull blossoms as the work progresses, but something remains unsatisfactory. In an effort to correct this, Potter enlarges the painting and its cast of characters. Now sheep, cow, goat, and the model for the cowherd take their places to the left of the bull.

If this seems far-fetched, we can imagine a less cumbersome variation: Potter sketches in a background from drawings made in the field and then does some firsthand work from the bull, perhaps in the paddock, perhaps in the studio. In any event, whatever we imagine, the painting becomes a composite, with numerous hidden faults threatening its glassy surface. Despite its convincing realism, this painting develops a huge diagonal split between foreground and background. The incorporation of this split by an arbitrary enframement of the scene dictates an unusual but successful rhythm, one that activitates elusively defined displacements, both positive and negative. At the same time this coupling enhances a quirky, projective quality of shape and scale, a quality that makes this painting inexplicably alive and plainly original.

In terms of displacement of pictorial volume, this painting is completely irrational. The triangle describing the foreground is equivalent in felt magnitude to a Mack truck, while the background triangle tucked in behind the diagonal ridge carries the weight of its matchbox cousin. This peculiar attitude toward spatial displacement is further acknowl-

edged by the unsubtle juxtaposition of a tiny foreground frog against the dominant bulk of the bull. The whole experience is a complete reversal of expectation, where the intelligent, measured reading of pictorial space is replaced by a more accurate emotional reading of that space. Once the basic architecture of pictorial space has been rent askew, all kinds of possibilities open up. We have to ask ourselves two things: Why is a painting devoted to intense, detailed observation so out of kilter? And why is this awkwardness so productive in terms of pictorial vitality?

The question about the painting's basic spatial distortion, the volumetric incongruity between foreground and background, can probably be explained by the intensity of Potter's youthful effort. In a sense he put so much into each part, foreground and background, that he hated to diminish any of their essential characteristics. As a result he made a painting with two fully realized halves, two competing identities. This creates a unity resembling marriage, one in which the closer we look, the more fragmented the whole appears. In a manner similar to marriage, the fragments rubbed together often become charged, and it may be this same charged quality that marshals the realignment of Potter's awkward elements into their final pose, one whose strange composition opens the way to what is finally an expansive and gracious survey of the Dutch savannah.

Our first reaction to this painting suggests an encounter with a bovine masterpiece. It is as though Potter has done with his bull what Caravaggio and Velásquez were getting at with the horses in the *Conversion of Saint Paul* and the *Surrender at Breda*. Potter uses the scale of animal bulk to express the scope and sweep of our vision—its definition in terms of its limits. Simultaneously he makes a pointed remark, reminding us of what Caravaggio and Velásquez both suggested: that we remain quite small, awkward physical

realities compared with the posed grandeur of our organized vision—our vision of ourselves in the descriptive panorama around us. In Potter, as in Velásquez and Caravaggio, there is the implied sense that we the viewers, as well as the creator in that same position, are really larger than what we see, larger than life, and as such are supremely capable of controlling what we see, both our imaginative and our literal vision.

One always loves paintings that are like one's own. In this case Potter's *Young Bull* is a faithful image of a painting of mine from 1975, *Leblon II* (plate 31). The Potter painting leans to the left. The heads of the peasant, cow, and bull form a triangle within which the X shape of the crossed tree trunks are inscribed. This is a very formal focus for a seemingly casual—at best, eccentrically asymmetrical—composition. The real beauty of this shifted focus, though, is how it sends us spinning off in search of other visual foci, or perhaps the other way around: how the search for other foci helps us locate the real compositional center. From the crossed trunks we meet the bull's eyes, from his eyes we find the cow's head, and from the cow's head we travel to the peasant's face. This triangle is the compositional focus, the painting's organizational core. Once we have found it we feel secure, even though we are puzzled as to why we have drifted so far to the left; we feel that in order to keep our aesthetic balance we have to turn right to look out over the landscape's imaginary distant center.

For me the painting begins on the left edge, where the plank cutting off the cowherd's right arm hides the hand he relieves himself with. The plank and the arm begin a process of interweaving which sends the plank between the tree trunks and the peasant's left arm out over the forwardmost trunk. This interweaving anchors the painting's main structural armature. The plank continues through the crossed

tree trunks as an imaginary line drawn along the ridge of the cow's back, a line further lengthened to include the darkened edge of the landscape's foreground rise, creating an extension that marks the painting's dominant diagonal division.

But compositional strength aside, what makes this painting in my eyes is the success of inexplicable, opportunistic juxtapositions, perhaps an unconscious transformation of the composure of its implied figures. For example, I delight in the reformation and restatement of the jack-like figuration on the left, where the X figure of the tree trunks pierced by the plank shaft through its center turns into a bent Y, into a new cattle-brand as it were, a new pictorial figure formed by the pressure of the white-faced cow's weight. As a result the plank and the backwardmost trunk now form the top V half of a new Y figure. At their joining the Y 's leg is pronated, bent and miraculously flattened by the cylindrical cow into both an edge and a plane indicated by the auspicious shadow cast on the center to right foreground. It is this kind of virtuosity, one of unexpected spatial manipulation rising above its diagrammatic expression, a virtuosity continued by the surprisingly tense figurative articulation keyed to the white cow's face, which I feel the Naples-yellow T in *Leblon II* echoes.

The final innovative effort of Potter's painting manifests itself in the convincing dispersal of daylight over the pictorial surface. Although the light of early northern painting was certainly jewel-like and clear, as was that of much of Renaissance painting to follow, neither of them had the fluidity and depth of field which Potter's brightness brings to this painting. The success of his landscape light did for daylight what Caravaggio did for artificial light: it solved the problem. After the example of Potter and Caravaggio, everyone

knew how to light a painting; the technique was available to all. It became simply a question of being convincing, a question of degree of success.

Potter's light does not come easily to abstraction. It is natural and real, producing descriptive conditions that are at odds with abstraction's predilection for the studied and the artificial, conditions also at odds with abstraction's shallow roots in Impressionism. Compared with seventeenth-century Dutch painting, the light of Impressionism is murky and opaque. I know this assertion will provoke argument, but in fact Impressionism generates very little light or color through reflection; it relies on a necessarily blunted exterior illumination and optical mixing for most of its effects. The thin glaze technique of the north helps to build a glassy outdoor clarity which is to be prized. It depends on a translucent, "see-through" relationship which is the opposite of Impressionism's opaque "see-together" juxtapositions. The touch that ties *Leblon II* to Potter's landscape is bound to just this glassy, translucent, clear surface color, the color that builds the light of the outdoors. Enameled lacquers on a reflective, polished aluminum surface produce a bright, mechanical landscape. A landscape that gives all the appearances of being artificial and industrial turns out to be fresh and homemade, yet limpid and natural, as inevitable as the mountains rising behind Santa Anita on a sudden smogless morning.

Eugène Fromentin's 100-year-old account of Potter's painting (*The Old Masters of Belgium and Holland,* trans. Mary C. Robbins, New York, Schocken Books, 1963) strikes me as amazingly accurate. There is great comfort in the realization that one's own loose associations can sometimes be seen to echo insights of the past. In some ways Fromentin makes me feel almost tame; in other ways, though, we share the same pictorial vibrations. For example, the following account touches nearly everything I have tried to say about Potter and myself, about the past and the present of painting; but perhaps more important, it does these things by

sounding a common artistic, critical voice. In this extract we hear the voice of a painter talking about painting:

The Bull is priceless . . . The reputation of the picture is at once very much exaggerated and very legitimate; it results from an ambiguity. It is considered as an exceptional page of painting which is an error. It is thought to be an example to be followed, a model to copy, in which ignorant generations can learn the technical secrets of their art. In that there is also a mistake, the greatest mistake of all. The work is ugly, and unconsidered; the painting is monotonous, thick, heavy, pale, and dry. The arrangement is of the utmost poverty. Unity is wanting in this picture which begins nobody knows where, has no end, receives the light without being illuminated, distributes it at random, escapes everywhere, and comes out of the frame, so entirely does it seem to be painted flat upon the canvas. It is too full without being entirely occupied. Neither lines, nor color, nor distribution of effect give it those first conditions of existence indispensable to every well-regulated work. The animals are ridiculous in form. The dun cow with a white head is built of some hard substance. The sheep and the ram are modelled in plaster. As to the shepherd, no one defends him. Two parts only of the picture seem made to be understood, the wide sky and the huge bull. (pp. 157–158)

Fromentin himself called this "rough" criticism, but it seems more accurate and generous than anything else. It has the same level of insightful attention that Don Judd brought to the criticism of the 1960s, a gift that often was not all that much appreciated, largely I think because it was founded on honestly felt principles which it hoped to advance rather than, as was suspected, on opportunities which it hoped to exploit. When Fromentin says: "The rest is an accompaniment that might be cut out without regret, greatly to the advantage of the picture" (p. 159), he sounds like the hard-nosed, literalist Judd of the late sixties; however, when he announces: "What amazes in Paul Potter is the imitation of objects pushed to an extreme. It is ignored or it is not noticed in such a case that the painter's soul is worth more than the work, and his manner of feeling infinitely superior to the result" (p. 159), he sounds like a sensible critic, much like the early Judd at his best, one who loves what he sees, what he hopes will be realized. Fromentin's "rough" criti-

cism reminds us that no one appreciated the potential of the extremes available to abstraction better than Judd in the sixties; no one sensed the expanding souls of Malevich and Newman better than he.

Fromentin reminds us that "when he painted the Bull in 1647, Paul Potter was . . . a very young man, and according to what is common among men of twenty-three, he was a mere child" (p. 159). For some there are more echoes of the 1960s in these words than might meet the ear. Take, as an example, the first printed criticism of my work, which appeared in the *New Yorker* in 1960. There Robert Coates lamented "how sad it was to see the 23-year-old Frank Stella right back where Mondrian was twenty-five years ago." I realized that this remark was a polite put-down; nevertheless, the thrill it gave me was overpowering. It would have been an honor to be right back where Mondrian was twenty-five years ago, if that had been the case; but even without that possibility, the fact that my name appeared in print in the same sentence with Mondrian's seemed to be an incredible affirmation of personality and ability. It actually took me a while to get over the shock of publicity, the quick glare of history passing over me. Essentially, my psychic readjustment dampened youthful fantasies; the dream of achieving freedom through the establishment of an artistic identity faded.

To do what I was able to do, and what I am able to do now, I walk on roads built by others. It seems obvious that all that effort preceding me should have taken its toll, yet the image I held of successful artists (one mostly taken from magazines) always showed them poised and healthy. In some ways I am more amazed now by Mondrian's ability to project himself as a marvelous, autocratic, aesthetic technician

Plate 31 FRANK STELLA
Leblon II (1975)
Mixed media on honeycombed aluminum, 80 × 116 in.
Collection: Frank Stella

Plate 32 FRANK STELLA
Chocorua III (1966)
Alkyd and epoxy paint on canvas, 120 × 128 in.
Collection: Frank Stella

Plate 33 FRANK STELLA
Gur III (1968)
Fluorescent alkyd on canvas, 120 × 180 in.
The Love Collection, Palm Beach, Florida

Plate 34 FRANK STELLA
Maha-lat (maquette for *Indian Bird Series;* 1977)
Printed metal alloy sheets, wire mesh, and soldered and welded metal
 scraps with crayon, 15½ × 20 in.
Collection: The Museum of Modern Art, New York
Fractional gift of the artist

Plate 35 FRANK STELLA
Thruxton 3X (1982)
Mixed media on etched aluminum, 75 × 85 × 15 in.
The Shidler Collection, Honolulu, Hawaii

Plate 36 FRANK STELLA
Valpariso Flesh and Green (1963)
Metallic paint on canvas, 78 × 135¼ in.
Collection: Frank Stella

than I am by the beauty of his work. Similarly, I marvel at the success of Picasso's cavalier pose as a creator of horizon-filling monuments of pictorial genius. What I see now is a series of images of tired, gnarled, old, desperate men. Who else could have made what they made?

Still, life is more wonderful than the imagination and recall of the people who live it. What saves painting is that a totality of experience drives it, lifting it above the pettiness of encounters between creator and critic. When Fromentin tries to account for Potter's youthful success, he suggests in passing something that is as obvious as it is important. He remarks: "Till 1647 Paul Potter lived between Amsterdam and Haarlem, that is, between Franz Hals and Rembrandt, in the heart of the most active, the most stirring art, the richest in celebrated masters, that the world has ever known, except in Italy in the preceding century" (p. 160). Fromentin's statement describes exactly what I felt in New York in 1958 living between Pollock and de Kooning, in the heart of the most active, most stirring art, with the exception perhaps of Paris in the preceding century. I believed I was surrounded by great painting. Exciting abstract expressionist painting seemed to be everywhere. I went from gallery to gallery, museum to museum, opening to opening, and then back to my studio to look at my own painting. Sometimes, walking down Madison Avenue, I would look up and try to find the Empire State Building, hoping to orient myself, trying to get a grip on things; in the process I would find a piece of it, and build the rest of the image in my mind. Almost inevitably, as soon as the image of the Empire State Building was completed it would be shifted aside to accommodate the image of a painting. I remember holding Barnett Newman's *Ulysses* back (fig. 48), trying to keep its pushy blueness from toppling the Empire State Building. What seems to me now to be special about my experience in New York in the late fifties is this sense of literal pictorial support. The painting activity surrounding me held me up physically and emotionally. The painting that was flowering everywhere was very open and available; somehow the supposed aloofness of its creators was unable to sustain itself in the public work. I may have felt lonely in New York, but I never felt shut out.

I do not think it was a conscious effort on my part, but I came to New York in the summer of 1958 well-prepared even though I was convinced that it would only be a temporary stay. After graduation from Princeton in June, I was planning to paint in the city until the following September, at which time I expected to be drafted into the Army in Boston. When I failed the physical examination because of a faulty opposition between the thumb and fingers of my left hand resulting from a childhood accident, I was stunned. The only thing I could think to do was to get back to New York as quickly as possible before my parents could start grilling me on my plans for the future. When I got there, I suddenly had to look at my paintings and my ideas about painting with an urgency I had not experienced before. I looked at the enameled, dripping bands spreading across the cotton duck in front of me and tried to imagine how they were going to feed me. It seemed hopeless, so I began to think about working part-time at the only trade I knew—house painting.

Something started to happen that fall which surprised me. I was very good at being alone with nothing but my own painting and my own images of other people's painting. For the following eighteen months, I lived in a world dominated by painting. There was almost no distraction and no conflict. I stress this remark because the literature about the late fifties always emphasizes a reaction in my work against what was then a dominant mode of painting. There must be some truth to the descriptions, and certainly some of my own argumentative assertions seem to support that view, but the fact is that the paintings I made are completely acceptable as standard, normative abstract expressionist works, and the only significant difference between my work of the late fifties and early sixties and most of the work surrounding it was

Figure 48 BARNETT NEWMAN
Ulysses (1952)
Oil on canvas, 11 ft. × 4 ft. 2 in.
Collection: Domenique de Menil, New York

the way it looked to other people. True, it looked different, but the spirit and feeling were so close to everything going on around me that I was surprised by the hostility and ridicule it evoked. I had expected to be criticized for not being different enough, for not having developed enough. I thought I had found a way to make pigment and the space described by its manipulative gesture a bit more definite, a bit more discreet, and finally, quite a bit more concrete. Essentially I did something which I could not understand that well in terms of the reactions of others.

I remember being infuriated by a friend's account of Leo Steinberg's description of the space in my black stripe paintings when he cited the similarity of their spatial organization to the recessional character of perspectival Italian Renaissance space. This was exactly the opposite of what I intended; I wanted everything to be on the surface. Furthermore, I saw a tremendous threat in any comparison with Italian Renaissance painting. A paranoid instinct told me that if the humanism of the past was not used successfully as a club to beat abstraction to death, it would be used as a sponge to absorb and smother it to death. Now, although I would disagree with Steinberg's spatial reading, I cannot deny that the link to Italian painting in my work is obvious. Here we have, I think, come close to the core, both physical and psychological, of my attitude toward the dilemma of abstraction. It is my artistic will and destiny, for better or worse, to be a pragmatic classicist. My work will be half acquired New England experience, half unconsciously held Mediterranean gift.

This means that on an intellectual level, the thin, planar, stingy, practical abstraction of antimaterialism is readily available. In a sense the Protestant sensibility of New England reminds one that Protestant painting in the north of Europe was only too willing to be abstract. However, on an emotional level there is no resonance from the efficacy of this bias; in fact there are the beginnings of a conflict. What I want to do, and what I believe abstract painting itself

wants to do today, is to bring some of the solidity of Italian painting into the foreground of our painting experience. We need to establish a productive tie to Cubism and its forefather, Renaissance classicism. In this context it is worth reconsidering one of the biggest misapprehensions of current art criticism, one that first appeared in the late sixties or early seventies—the notion that the best abstract painting defined itself by being post-Cubist. The truth was that abstract painting defined its fundamental inviability by its inability to gain access to Cubism's material strength.

The attraction of Potter's bull is the attraction of innocence. The way his bull trots between Hals and Rembrandt toward the future seems similar to the way my early stripe paintings moved between Pollock and de Kooning relatively uninfluenced, undeflected by their powerful presence. While Pollock and de Kooning struggled with the stubborn armatures of Cubism, the stripe paintings, largely unconsciously, turned those twisted armatures into flattened, surprisingly substantial presences. Their ability to bring a weighted flatness, a dimensionally coherent presence to the new surface of painting, the cotton duck field, combined with the ability to spread that symmetrical coherence across and into that same field with a convincing pictorial tension, made them unique. It was hard to see at that time where they came from.

I took it for granted that the stripe paintings came from a fairly natural adaptation of overall post–World War II painting to a landscape instinct tempered toward abstract rendering. In fact, that is the way the paintings actually developed—for example, from *Coney Island* (fig. 49) to *Astoria* to *Delta* (fig. 50; all 1958). However, when I superimposed a simple idea of banded organizational symmetry on top of landscape gestures, the resulting development changed everything. It completely changed the way I understood what I thought I knew about the painting of the past, in

Figure 49 FRANK STELLA
Coney Island (1958)
Oil on canvas, 85¼ × 78¾ in.
Yale University Art Gallery
Gift of Larom B. Munson, B.A. 1951

Figure 50 FRANK STELLA
Delta (1958)
Enamel on canvas, 85 × 96 in.
Collection: Frank Stella

two significant ways: first, it gave me a very clear sense of how the making of painting was sucked into the continuum of painting; how painting, especially for those who were making it, had become an amazing, coherent, growing organism, much more independent of history and perhaps even of psychology than one would have thought possible. It hit me that there was an "art history" alive and well, with which the artist must make his peace. Second—and this was something that as a young man one could not say in public because it was certain to invite ridicule—once one had become part of this organism, one had the power to influence it. This was pretty heady business, but the access to power was tempered by a sense of responsibility which introduced the possibility of a new kind of failure. It was not enough to worry that in the pursuit of art one might fail to catch up to it; in addition, one had to worry about doing part of the job to keep it running.

The change from student to participant changed my position as an observer of art making and art history. I adapted pretty well. I was deficient in amount of experience but not in intensity of experience, which turned out to be not so much a handicap as it was simply a definition of circumstance—in this case, youth. I had a goal: to paint abstract paintings. By that I meant to make paintings which were faithful to the visual culture of the past, but which were still free from their dependence on conventional representational models. I really believed that the cord to normal vision could be cut, and that painting could live in a world of its own. I wanted an independence expressed in painting which obviously on another level reflected my desire to be independent from my family, from the strictures of responsibility and authority.

My dream, or perhaps my desire, as far as painting went, had already been realized to a certain extent by postwar abstract expressionism, especially by Pollock and de Kooning, but I sensed something in their work which worried me more than the stunning level of their accomplishment im-

pressed me. I sensed a hesitancy, a doubt of some vague dimension which made their work touching, but to me somehow too vulnerable. It did not seem right or fair that work such as Pollock's or de Kooning's should be subjected to threats from the representational painting of the past. Although I knew it did not make any strict sense, I was convinced that a completely independent abstract art, one that had really severed its roots from a representational bias for pictorial depiction, would be an improvement, and would preserve and defend the accomplishment of abstract expressionist painting. Even now, writing twenty-five years after the fact, it is hard to know whether describing this ambition sounds simple or naive. All I can say is that the ambition was born in the paintings made in 1958 from June to November in New York City.

When I painted over landscape-derived abstract painting with a rigid symmetrical pattern (fig. 51), I made paintings that successfully canceled out their origins. Others had done what I had done, but they were not able to hold the line. I saw in front of me a system that would guarantee the exclusion of painterly gestures which in seemingly abstract painting always brought the ghost of figuration with them. But I was so eager for freedom and independence that I had no sense of consequence. If anyone had hinted to me that a real establishment of abstraction on truly independent footing would be the beginnings of its problems, I would have dismissed the warning as clever, wishful drivel. Unfortunately, this hypothetical warning anticipated a real danger. My greatest fear at the time was that abstract art would be weakened in its stance against representational art—that somehow abstract art would never get to be the main current, that it would simply be a tributary absorbed casually into the flow of Western visual culture, that by itself it would never be the surging, flooding crest of Western art.

Figure 51 FRANK STELLA
Point of Pines (1959)
Black enamel on canvas, 83¾ × 109⅛ in.
Collection: Frank Stella

My optimism for the future is based on a feeling that what in the late fifties helped my paintings attain—if it is possible to say such a thing—a greater, more coherent, more understandable, and more clearly felt level of pictorial abstraction is the same thing that will help them meet the present crisis in abstract painting with a positive solution. The success of abstract painting of the sixties (plates 32, 33) was based on a collective effort which took off from the immediately preceding successes of the giants of abstract expressionism. It sustained its success as well as it did because it was able to reach a little deeper, to be a little less self-conscious about its debt to Cubism and a European past. In effect, 1960s abstraction was able to avoid the struggle which Pollock and de Kooning could not, the struggle with Picasso.

Abstract expressionism shielded the generation succeeding it from the heavy arm of European modernism, a solid Mediterranean limb wielding the hammer of material presence. This protection allowed 1960s painting direct access to the founders of abstraction—to Mondrian, Kandinsky, and Malevich. The free, unfettered access to abstraction's early roots had a wonderful and powerful effect: close attention to the early masters coupled with a natural, relaxed attitude toward enlarged pictorial scale and gesture made exciting painting. Jack Youngerman, Ellsworth Kelly, and Sam Francis took off in what seemed like a marvelous, yet familiar, vector. Helen Frankenthaler and Friedel Dzubas were reaching new, relaxed, lyrical heights. Morris Louis, Kenneth Noland, and Jules Olitski undertook an exotic trip in search of firstness, while Donald Judd, Larry (now Lawrence) Poons, and I laid the track to literalism. At the same time what Phil Leider called "the other kind of art" was quite powerful too—Jasper Johns, Jim Rosenquist, and Roy Lichtenstein, for example. Whether the strength of these last three came from similar sources is hard to say for certain, but to me it seems likely enough, especially if we look at the painting.

At issue, though, is not the beauty and success of 1960s American painting but its apparent decline in the 1970s (fig. 52). It is hard to tell if abstract painting actually got worse, if it merely stagnated, or if it simply looked bad in comparison to the hopes its own accomplishments had raised. It is possible that all three observations are true, but for me the last description is the most telling. What bothers me is not so much that efforts might have been bad but that the hopes have been tarnished, essentially enervated by the failure to maintain the momentum of the sixties.

Although I have a pretty good idea of what I have done and what I am going to do about the situation confronting abstraction, I offer, for what it is worth, what I think painting as our collective endeavor has to do to right itself. It has to understand its successes better, and it has to understand its sources better. With a better understanding of its accomplishments and its past, painting has to build in order to flower again. The authentic, innovative brightness and expansiveness of the sixties can support structures of even greater light and reach. The roots of 1960s abstraction, so thoroughly grounded in the abstraction of the north, in the encouraging antimaterialism of Mondrian, Kandinsky, and Malevich, must be reinforced with energy drawn from the realism of the south—the tough, stubborn materialism of Cézanne, Monet, and Picasso. It seems obvious that the future of abstraction depends on its ability to wrest nourishment from the reluctant, unwilling sources of twentieth-century abstraction: Cézanne, Monet, and Picasso, who insist that if abstraction is to drive the endeavor of painting it must make painting real—real like the painting that flourished in sixteenth-century Italy.

Figure 52 FRANK STELLA
Warka III (1973)
Mixed media, tilted relief, 93 × 100 in.
Collection: Frank Stella

At the time when I was painting black enamel stripes into cotton duck, I remember hearing a lot about Caravaggio. As the praise mounted for his importance and inventiveness, I thought to myself: "I hate Caravaggio; that's representational painting. It's ordinary. That's what they love; that's what they will never give up—its ordinariness. I want painting to be special, not ordinary. Abstraction is special; they're never going to like it." I was wrong on a lot of counts. Caravaggio was ordinary, but he invented an ordinariness that has carried painting farther than any such single effort; and although abstraction is special, its specialness can be defined by its ordinariness.

It is hard to gauge the significance of first experiences with endeavors that later become the working, effortful focus of one's life. At Andover I was already interested in art, but the opportunities there seemed to thrust themselves at me. The idea that in the midst of a grinding mechanism of elite education, Andover offered an oasis of self-indulgence and pleasure—a major course in studio art, eight hours a week in which one could smear free Cadmium red around on shellacked cardboard rather than face the chemistry lab—seemed unbelievable. When I signed up for a preliminary prerequisite course, half art history and half studio, I was very anxious. I wanted to qualify for the major course.

The first problem we were given in the studio was a still-life setup. We were told to make a painting from it. The studio was in the basement of the Addison Gallery, where upstairs on the walls one could look at a small, concise, up-to-date history of American painting. I had been through the gallery quite a few times, and I knew what I liked. I remember Winslow Homer's *West Wind* and a Frederic Remington painting of a wolf howling in a night of wild acid green.

Another early picture that stood out for me was an Eakins portrait whose painted gold frame had inscriptions drawn over it. These paintings represented the past for me as I looked at the still-life objects I was supposed to deal with on the table in front of me. I started to look around the studio at some of the other students' paintings and at the paintings our teacher, Patrick Morgan, was making in the corner by the window, by the north light, which I guessed was his prerogative as an artist. I couldn't help thinking how much nicer it was down at my end by the southern exposure—much warmer with much more light. I liked what Pat was doing, the naturalness of his commitment to abstraction (fig. 53), and I liked the precocious intensity of the work of some of the advanced students, hipsters like Hollis Frampton and Carl Andre. I wanted to make abstract paintings, paintings with just paint.

When I looked up at the table I saw some sickly ivy coming out of a pot and thought, "I don't want to learn how to paint that; it's too dreary. I want to paint like the recent American abstract painting upstairs, like some of the paintings I've seen at Pat's house." I thought of these and remembered some of Maud Morgan's paintings (fig. 54) and a votive lights painting by Loren McIver. Something about their size and intensity seemed to relate to the ivy and the cast-iron angle brace on the table.

Then my mind began to wander; I started dreaming of a big black and white Franz Kline, and I started to imagine my hands on the house-painting brushes I had used with my father that summer. With the brush in hand, I remembered mixing the paint, pouring it from gallon can to gallon can after stirring in the gooey tinting pigment. That made me think of the Pollock upstairs. It was hard to take my hand away from the mixing sticks, hard to stop fantasizing about swirling the dripping skeins over the floor. I remembered my parents talking about the floor-spattering techniques

Figure 53 PATRICK MORGAN
Untitled (1951)
Oil on board, 16 × 9⁷/₁₆ in.
Collection: Frank Stella

used to simulate linoleum patterns. But this seemed too messy, and I pushed the dripped line aside in favor of the fabulous brush line in a Hans Hofmann painting I had seen at the Morgans' house. That line seemed to represent an almost incomprehensible gesture. What did the brush look like that had such a flexible, slender tip, a tip that could move so far, so fast and still carry such a load of pigment, such an intense red?

Then I woke up. The Hofmann triggered something; it must have been the image of the load of pigment. A lecture about Seurat and neo-Impressionism started to replay itself in my mind—daubs of pigment on top of each other and next to each other, mixing optically to create the complementary colors observed in nature. Then I looked at the vine on the table, at the shadows and the play of light. I did not see anything that reminded me of Seurat, just as the slides of Seurat paintings that I had seen had not reminded me of anything other than a reductive static scheme of things I might have seen. That was it. My fingers tapped the equation on the counter top: static scheme plus daubs of pigment equal a still-life painting. Problem solved.

The elation carried me pretty high; I was sure that I would qualify, and I was sure that I would never have to look back, that I would never have to account for anything more than what my hand made. I knew that my hand was not going to make any more renditions, no matter how schematic, of potted ivy and table tops. I finished my painting (fig. 55) in thirty minutes. It received mixed reviews; but all that really mattered was that I was free to make the kind of paintings I really wanted to make. In that small moment of confrontation when I felt I had to do it or forget it, I formed my basic feeling about abstract painting, although I did not know it at the time. In the thirty or so years since that date, nothing in my experience of looking at and making painting has given me cause to doubt what I believed then and what I believe now.

First, I believe that access to abstraction to anyone born after 1936 is direct and unencumbered. One wants to do it and one does; it is that simple. If a young person walks through a gallery of American painting in 1950 and confronts the work of Copley, Inness, Sargent, Eakins, Remington, Homer, Dove, Hartley, Hofmann, Pollock, and Kline, he will want to paint like Hofmann, Pollock, and Kline, admiring Hartley and Dove for their proximity to the former, and acknowledging the rest for their accomplishment and effort in facing the task of art. Looking at what happened and what is happening, one has to want to do what is happening. Immediate sources count for a lot.

Second, I feel that abstraction became superior to representationalism as a mode of painting after 1945. This is obvious on the level of physical and visual excitement, on the level of pictorial substance and vitality. It also established its superiority on a theoretical level: abstraction has the best chance of any pictorial attitude to be inclusive about the expanding sum of our culture's knowledge. It is flexible and expansive. It has no need to be exclusive, even perhaps of representationalism itself.

Finally, in terms of my own pictorial experience (plates 34–36) I believe that abstraction faces no limits to expansion and extension, either in the direction of magnification or of reduction. It is innately well suited for growth. It avoids, for example, some of the obvious problems of realism, in which billboard technique often reduces representationalism to a form of abstraction by magnification. In practice, if not in theory, a face ceases to be much of a face if it gets big enough. With abstraction the problem is more one of sustaining pictorial energy than of keeping an image intact. The size of an abstract painting never has to account to our everyday sense of scale; there is no point in comparing an

Figure 54 MAUD MORGAN
Minatory (1951)
Oil on board, 29 × 24 in.
Harvard University Art Museums, Cambridge, Massachusetts
Gift: Boston Society of Independent Artists, Inc.

Figure 55 FRANK STELLA
Still life (1954)
Oil on paper, 19 × 25 in.
Collection: Addison Gallery of American Art,
 Phillips Academy, Andover, Massachusetts

abstract image with an image from the real world. Abstraction has the freedom to be large without magnification, the ability to be small without miniaturization. In a sense abstraction gains its freedom, its unfettered expandability, its own working space by eluding the spatial dictates of the real and the ideal image. Clearly, abstraction today works to make its own space.

All these arguments may be open to dispute, but the fact remains that where it counts, on the pictorial surface, there has not been a serious challenge to abstraction in the last thirty years. The only challenges come from within. Sometimes they echo problems from the past, but mostly they just reflect our uneven abilities as we confront the challenge of making art.

Illustration Credits

Index

Illustration Credits

Photographs of works in museums and private collections, unless otherwise noted below, were provided by and are reproduced through the courtesy of the individuals and institutions indicated in the captions.

Black and White Photographs

Alinari/Art Resource, New York: 9, 10, 17
Earl Childress, photographer: 47
Ken Cohen, photographer: 13
David Heald, photographer: 34
Robert E. Mates, photographer: 32, 33, 35
Eric Pollitzer, photographer: 52
Steven Sloman, photographer: 51, 53
V.A.G.A., New York (copyright 1986): 1, 5, 12, 13, 21, 22, 23, 24, 26, 32, 33, 34, 35, 38, 46

Color Plates

Earl Childress, photographer: 30
Bruce C. Jones, photographer: 34
Jacqueline Hyde, photographer: 24
Museum of Modern Art, New York: 18
Photo Meyer, Vienna: 1, 6, 11, 12, 25
Scala/Art Resource, New York: 2, 3, 4, 16, 22, 28
Steven Sloman, photographer: 31, 32, 35, 36
V.A.G.A., New York (copyright 1986): 13, 14, 17, 18, 19, 23, 24

Index

Abstract expressionism, 42, 66, 110, 153, 158, 160; and Kandinsky, 113, 120, 123

Abstraction, 99, 143, 146; and Kandinsky, 1, 46, 71, 74, 79, 84, 109–110, 113, 116, 120, 123, 125, 131, 134, 160; and Mondrian, 1, 46, 77, 79, 82, 84, 131, 134, 160; and Pollock, 1, 55, 60, 61, 82, 84, 110; and color-field abstractionists, 1, 64, 66, 97; and Caravaggio, 4, 5, 12, 22, 35, 41, 43, 131, 134, 141; and space, 5, 12, 22, 35, 41, 42–43, 46, 60, 64–66, 71, 74, 77, 82, 84, 98, 104, 116, 120, 167; and illusionism, 12, 22, 65–66, 79, 82, 97–98, 141; and Rubens, 22, 41, 43, 54–55, 60, 61, 66; and surface, 42, 46, 51, 82, 84, 97, 98, 113, 116, 167; and formalist abstraction, 42, 60; and surface, 42, 46, 51, 82, 84, 97, 98, 113, 116, 167; and pigment, 43, 46, 55, 66, 71, 77, 82, 110, 116, 120; and realism, 61, 68, 71, 74, 77, 79, 82, 84, 98, 110, 113, 134, 164; and figuration, 71, 74, 77, 79, 82, 116, 123; and Picasso, 71, 74, 77, 79, 84, 89, 160; and Malevich, 71, 74, 77, 79, 84, 97, 131, 134, 160; and volume, 71, 77, 79, 82, 91, 97, 98, 116; beginnings of, 110, 120, 131; and modernism, 110, 113; and Paulus Potter, 131, 134, 141, 145; and F. Stella, 131, 153, 155, 158, 160, 162, 164, 167

Alberti, Leone Battista, 46, 65

Altdorfer, Albrecht, 70

Andrea del Sarto, 38

Andre, Carl, 162

Architecture, in painting, 5–6, 10–11, 54; and Caravaggio, 5, 12, 18, 23, 27–28, 33–34

Barocci, Federico, 41, 46, 54

Baroque art, 11, 27, 41, 43

Bellori, G. P., 17

Berenson, Bernard, 18–19, 46

Bergman, Ingmar, 18

Bloemart, Abraham, 143

Botticelli, Sandro, 12, 19, 28, 34, 40, 64

Bronzino, Agnolo, 23, 54
 WORKS: *Saint John the Baptist* (pl. 2), 10–11, 12, 14

Brooks, Mel, 18

Calder, Alexander, 109

Caravaggio, 65, 66, 91, 162; and space, 4–6, 9–11, 12, 18–19, 22, 23, 27–28, 33, 35, 46, 64, 68, 100, 103–104; and realism, 11–12, 17–19, 22, 34, 54, 68; and surface, 11–12, 19, 35, 100; and light, 12, 17, 18, 70, 145; and Raphael, 23, 26–28, 34, 35, 38, 43, 50, 51; and Rubens, 23, 26, 28, 35, 38, 40–41, 55, 64, 68; and abstraction, 35, 41, 43, 46, 99–100, 134, 141; and Annibale Carracci, 47, 50, 51, 55; and Kandinsky, 103–104, 109
 WORKS: *Beheading of Saint John the Baptist*, 4, 17; *Calling of Saint Matthew*, 5, 12, 17, 26; *Conversion of Saint Paul* (pl. 28), 27, 131, 134, 138, 144; *David and Goliath* (pl. 22), 99–100, 103–104, 106, 109, 123; *Death of the Virgin* (fig. 14), 47, 48; *Deposition*, 4, 11; *Entombment*, 40–41; *Madonna of the Rosary* (pl. 6), 27–28, 30, 33–35, 38; *Martyrdom of Saint Matthew* (pl. 4), 9, 12, 16, 17, 18, 26, 50; *Narcissus*, 27; *Saint John the Baptist* (pl. 3), 12, 15, 23; *Seven Acts of Mercy*, 11; *Supper at Emmaus* (fig. 7), 23, 24

Carracci, Annibale, 35, 47, 50–51, 54–55
 WORKS: *Assumption of the Virgin* (pl. 7), 31, 43; Farnese Gallery, ceiling fresco (fig. 16), 12, 33, 50–52; *Resurrection of Christ*, 50; *Madonna and Child in Glory with Saints* (pl. 9), 47, 50, 56

Carracci, the, 19, 23, 38, 46, 50, 54, 66, 70

Cézanne, Paul, 79, 92, 116, 160
 WORKS: *Bathing Women*, 113; *Large Bathers* (fig. 37), 116, 118

Chia, Sandro, 41

Chiaroscuro, 6, 11, 28, 35, 65, 91, 92, 134

Classicism, 12; and Poussin, 4, 22; and Caravaggio, 4, 23, 27, 28, 33, 141; and the Renaissance, 4, 27, 34, 35, 155; and Annibale Carracci, 47, 50; and Picasso, 71, 79, 91, 92; and abstraction, 134, 141, 155

Clemente, Francesco, 41

Coates, Robert, 146

Color: and abstraction, 1, 12, 42, 64, 66, 97, 123; Venetian, 4, 6, 22, 23; and Rubens, 22, 23, 38; and Raphael, 35, 38; and Mondrian, 79, 82

Contrapposto, 74

Copley, John Singleton, 164

Correggio, 19, 38, 54, 66

Crivelli, Carlo, 5, 34

Cubism, 60, 66, 97, 123; and abstraction, 1, 42, 46, 51, 77, 79, 110, 116, 155, 160; Picasso's break with, 71, 74, 77, 79, 89, 91–92

Cucchi, Enzo, 41

David, Jacques Louis, 33
Decoration, 5, 10, 12, 33, 42, 50–51
De Kooning, Willem, 23, 110, 127, 153, 155, 158, 160
 works: *Suburb in Havana* (fig. 42), 127, 128
Delacroix, Eugène, 5, 22
Donatello, 1
Dossi, Dosso
 works: *Jupiter, Mercury, and Venus* (pl. 25), 127, 135
Dove, Arthur G., 164
Dzubas, Friedel, 160

Eakins, Thomas, 162, 164
Expressionism, 120, 123; International, 42

Fassbinder, Rainer Werner, 18
Fauvism, 116
Fellini, Federico, 18
Figuration, 4, 5, 60, 134; and Caravaggio, 11, 26–27, 55; and Raphael, 28, 35; and Pollock, 61; and abstraction, 71, 74, 77, 79, 82, 116, 123
Fiorentino, Rosso, 23, 54
Flatness, 42, 43, 51, 74, 97, 125, 155; before Caravaggio, 4, 5, 28; and Cubism, 71, 77
Floris, Franz, 64
Foreshortening, 4, 10, 11, 74
Formalist abstraction, 42, 60
Frampton, Hollis, 162
Francis, Sam, 41, 160
Francken, Hieronymus, 143
Frankenthaler, Helen, 41, 64, 110, 160
Fromentin, Eugène, 145–146, 153

Géricault, Théodore, 22, 38
 works: *Deposition*, after Rubens, 38; *Entombment*, after Caravaggio, 40–41; *The Raft of the "Medusa"* (fig. 11), 38, 39
Giordano, Luca, 42
Giorgione, 4
Giotto, 1, 64
Giulio Romano, 66, 100
Gonzalez, Julio
 works: *Reclining Figure* (fig. 21), 69, 70
Gossaert, Jan, 70
Gothic art, 103
Goya, Francisco, 64

Graffiti, 51, 143
 works: "Miracle of the Lower East Side" (fig. 47), 141, 142; "Working Space" (pl. 30), 134, 140
Guggenheim Foundation, 109–110
Guggenheim, Solomon R., 109

Hals, Franz, 153, 155
Hartley, Marsden, 164
Hayter, Stanley William, 103–104, 109
Hofmann, Hans, 46, 74, 120, 123, 164
 works: *Spring* (fig. 40), 122, 123
Homer, Winslow, 164
 works: *West Wind*, 162

Illumination, manuscript, 1, 33, 65
Illusionism, 1, 10, 28; and Caravaggio, 4, 11, 12, 19, 22, 33, 54, 55, 141; and sixteenth-century Italian art, 12, 40, 51, 66; and Rubens, 40, 54–55, 60; and modern art, 66, 79, 82, 97, 98, 113, 141
Illustration, 1, 5, 79, 84, 89, 100, 104; post-Renaissance, 12, 40, 41; and abstraction, 42, 43, 46, 65, 113, 141
Impressionism, 46, 56, 79, 110, 116, 141, 145
Inness, George, 164

James, Henry, 102
Johns, Jasper, 160
Judd, Donald, 146, 160

Kandinsky, Wassily, 74, 79, 99; and abstraction, 1, 46, 71, 110, 113, 116, 120, 123, 125, 131, 134, 160; and space, 42, 71, 79, 97, 103–104, 113, 120; and Picasso and Malevich, 84, 89, 91, 97; as successor to Caravaggio and Titian, 103–104, 109; late paintings of, 110, 116, 120, 123, 125; and weightless composition, 116, 123
 works: *Allusion*, 120; *Ambiguity (Complex/Simple)* (pl. 23), 107, 120; *Black Lines* (fig. 32), 110, 111; *Composition IV* (fig. 24), 75; *Composition IX* (pl. 24), 108, 123, 125; *Composition X* (fig. 38), 116, 119; *Dominant Curve*, 90; *Horizontal Blue* (fig. 34), 110, 114; *K622*, 120; *Painting with Black Arch*, 84; *Pink Sweet* (fig. 35), 110, 115; *Red Oval*, 97; *Sketch 1 for Composition VII* (fig. 1), 2; *Sky Blue* (fig. 46), 131, 133; *White Center* (fig. 33), 110, 112
Kelly, Ellsworth, 41, 160
Klee, Paul, 120
Kline, Franz, 162, 164
Kosuth, Joseph, 127
 works: *The Seventh Investigation (A.A.I.A.I.) Proposition One (Context), Part B* (fig. 44), 127, 130

andscape, 6, 18, 65, 134, 145; abstract, 71, 77, 82, 120

aocoön, 34, 60

ascaux, 65, 144; Red Cow and Chinese Horse (pl. 29), 134, 139, 141, 143

eider, Philip, 160

e Nain, Louis, 91

eonardo da Vinci, 4, 5, 6, 11
 WORKS: *Last Supper,* 10; *Mona Lisa* (fig. 3), 5, 6, 7

ichtenstein, Roy, 160

ight, 5, 6, 33, 91, 92, 145; and Caravaggio, 11, 12, 17, 18, 28; and Mondrian, 79, 82; and shading, 98, 113

ouis, Morris, 12, 46, 64, 66, 97, 123, 125, 160
 WORKS: *Alpha Gamma* (fig. 20), 67

1alevich, Kasimir, 42, 74, 79, 120, 146; and abstraction, 71, 77, 99, 131, 134, 160; and Picasso, 84, 89, 91, 92, 97, 98
 WORKS: *Black Cross,* 84; *Girls in the Field* (pl. 20), 92, 96, 97; *Red Riders* (fig. 45), 131, 132; *Suprematist Composition: White on White* (fig. 25), 71, 76; *Yellow Quadrilateral on White,* 97

1anet, Édouard, 4, 9, 12, 21, 33, 35, 40, 143

1annerism, 10, 43, 47, 74; and Caravaggio, 4, 27, 109; and Michelangelo, 11, 54, 65; and Rubens, 23, 55, 60, 64, 109; northern, 143

1aratta, Carlo, 41, 42
 WORKS: *Immaculate Conception* (pl. 8), 32, 43

1atisse, Henri, 46, 120

1cIver, Loren, 162

1edieval art, 5, 34, 38, 65

1ichelangelo, 1, 4, 6, 12, 26, 50–51; mannerism of, 11, 23, 33, 54, 65
 WORKS: *Last Judgment,* 10, 54, 60; Sistine Chapel, ceiling fresco (fig. 17), 10, 12, 33, 50–51, 53–54

Miracle of the Lower East Side" (fig. 47), 141, 142

1odernism, 64, 110, 113, 134; and space, 43, 82, 120; and Picasso, 71, 77; and illusionism, 97–98; European, 120, 160

1ondrian, Piet, 1, 5, 89, 91, 120, 146; and space, 12, 22, 42, 79, 82, 84; and pictorial energy, 22, 79, 82, 99; and abstraction, 46, 77, 79, 99, 131, 134, 160
 WORKS: *Broadway Boogie-Woogie* (pl. 13), 82, 84, 85; *Composition in White, Black, and Red* (pl. 14), 82, 86; *Composition in Yellow, Blue, and White, I* (fig. 5), 20, 22; *New York,* 82; *Victory Boogie-Woogie,* 82

Monet, Claude, 5, 22, 23, 92, 110, 160

Moravia, Alberto, 131

Morgan, Maud, 162
 WORKS: *Minatory* (fig. 54), 165

Morgan, Patrick, 162, 164
 WORKS: Untitled, 163

Motherwell, Robert, 64, 123

Naturalism, 4, 12, 35, 47, 55, 134

Negative intervals, 141, 143

Neo-Impressionism, 164

Newman, Barnett, 1, 42, 46, 66, 84, 123, 125, 146
 WORKS: *Dionysius* (fig. 41), 123–125; *Ulysses* (fig. 48), 153, 154

Noland, Kenneth, 41, 43, 97, 123, 160
 WORKS: *17th Stage* (fig. 12), 43, 44

Olitski, Jules, 41, 43, 160
 WORKS: *Radical Love 8* (fig. 13), 43, 45

Painterliness, 5, 11, 12, 82; Venetian, 4, 22, 23; and Rubens, 22, 23, 35, 54, 68; and Raphael, 35

Palma Giovane, 100

Panofsky, Erwin, 100, 102

Parmigianino, 23, 54

Perspective, 4, 5, 46, 77; Renaissance, 6, 34, 51, 64–65, 155

Perugino, Pietro, 19

Phidias, 1

Picasso, Pablo, 5, 43, 61, 120, 153, 160; break with Cubism, 71, 74, 77, 79, 84, 89, 91–92, 97
 WORKS: *Bather with a Beach Ball* (fig. 26), 77, 78; *Guernica,* 64; *Ma Jolie (Woman with a Guitar)* (fig. 22), 71, 72; *Seated Woman* (pl. 17), 89, 91–92, 93; *Seated Female Nude with Crossed Legs* (pl. 19), 92, 95; *Still Life with Chair Caning,* 84; *Woman Dressing Her Hair* (pl. 18), 92, 94; *Woman Seated at Seashore* (fig. 23), 73

Piero della Francesca, 12

Pietro da Cortona, 41, 42, 46, 51

Pigment: and Venetian painting, 4, 23, 104; and abstraction, 5, 42, 46, 66, 68, 110, 116, 120; and Rubens, 23, 43, 55, 68, 70, 110; and Pollock, 55, 60, 82, 110; and Picasso, 71, 89, 91, 92; and Kandinsky, 74, 89, 97, 116, 120; and Mondrian, 77, 79, 82; and Malevich, 77, 89; and Stella, 155, 164

Point of view, 10, 77; and Kandinsky, 89, 116, 120
Pollock, Jackson, 22, 91, 164; and contemporary painting, 1, 12, 46, 55–56, 61, 64, 110; and space, 12, 42, 56, 82, 84; and Rubens, 55, 60, 61, 64, 110; drip paintings, 55, 60, 61, 64, 82, 84, 110; later works, 61, 64; and Cubism, 61, 155, 160; and Kandinsky, 120, 123; and F. Stella, 153, 155, 158, 162, 164
 WORKS: *Autumn Rhythm*, 84; *Blue Poles*, 84; *Number 1, 1948* (fig. 6), 21, 82; *Number 3, 1949: Tiger* (fig. 18), 62; *Number 23, 1951 (Frogman)* (fig. 27), 61, 77, 80; *Number 28, 1951* (fig. 29), 82, 83; *Out of the Web: Number 7, 1949* (pl. 15), 84, 87, 141; *She-Wolf* (pl. 10), 57, 61; *Sounds in the Grass: Shimmering Substance* (fig. 28), 77, 81
Pompeii, Villa of the Mysteries, wall painting frieze (pl. 16), 84, 88, 91
Poons, Larry (Lawrence), 160
Poussin, Nicholas, 4, 11, 22, 61
Potter, Paulus
 WORKS: Young Bull (pl. 27), 131, 134, 137, 141, 143–146, 153, 155
Pozzo, Andrea, 51

Raphael, 4, 5, 12, 43, 54; and Caravaggio, 11, 18–19, 23, 26–28, 34, 35, 38, 50, 51; and Rubens, 23, 26, 35, 38, 51; and Kandinsky, 113, 116
 WORKS: *Canigiani Holy Family* (fig. 36), 113, 116, 117; *Deposition* (fig. 10), 35, 37, 38; *Stoning of Saint Stephen*, 26, 50; *Transfiguration* (pl. 5), 23, 27, 29; Vatican *stanze*, 23, 26
Realism, 42, 98, 160; and Caravaggio, 11, 12, 19, 22, 54, 68; and abstraction, 61, 68, 71, 74, 77, 79, 82, 84, 110, 113, 134; and Picasso, 71, 74, 79, 84, 92, 97; and Paulus Potter, 134, 141, 143
Reality vs. artificiality: in Rubens, 38, 40–41, 54, 68; in abstraction, 43, 46
Regionalism, American, 61
Rembrandt, 5, 11, 19, 22, 27, 153, 155
Remington, Frederic, 162, 164
Renaissance, the, 5, 10, 12, 47, 100; and abstraction, 1, 65, 134, 155, 160; and Caravaggio, 4, 17, 23, 26–27, 35, 38, 103; and Raphael, 26, 35, 38; and Rubens, 26, 35, 38
Reni, Guido, 19, 91
Ribera, Jusepe, 19, 91
Rodin, Auguste, 74
Rosenquist, James, 160

Rubens, Peter Paul, 4, 19; and space, 5, 11, 23, 38, 43, 46, 54, 60, 64–65, 68, 70; and Caravaggio, 5, 11, 23, 26, 28, 35, 38, 40–41, 54, 55, 64, 66, 68, 70; and painterliness, 22, 23, 46, 54, 55, 60, 68, 70; and abstraction, 22, 41, 43, 46, 54–55, 60, 61, 64–65, 66, 68, 109, 110; and Raphael, 23, 26, 35, 38, 43, 51; and artificiality vs. reality, 38, 40–41, 43, 54, 68; and Annibale Carracci, 47, 50, 51, 54, 55, 70; and Pollock, 55, 60, 61, 64, 110
 WORKS: *Assumption of the Virgin*, 65; *Debarkation at Marseilles* (fig. 15), 47, 49; *Descent from the Cross* (fig. 8), 23, 25, 66; *Entombment*, after Caravaggio, 40–41; *Last Judgment*, 60; *Madonna among a Glory of Angels* (fig. 9), 35, 36; *Miracles of Saint Francis Xavier* (pl. 12), 38, 59, 66, 68, 70; *Miracles of Saint Ignatius of Loyola* (pl. 11), 38, 58, 66, 68, 70; *Three Graces* (fig. 19), 63, 66

Sargent, John Singer, 164
Sculpture, 10, 28, 33, 34, 54
Seurat, Georges, 1, 164
Sfumato, 6
Sotheby and Company, 109
Spranger, Bartholomaeus, 143
Steinberg, Leo, 155
Stella, Frank, 97, 123, 127, 146, 153, 155, 158, 160, 162, 164
 WORKS: *Astoria*, 155; *Chocorua III* (pl. 32), 148, 160; *Coney Island* (fig. 49), 155, 156; *Delta* (fig. 50), 155, 157; *Diavolozoppo* (pl. 26), 127, 136; *Gur III* (pl. 33), 149, 160; *Leblon II* (pl. 31), 144, 145, 147; *Mahalat* (pl. 34), 150, 164; *Point of Pines* (fig. 51), 158, 159; *Still life* (fig. 55), 164, 166; *Thruxton 3X* (pl. 35), 151, 164; *Tomlinson Court Park II* (fig. 43), 127, 129; *Valpariso Flesh and Green* (pl. 36), 152, 164; *Warka III* (fig. 52), 160, 161
Suprematism, 89
Surrealism, 42, 61, 66, 79

Teniers, David, 143
Tiepelo, Giovanni Battista, 51
Tintoretto, 18, 19, 23, 34, 54, 64, 65, 66
Titian, 1, 6, 54; and Caravaggio, 4, 11, 12, 18, 19, 22, 99, 103–104, 109; and Rubens, 22, 23, 38
 WORKS: *Flaying of Marsyas* (pl. 21), 99–105, 123; *Presentation of the Virgin* (fig. 2), 3
Tobey, Mark, 120, 123
 WORKS: *Form Follows Man* (fig. 39), 121, 123
Trompe-l'oeil, 28, 42, 54
Turner, Joseph Mallord William, 5, 22, 23

Uffizi, Galleria degli, 6, 8

Van der Weyden, Rogier, 12, 28, 70
Van Eyck, Jan, 5, 12
Vasari, Giorgio, 38
Velásquez, Diego, 1, 4, 5, 6, 19, 40, 143
 WORKS: *Las Meninas,* 9, 18; *Surrender at Breda,* 144
Vermeer van Delft, Jan
 WORKS: *Allegory of Painting* (pl. 1), 9, 13
Veronese, Paolo, 23, 34
Volume, 98, 104, 143–144; and Picasso, 71, 77, 79, 91–92; and Mondrian, 79, 82; and Kandinsky, 97, 116
Vuillard, Édouard, 50

Weightless composition, 116, 123
"Working Space" (pl. 30), 134, 140

Youngerman, Jack, 41, 160

Library of Congress Cataloging-in-Publication Data

Stella, Frank.
 Working space.

 (The Charles Eliot Norton lectures; 1983–84)
 Includes index.
 1. Painting, Abstract. 2. Space (Art)
3. Caravaggio, Michelangelo Merisi da, 1573–1610—
Influence. 4. Rubens, Peter Paul, 1577–1640—
Influence. I. Title. II. Series.
ND196.A2S73 1986 759.06'52 85-46053

ISBN 0-674-95960-4 (alk. paper)
ISBN 0-674-95961-2 (pbk. : alk. paper)

Designer: Marianne Perlak
Compositor: Graphic Composition, Inc.
Printer: Federated Lithographers-Printers, Inc.
Binder: Arcata Graphics / Halliday
Text: 10½ on 13 Galliard with Galliard display
Paper: 80 pound Centura Dull
Binding: Iris 101, 817 (cloth)
 15 point coated one side (paper)
Endsheets: Rainbow Colonial Clay